PHOTO SCHOOL

PHOTO SCHOOL

A complete photographic
course, with over 100 projects.

M

MACMILLAN LONDON

Michael Freeman

CONTENTS

1 BASIC TECHNIQUES

2 IMAGE MANAGEMENT

3 IMAGE INTERPRETATION

A Quarto Book
This book was designed and produced by Quarto Publishing Limited
32 Kingly Court London W1

Art Director Bob Morley
Editorial Director Jeremy Harwood
Art Editor Nick Clark
Editorial Lucy Lidell, Mary Trewby. Philippa Algeo, Richard Williams
Technical Consultant Richard Platt
Designer Tony Paine
Illustrators Simon Roulstone, Marylyn Clark, Edwina Keene
Paste-up Bill Robertson, Tony Armstrong, Annie Collenette

The Project Photographers Tony Armstrong, Brian Brookes, Alastair Campbell, Andrew Clark,
Nick Clark, Moira Clinch, Paul Cooper, Andrew Fenton, Neyla Freeman, Richard Hastings, Alex Hern,
Ian Howes, Timothy Hughes, Kenton Jacobs, Ted Kinsey, Peter Mackertich,
Bob Morley, Tony Paine, Nigel Parry, Richard Platt, Anne Marie Remakus, John Roberts, Fran Rosser,
Steve Rowland, Diane Royle, Leslie Sheryll, Ewan Walder

Photoset in Great Britain by Text Filmsetters Ltd, Orpington,
Kent and Flowery Typesetters, London
Color origination by Hong Kong Graphic Arts, Hong Kong
Printed in Hong Kong by Leefung Asco Limited

Published in paperback 1983 by
PAPERMAC
a division of Macmillan Publishers Limited
4 Little Essex Street London WC2R 3LF and Basingstoke

Associated companies in Auckland, Dallas, Delhi, Dublin,
Hong Kong, Johannesburg, Lagos, Manzini, Melbourne, Nairobi,
New York, Singapore, Tokyo, Washington and Zaria
ISBN 0 333 34562 2 (limpbound)

THE PROJECTS

INTRODUCTION

WHETHER YOU REGARD PHOTOGRAPHY as a craft or an art, essentially it is practical. Few pictures can be taken from an armchair; even a cursory glance at any selection of effective photographs shows that most, if not all, required effort – effort to find an interesting subject, waiting until natural lighting conditions were just right, altering the arrangement of a still life and so on. Pressing the shutter release is the least important part of the photographic process; what counts is preparation and training yourself to see, anticipate and organize images in the viewfinder.

The best way to become a competent photographer is to use your camera. The more you handle and experiment with it, the more familiar it will become, and the less it will get in the way of what you are trying to achieve. Cameras and lenses, however attractively packaged and enjoyable to fiddle with, are only a means to an end – producing photographs. When you reach the stage that they are almost second nature to operate, you will have more time to concentrate on the image. You can afford to make mistakes – a poorly-taken photograph costs only the price of the film – and it is better to be learning from these than to sit at home imagining a perfect picture that may never find its way onto a transparency or print.

This book is purpose-planned to help you on the way to taking the best possible photographs. Unlike many others on the subject, it is not designed to be dipped into at random, but to be followed from the first page to the last as a practical course in photography, the same type of course that you could expect to find in a college, or summer school. The best way to get full value from it is to start at the beginning and work through to the end, project by project. The book is organized in such a way that, at each stage, you can utilize what you have previously learned; as the sequence is progressive, picking up the course halfway defeats the whole idea.

There are three main sections. The first covers the techniques of handling cameras, lenses, film and darkroom equipment. These are the tools of the trade, so the aim of the early projects is to help you become proficient at using them. The second section shows how to take what are basically efficient photographs – pictures that are not only technically satisfactory, but satisfy generally accepted aesthetic standards. The projects here cover the different components that

make up any image, such as lighting, color and balance, and then the special demands of individual subjects, such as landscapes and portraits. The third and final section goes into what is, for many people, the most exciting ability of the camera – to develop individual creative ideas and styles. Its aim is to help you develop your own way of looking at images.

The majority of the illustrations are similarly creative. Rather than illustrate the book conventionally with examples of photographs taken for different purposes, we have deliberately assembled a small group of amateur photographers to undertake the projects – in fact, to do the complete course. So, the relevant photographs are not simply meant to show you how to do it; they are the way in which another photographer, working through the book in the same way as you are yourself, has chosen to tackle the task.

You will need a minimum amount of equipment and materials in order to undertake the course, although we have tried to make the requirements as simple as possible. You do not need a super-telephoto lens or a rapid-firing motor-drive, but you should not consider starting with a simple 110 fixed-lens camera either. If you have a camera of 35mm format or larger, plus three lenses (standard, moderate wide-angle and moderate telephoto), then you have the basic tools. In addition you will need an exposure meter (although most 35mm SLRs now have these built in to the body), a magnifying glass for examining negatives and transparencies and a light box on which to look at them, a tripod and a cable release. Some other items of equipment occasionally may be useful for special projects; you should be able to borrow them from a friend or hire them for a day or two from a dealer.

There are no magic formulae for instant creative success revealed in this course. These simply do not exist in photography. Technical gimmicks, such as special filters that add colors and distort the image, are no more and no less than tricks. They can never make a good photograph by themselves. The ingredients for success lie inside each photographer, and the best that any course of instruction can do is to draw them out and encourage them.

1 BASIC TECHNIQUES

This section of Photoschool is planned to give you a firm grounding in all the main aspects of camera and film handling, so that you can progress to the other sections of the book with confidence in your basic picture-taking abilities. Subjects covered range from the lens, aperture, shutter and exposure to film types, film processing and film printing.

The Lens

THE LENS IS the key part of any camera. An understanding of how and why it works is therefore vital, if you are to achieve good photographic results. For example, lenses are able to form images because their shape bends the incoming rays of light in a controlled way. This is known as refraction; it occurs when light passes from one transparent medium to another, striking the surface between the two at an angle. It is a common feature of transparent materials, including glass, crystal and water.

Demonstrating refraction
One of the simplest ways of demonstrating this effect is to fill a basin with water. Take a stick and hold it half in the water at an appropriate angle. Look at it from an angle close to the liquid's surface and it will appear to be bent. What has happened is that the light waves have been refracted as they pass from the water to the air. If you look at the stick from above, on the other hand, the effect is hardly noticeable. Refraction is greatest when the waves pass through the surface at an acute angle.

A simple prism works on the same basic principle, but with a slight difference. Light still strikes the surface at an angle and so is bent. However, when it leaves the prism, it has to pass through a surface lying at a different angle, so that, instead of being bent back to its original angle, it is refracted even more. Obviously, the angle at which the sides of the prism lie determine how much the light is refracted.

This is particularly important because a lens is, in fact, a stack of sections of different prisms. At its center, the two surfaces are virtually parallel to each other and so light waves pass straight through them, without being refracted. At the edges, however, the two surfaces meet at an angle and so the light here is bent quite sharply. By adjusting the curve of the lens, the light from a single point – a distant light source, say – can be made to come together at a single point behind the lens. This is called the focal point. The distance from the center of the lens (known as the principal point) and the focal point is the focal length of the lens.

This becomes clear if you think of a subject as being made up of an infinite number of points. Each of these is focused by the lens in a slightly different position to make up a complete image.

Images and focal lengths
To demonstrate this principle, remove a lens from the camera body and, indoors, hold it up to the light from a window, the front pointing away from you. Then, take a small sheet of tracing paper, or thin white notepaper, and hold it between the lens and your eye. Move it backwards or forwards, until you see a clear, small inverted image of the window and the view beyond it. The distance between the paper and the center of the lens is the focal length.

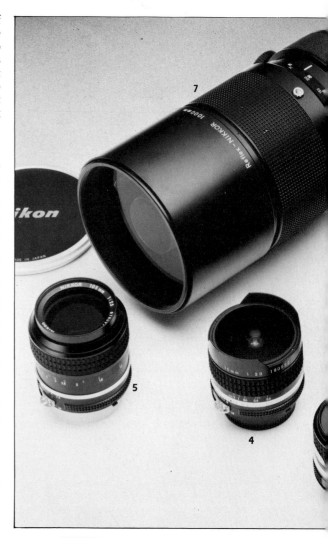

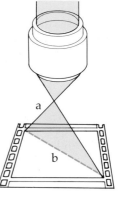

Above A range of fixed focal length lenses for 35mm cameras. The 50mm lens **1** is standard, while the wider-angle 35mm **2** is for general use. The 28mm wide-angle **3** is useful in photo-journalism. The 16mm 'fish-eye' lens **4** gives a distorted effect. Long-focus lenses magnify and reduce the effect of perspective. 105mm **5**, 400mm **6** and 1000mm **7** lenses.
Left The image appears normal when the focal length of the lens (a) roughly equals the diagonal measurement of the film format (b).

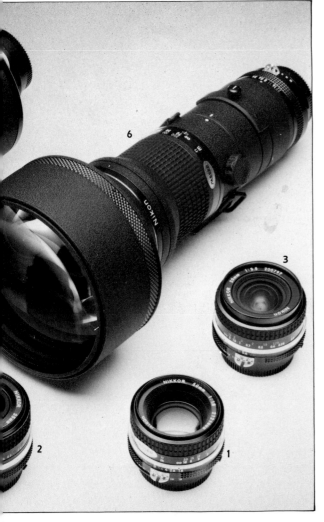

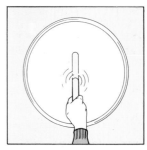

Refraction Transparent materials such as glass, crystal and water all demonstrate refraction. Hold a stick in water, viewing it from an acute angle to the surface, and it will appear bent (above left). This effect will diminish as the angle of view increases. It is hardly noticeable when viewed from above (above right).

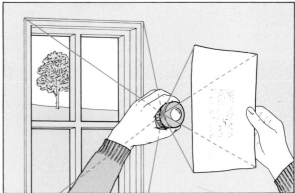

Focal length Remove the lens from a camera and hold it up to the light from a window. Hold up a piece of thin paper between your eye and the lens and move it backwards and forwards until it shows a small, clear, inverted image of the window and the view beyond. The focal length is the distance between the paper and the center of the lens.

Next, take a desk lamp, or any other small, convenient light source. Point the lens towards it at a distance of about 30cm (1ft) and adjust the position of the paper until a sharp image is produced. To do this, you will have to increase the distance between the lens and the paper; this is because the subject is nearer the lens and so the light from it strikes the lens at a different angle. Because of this, the light also leaves the lens at different angles and is focused further behind it. This experiment demonstrates the principle of focusing, which, in an actual 35mm camera, is most easily done by moving the center of the lens away from the film plane.

Put the lens back on the camera body and rotate the focusing ring until the image of the lamp is sharp in the viewfinder. The act of focusing extends the lens barrel, moving the glass – or, in some modern lenses, plastic – elements forward.

Remove the lens again. Point it towards the lamp as before, with the image focused on the piece of paper. Now move the lens towards the lamp. In readjusting the position of the paper, you will see that the image has become larger. In other words, the further the focal point from the lens, the more magnified is the image. This is the principle on which close-up and macrophotography works, extending the lens by means of tubes or bellows. This magnification also illustrates some of the differences between lenses of different focal lengths; a long focal length lens produces a larger image of the subject than a short one, from the same camera position.

13

Focal Length

FROM A PRACTICAL viewpoint, the most important difference between lenses is their focal length. This determines the basic form of the image, for the implications of a smaller or larger magnification go well beyond the simple effect of different image sizes.

Taking a simple lens as an example – modern cameras use several glass elements and are thus known as compound lenses, but the principle of operation is the same – you will find that its focal length can be increased by making it less convex. This means that its surfaces have a shallower curve. Because the angles between the opposite surfaces are less acute, the light waves are bent less sharply and so are focused at a greater distance behind the lens. This magnifies the image – one of the most important attributes of a long focal length lens. Conversely, a short-focus lens has a more pronounced curvature. The light rays are therefore refracted at a greater angle, meeting only a short distance behind the lens. The result is a smaller image.

Focal length and angle of view

Because the image area is the same on cameras of the same format – it measures 24mm x 36mm on a 35mm camera –

changing the magnification inevitably means changing the angle of view, another major quality of focal length. Short-focus lenses, in fact, are almost always referred to as wide-angle lenses. As the diagram here shows, there is a simple relationship between the two.

The angle of view generally thought of as standard is the one corresponding most closely to that of the human eye, even though the eye does not form an image in quite the same way as a camera lens. It flickers rapidly over a scene, scanning it rather than presenting the brain with a single stable view. As a result, although both eyes cover an arc of approximately 240° depending on the individual, most of what they are seeing is not in focus at any one time.

Nevertheless, a focal length of lens approximately the same as the diagonal of the film format produces an image that appears normal. For 35mm cameras, a 50mm lens is usually considered standard, even though this is slightly larger than the diagonal of the picture area. You can see this for yourself by fitting a 50mm lens to your camera and looking through the viewfinder with one eye, while keeping the other eye open. The two images – one direct, the other through the camera – should be about the same size.

Above A standard 50mm lens with an angle of view of 46°. This is close to the apparent angle of view of the human eye and gives a perspective free of the distortions of wide –angle and long-focus lenses. The six elements of this lens are arranged in four groups, which allows the manufacturer enough design flexibility to correct most common optical aberrations.

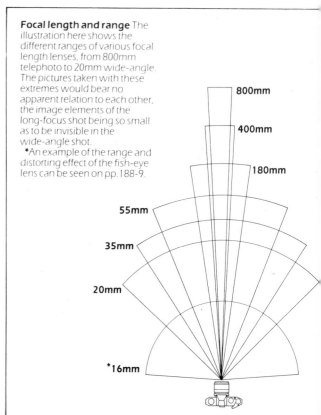

Focal length and range The illustration here shows the different ranges of various focal length lenses, from 800mm telephoto to 20mm wide-angle. The pictures taken with these extremes would bear no apparent relation to each other, the image elements of the long-focus shot being so small as to be invisible in the wide-angle shot.
 *An example of the range and distorting effect of the fish-eye lens can be seen on pp.188-9.

800mm
400mm
180mm
55mm
35mm
20mm
*16mm

Differences in focal length affect the image in the following ways. A short-focus, or wide-angle, lens provides a wide angle of view and good depth of field. Shapes, however, appear distorted towards the edges of the picture, while the sense of perspective is exaggerated. The foreground appears large in relation to the background, while, with the fish-eye design, there is strong barrel distortion at the edges of the picture.

All these qualities combine to suit wide-angle lenses for shooting in cramped interiors and other confined spaces, taking panoramic landscapes and producing images where great depth of field is important. They are also useful for creating distortion for graphic effect and for quick reaction shots, with no time for careful focusing and framing.

Standard lenses produce 'normal' perspective, angle of view and magnification, while their simple design makes wide apertures possible. Lenses of this focal length are therefore unobtrusive in their effect on the image.

The qualities of long-focus lenses are entirely different. They give a magnified image, a narrow angle of view, shallow depth of field and a flattened perspective. Optical aberrations are magnified, so it can be difficult to manufacture such a lens to a sufficient standard to give the best image quality. The background is larger in relation to the foreground, while the lens itself tends to be large and heavy. Such lenses, therefore, are best used with subjects that cannot be approached closely, for compressing planes, for making distant objects appear closer, so that they dominate a scene, and for selecting several different images from one viewpoint.

A zoom lens offers further possibilities. Between the limits of their focal lengths, such lenses provide an infinite choice of angles of view, magnification and other associated qualities. However, the image quality they produce tends to be slightly inferior to that of fixed focus. They are often larger, heavier and have smaller maximum aperture than their fixed focal length equivalents and, when the zoom control is operated produce a streaking effect.

A major virtue is practicality. A few zoom lenses can do the work of many fixed focal length ones. They are particularly useful when precise framing is needed from a fixed viewpoint, as, for instance, in some sports stadia. They can also be used, when appropriate, for a particular type of special effect – the streaking referred to above.

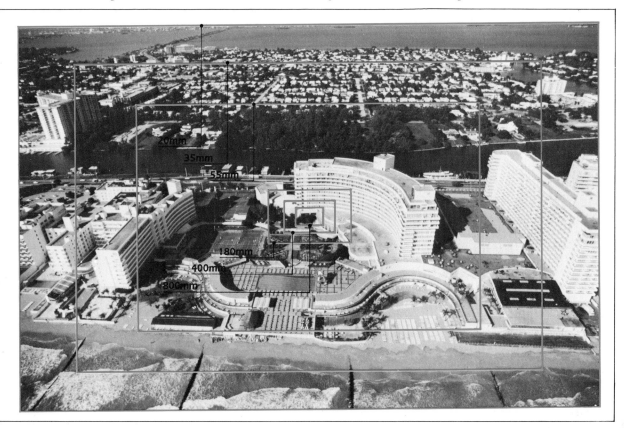

Image Quality

ONE OF THE basic skills any photographer must develop is the ability to maintain a high standard of image quality. This does not mean that the only acceptable form of photograph is a conventionally exposed, sharply reproduced image with a full tonal range, since there may be occasions when you will need to abandon some of these generally accepted qualities to produce the results you desire. In order to have full control over your photographs, however, you should possess the practical ability to use both equipment and materials precisely, whenever required.

Many factors influence the eventual quality of the final image. They include the choice of film, steady camera handling and accurate processing, but the most important without question is proper use of the lens. Lenses naturally vary, according to make, in their ability to resolve detail, to reproduce colors with good saturation, to give good contrast, and in their freedom from aberrations. Nevertheless, the image produced by any lens can be improved by taking some straightforward precautions to avoid common problems.

Dealing with flare

Flare is one of the most frequent faults to occur when using a lens and is nearly always avoidable. It is caused by unwanted light entering the lens and the result is what is termed a degraded image – an image that is weaker, softer and with poorer saturation than a perfect one.

Though there can be problems in excluding all light from outside the picture area, the defect can usually be prevented by shading the lens from bright lights and light areas. The important thing to realize is that such shading is important not only when there is a light source close to the picture area, but in any situation to some extent, all non-image forming light lowers the quality of the eventual photograph.

Lens cleaning

Another simple precaution is to keep the lens clean. Dirt, grease and marks such as fingerprints all lower image quality, though their effect may not be immediately obvious. Take particular care to protect the front element and back element surfaces, using front and rear lens caps whenever the lens is not in use. If any dirt appears inside the lens, have it checked by the manufacturer; lenses are precisely constructed and you may cause misalignment by attempting to dismantle one.

For outdoor use in particular, a colorless filter can provide valuable protection for the front element. Although the extra glass surface may cause a very slight loss of image contrast, this disadvantage is nearly always outweighed by the benefit of keeping the expensive lens surface free from scratches.

Lens shading equipment
Unwanted light entering the lens is a common cause of poor photographs. There is a large choice of accessories available to prevent non-image forming light from degrading the image. Lens hoods (right) can be either square or circular, and have the added advantage of protecting the surface of the lens from scratches. Other possible attachments include a French flag and arm (right, below) and a compendium shade (right, above), which is adjustable to suit different focal length lenses.

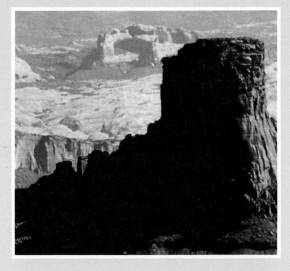

1 · USING FILTERS

For this project, use the longest focal length lens you have available. On a bright, sunny day – preferably with some visual haze – focus on a distant scene, with the sun slightly in front of the camera. The sun should not be allowed to shine directly into the lens, as the results will then be complicated by lens flare. Using color transparency film, make one exposure without a filter over the lens, a second with an ultraviolet filter and a third with a polarizing filter. When you put on the polarizing filter, rotate it until the image appears its darkest and most saturated (on some makes, there is a mark on the circumference of the mount to show the direction of polarization; if yours has one, rotate the mount until the mark points towards the sun).

Compare the results on a light box. The ultraviolet filter should make a noticeable difference to the color saturation and tonal contrast, but the photograph taken with the polarizing filter should show an even greater improvement. This is because this type of filter, which achieves its more usual effects by blocking certain forms of reflected light, also blocks some of the light that has bounced off atmospheric particles to cause the haze.

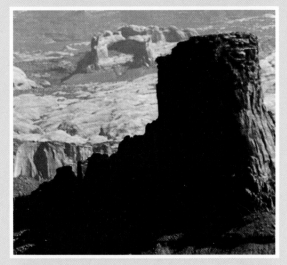

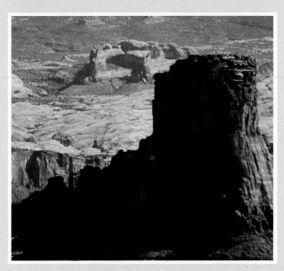

Left, top This long-focus landscape view of Canyonlands, Utah, was taken with the sun's rays cutting across the line of the shot. It is seriously affected by haze, having weak contrast and a blue cast.

Left, middle This photograph, taken with an ultraviolet filter, shows an improvement in contrast and color saturation.

Left, bottom Using a polarizing filter produces a sharper, more colorful and contrasty image altogether. Nikon, 400mm, Kodachrome 64.

Below A polarizing filter works like a screen of parallel slats, letting through polarized light vibrating in the same plane as the slats. When it is turned 90° (bottom) it blocks the polarized light.

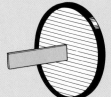

PROJECT **2**

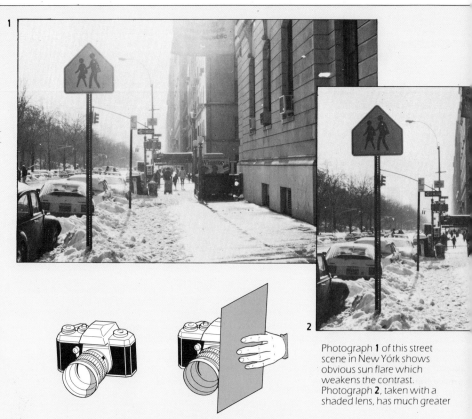

2 · CONTROLLING SUN FLARE

The effects of lens flare are most apparent with long-focus lenses. On a clear day, with the sun fairly low in the sky, compose a shot so that the image of the sun lies just outside the picture frame. Use the camera on a tripod. Even if a normal lens hood is attached, some flare will still degrade the image.

If you look at the front of the lens, you will see that the hood casts its curved shadow over only a part of the front element. Make one exposure like this and then, standing in front of the camera, hold a piece of card so that its shadow just covers the lens. Make a second exposure and compare the two processed frames.

Photograph **1** of this street scene in New York shows obvious sun flare which weakens the contrast. Photograph **2**, taken with a shaded lens, has much greater

PROJECT **3**

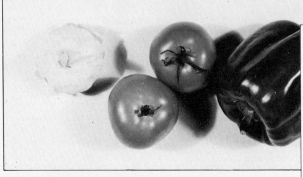

3 · CONTROLLING FLARE FROM THE SUBJECT

Any non-image forming light that enters the lens causes some flare. This does not need to come from an obvious light source. For this project, spread a large sheet of white paper, or cloth, on the floor. If you are working in daylight, place it close to a window; otherwise arrange two lamps on either side of the camera to provide fairly even illumination. Take any suitable handsized object and place it in the middle of the paper, or cloth. Fix the camera on a tripod, pointing vertically downwards and close enough for the subject to almost fill the frame. In this setting, most of the white background is outside the picture area, yet the exposure will show that it is light enough to degrade the image. Surround the subject closely with pieces of black card. Shoot again and compare the results.

contrast. When shooting in color, it is worth remembering that shading the lens produces a marked improvement in color saturation.

Equipment care It is very important to look after all your camera equipment in order to produce good-quality pictures. A camera case should be chosen to give maximum protection, like this aluminum model **1** (below) which has gaskets to seal it against dust and moisture. Lens cases can be of soft **2** or hard leather **3**, or of clear plastic **4**. Cans of compressed air **5** or a blower brush **6** are useful for removing dust. Cotton swabs **7** and a soft toothbrush **8** should be used to clean the camera, while a cloth **9** should be used to remove water and grease.

When cleaning your lens, use the procedure shown in the diagrams below. It is essential to avoid rubbing abrasive particles into the glass.

Filters and image quality
A colorless ultraviolet filter does not only provide the lens with physical protection; it also helps to cut down the effects of haze. Haze, or ultraviolet scattering, is always more apparent in a photographic image than in real life, the reason for this being that most films are extra sensitive to the shorter ultraviolet wave lengths. These wave lengths are the ones scattered most easily by atmospheric particles.

The effects of haze are most apparent over a distance, with a long-focus lens and with the sun more or less in front of the camera. Project 1 will give you an idea of the importance of filters.

Photograph **1**, taken with a white background, illustrates the effects of subject flare, with poor detail and weak contrast. Photograph **2** was taken with pieces of black card placed around the picture area, controlling the reflections from the background. The contrast and density are significantly improved, and the detail on the onion is now clearly visible.

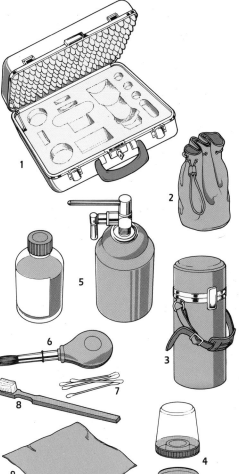

Lens cleaning Keep compressed-air can almost upright to avoid spraying any propellant.

Use blower brush regularly to keep lens surface free of dust.

Use the lens cloth gently to remove water or grease spots without damaging the lens coating.

Aperture

THE SETTING OF the aperture diaphragm inside the lens determines several factors, most notably the amount of light the film receives. The diaphragm opens and closes to produce a circle of varying diameter; at its widest, the lens can gather as much light as possible, while a smaller aperture restricts the amount of light reaching the film. In addition, the aperture also affects the image. It does this in two ways – first, by altering the depth of field and second, by reducing or exaggerating the various lens aberrations that limit image quality.

Changing the quantity of light

In order to make exposure calculations simple, all photographic lenses are calibrated, so that the exact amount of light they pass is immediately obvious. In addition, most lenses have click stops, known as f-stops, at particular points. The standard series of f-stops is f1, f1.4, f2, f2.8, f4, f5.6, f8, f11, f16, f22, f32 and so on.

An f-stop is calculated by dividing the focal length of the lens by the diameter of the aperture. If, for instance, the aperture on a 120mm lens is adjusted until it measures 15mm across, then the f-stop will be f8. The standard series is arranged so that the exposure is progressively doubled or halved from one stop to the next. The aperture at f2.8 is twice the size of the aperture at f4 and half that at f2.

Because the f-stop calculation depends on the focal length, it follows that, to admit the same quantity of light to the film, a long focal length lens will need a wider aperture than a short focal length lens. In practice, however, this causes no problems, as the f-stop is the same in both cases.

Altering depth of field

As well as determining exposure, altering the aperture also changes the depth of field. This is the term given to the two limits of acceptable sharpness, beyond and in front of the point on which the lens is focused.

The measure of sharpness is determined by the size of the circle of confusion. This is the largest point recorded by the lens – all lenses record points as circles – that still looks like a

4 · CONTROLLING EXPOSURE

This project does not involve photography; it is simply a desk examination of the lens. Although most single-lens-reflex (SLR) lenses have what are known as fully automatic diaphragms – these allow viewing at full aperture until the shutter is released – the diaphragm will open and close as you turn the control ring on the barrel, when the lens is removed from the camera. Take a standard lens and a metric ruler. Set the aperture at f2.8 and measure, as well as you can from the back, the diameter of the aperture. If the focal length is 50mm, the opening will be 18mm across. Next, turn one stop to f4. This time, with a 50mm lens, the aperture will be smaller (12.5mm in diameter). The area of the aperture has been halved by moving from f2.8 to f4; hence, half the amount of light is passed.

Next, take a wide-angle and a telephoto lens and set them both to the same f-stop. The aperture on the telephoto is larger than that on the wide-angle. The difference in size is because the light has longer to travel in the long-focus lens and obeys the inverse square law (see p.185).

Lens marks A crude guide to the depth of field is marked on most lenses adjacent to the distance scale. For most aperture settings, the maximum and minimum distances that will be sharp are color-coded (**left**) to the appropriate f number on your depth of field scale.

Depth of field At full aperture **1**, the circles of confusion are broad; consequently, the sharp points that the eye interprets lie very close together, resulting in a shallow depth of field. When the lens is stopped down **2**, the circles of confusion are narrower, the sharp points more widely spread and the depth of field greater. Minimum aperture **3** is used to achieve maximum depth of field.

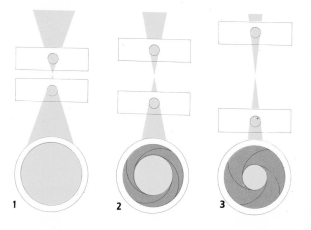

PROJECT **5**

5 · ESTABLISHING OPTIMUM SHARPNESS

Most lens faults are at their worst at the corners of the frame – that is, furthest from the center. Find a subject with much well-focused detail – a busy urban or natural landscape, for instance. Alternatively, use a commercial test card, following the supplier's instructions. Photograph at each f-stop, using very fine grain black and white film. After processing, examine the same corner detail on each frame, with the negatives on a light box and using a magnifying glass. Which f-stop gives the sharpest image?

Lens covering power This is the circular extent of an acceptably distinct image, within which the film format must lie.

f2 center

f2 corner

f5.6 center

f5.6 corner

f16 center

f16 corner

Left These center and corner details demonstrate the effect on sharpness of using different apertures. The center details show little difference between f2, f5.6 and f16, though the f2 detail has noticeably less depth of field. The corner details, however, show marked differences in sharpness. The f2 detail is very indistinct and the f5.6 a little better, though still unsatisfactory. The f16 detail is by far the clearest, though it does not have the sharpness of the center detail at f5.6.

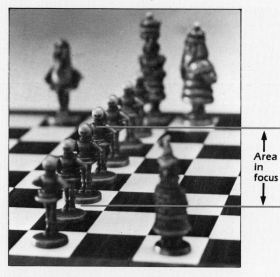

The photographer chose to use a chess-board as background for this project, its black and white squares providing an ideal graduated scale for measuring depth of field. He used a Sinar view camera with a 300mm lens. This shot, at 5.6 (the maximum aperture of the lens), shows a depth of field of about one square on the chess-board.

6 · TESTING DEPTH OF FIELD

Here, the purpose is to show the precise increase in depth of field when the aperture is reduced. Although many photographic subjects will demonstrate the principle, look for something that can be measured easily; a regularly-spaced row of objects, such as a fence or railings, is ideal. Set up the camera with its standard lens on a tripod and aim it diagonally towards the row. Focus, at maximum aperture, somewhere slightly closer than the centre of the image. Mark the point on the row with a crayon or adhesive label and measure the distance exactly. Do not rely entirely on the distance scale engraved on the lens. Photograph the scene at each f-stop on the aperture ring, using the shutter speed to adjust the exposure each time. Then, take two or three of the aperture settings and, with the preview lever depressed, try and judge by eye the limits of the depth of field – that is, the nearest and farthest points from the camera that appear sharp. At a small aperture, the lack of light will make this difficult, but keep a note to compare later with the printed photographs.

Process the film and make enlarged prints. Over each print, slide two straight-edged pieces of paper from each side to cover all but the sharp part of the photograph. By counting the spaces in the picture, you can measure the depth of field for each f-stop. Note how this compares with your visual judgment at the time of shooting and also how it compares with the depth of field scale on the lens.

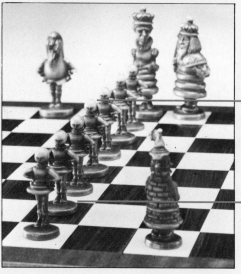

At f16, most of the pawns in the centre of the board are in focus but the main pieces in the background and the foreground are not very sharp.

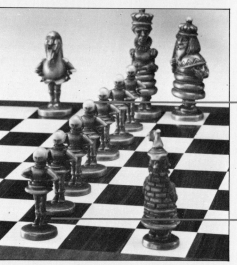

At f32, all but the furthest background piece are in focus. With this subject, this is the most satisfactory result, but a narrow depth of field can be used creatively, to emphasize certain elements of the image.

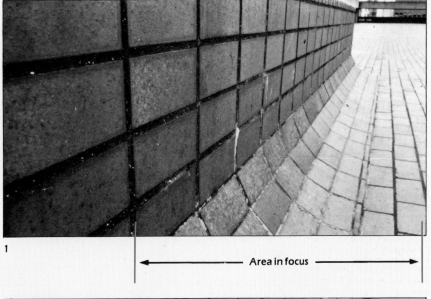

7 · FOCAL LENGTH AND DEPTH OF FIELD

Because a long focal length lens needs a larger aperture for the same f-stop as a wide-angle lens, the depth of field is less. Use the same row of objects as before, but this time use a wide-angle lens for one exposure and a long-focus lens for another, each with the same aperture setting and from the same camera position. On the finished prints, measure and compare the difference between the depth of field.

Photograph **1**, taken with a 28mm wide-angle lens, shows a large area in focus, several times the size of that in photograph **2**, taken with a 135mm lens.
1/60sec, f4.

1

Area in focus

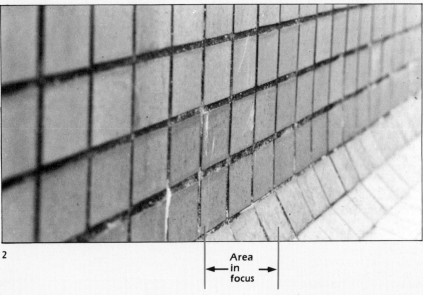

2

Area in focus

point to the naked eye. Stopping down – in other words, closing the aperture – means that the angle at which light waves converge on the film becomes shallower. As a consequence, the circles of confusion on either side of the film plane are smaller, with the result that more of the subject, in depth, becomes sharp. A large aperture opening, on the other hand, reduces this depth of field considerably.

Changing image quality

All optical designs involve compromise, since no designer has ever produced a perfect lens. Of all the faults that can affect lenses, a number are most apparent close to the edges of the image. Spherical aberration, for instance, occurs because a lens with a spherical surface – this is the case with most lenses, for reasons of cost – produces a sharp image only on to a spherical surface, whereas most film planes are flat. The result is a blurring towards the edges.

The only way to reduce the impact of such faults is to reduce the aperture to use the central part of the lens. But, conversely, using a small aperture can exaggerate other faults. Diffraction, the scattering of light at a sharp edge, increases when the lens is stopped down, for instance.

The net effect of this is that sharpness and general image quality is best for most lenses at two f-stops below maximum. This is called the optimum aperture; for a standard lens, with a maximum aperture of f2.8, the optimum aperture is f5.6.

Shutter and Movement

8 · **Stopping subject movement**
9 · **Panning**
10 · **Improving your slowest shutter speed**

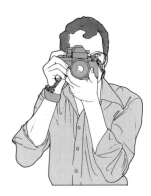

Camera handling Support the weight of the camera equally between the palms or heels of the left and right hands, leaving the fingers free, where possible, to operate the controls (above). Press the camera against your face and squeeze the shutter firmly but gently. With a heavy, long-focus lens the prone position **1** (below) is one of the steadiest, especially with a support such as a camera bag. The kneeling position **2** is next steadiest, resting the elbow on your knee. Standing **3** is the least steady. With a long-focus lens, either support it firmly from below with the left hand or pull it back to brace against your face. Panning **4** involves moving the camera to freeze a subject's motion.

THE AMOUNT OF light that reaches the film is controlled not only by the lens aperture (see p.20), but also by the camera shutter. On most cameras, this can be set to remain open for between 1/2000 of a second and several seconds, according to the type of shot. Mechanical shutters are nearly always calibrated in such a way that each setting is half or twice as fast as the one next to it, so that the difference between the two is the equivalent of one f-stop. On many automatic cameras, however, electronic operation makes it possible for continuous adjustments to the shutter speed.

There are two common shutter designs – between-the-lens leaf shutters and focal plane blind shutters. The former are fitted to non-reflex cameras and, mechanically, operate in a similar way to the lens aperture, a centrally-opening iris being formed by interlocking blades. Focal plane shutters, placed just in front of the film, are needed in reflex cameras, so that the mirror used for viewing can be located in the main camera body. They operate either horizontally or vertically by means of an adjustable slit that passes across the film plane. At faster speeds, the width of this slit determines the exposure; at slower ones, a timing mechanism takes over.

The faster speed, the less reliable the shutter is likely to be; this can be noticeable at 1/1000 sec and 1/2000 sec. Age and use can also affect a shutter's efficiency, so its accuracy should be checked by the manufacturer or a camera repair store every year or two.

Controlling movement

It is important that the shutter speed should be controlled correctly if there is movement in the subject you are photographing. Unless the speed is fast enough, moving subjects will appear blurred in the final image. A controlled amount of blur can be used effectively in some situations – to give an

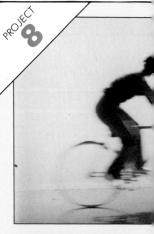

8 · STOPPING SUBJECT MOVEMENT
This project will help to give you practical experience of the shutter speeds you will use most frequently in your photography. For it, you will need a friend to act as a model, a bicycle and a quiet path or road, with an uncomplicated background.
 Set the camera up on a tripod, so that the image of

PROJECT 9

9 · PANNING
If your subject is moving smoothly – an automobile, bicycle or aircraft, for instance – the normal method used to photograph it involves nothing more complicated than moving the camera to keep the subject in frame. This is panning. Done efficiently, it reduces the apparent movement of the subject, while at the same

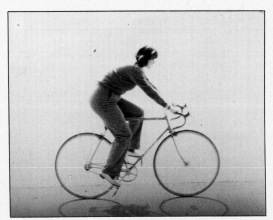
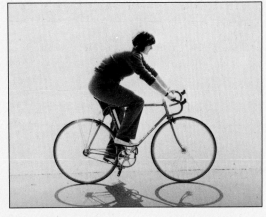

a standing figure fits comfortably within the frame. Then, have your friend walk along the path at a normal pace several times. Each time make an exposure, varying the shutter speed from 1/1000 sec to 1/15 sec. Next, take the same sequence of exposures, but this time with your friend running rather than walking. Finally, repeat the sequence with your friend

riding the bicycle at a normal, comfortable speed (alternatively, use a skateboard, roller skates, a slowly driven motorcycle, or anything that provides smooth movement). At the faster speeds, you may find it difficult to release the shutter at precisely the right moment. In such a case, take several shots, but always be sure to note the shutter speed used for each frame.

Develop and print the results. Examine the prints to find the slowest shutter speed in each sequence that holds the subject sharp. Note that in each case at least one leg, and, in some cases, an arm, is moving momentarily faster than the whole body. An even higher shutter speed would be needed to freeze everything in the shot, such as the spokes of the bicycle wheels.

These photographs are a selection from the third part of the project. Photograph **1**, taken at 1/15 sec, records the figure on the bicycle as little more than a blur. Photograph **2**, taken at 1/125sec, has succeeded in stopping the movement of the subject, but with minimal detail. At maximum shutter speed, 1/1000sec, the image is sharp enough to enable the name on the frame to be read.

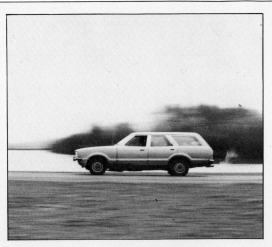
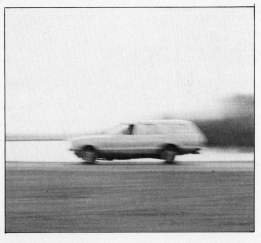

time blurring the background.
　Use either the same setting as in the previous project, or any road with a clear field of view, and a bicycle, motorcycle or automobile as the subject. As the vehicle moves across your field of view, track it through the viewfinder, keeping its image as steady as possible. Using a long-focus lens from a

distance gives a more definite contrast between the subject and its background. Make a sequence of exposures, varying the shutter speed from 1/250 sec down to 1/2 sec.
　Taking the developed prints, find the slowest shutter speed at which the subject remains sharp, as in the previous project. Note here how the blurring of

the background not only simplifies it, making the vehicle stand out more clearly; it also adds an impression of speed that would be lacking in a perfectly frozen shot. Another project illustrates the technique of intentional blurring for special effect, but this sequence is designed to show the effect of using a very slow shutter speed.

1 Panning with a shutter speed of 1/30sec records the car as a blur. At 1/100sec the car is reasonably sharp against a blurred background, giving a good impression of speed. At 1/250sec even the detail on the wheels of the car is frozen, and so is the background to a certain extent. The choice of shutter speed is subjective, depending on the kind of image you want to produce.

PROJECT **10**

While an out-of-focus image appears blurred, the characteristic effect of camera-shake is to produce a double image, as in the detail above.
55mm, 1/30sec, f11.

10 · IMPROVING YOUR SLOWEST SHUTTER SPEED

Many of the most interesting photographic opportunities occur in low light conditions, or involve the use of lenses with small maximum apertures. Because of this, you should develop one of the fundamental photographic skills – the ability to handle a camera steadily and precisely. The illustrations on p.24 show some of the best shooting positions. By finding the ones that suit you best and learning to use them well, you will find it possible to improve the slowest shutter speed at which you can expect sharp images by up to two f-stops.

Choose any convenient subject that you can photograph easily; it only needs to contain sufficient fine detail to show the effects of camera shake. With each lens – long-focus, standard and wide-angle – make a series of exposures at speeds varying from 1/250 sec down to 1/4 sec, without worrying about your shooting position. Examine the results, noting the slowest shutter speeds you could achieve while keeping the image sharp. Use these as your baseline for improvement and, over

The enlarged detail above, taken at 1/60sec, shows an acceptable degree of sharpness. Most camera manufacturers recommend that, at speeds slower than this, it is advisable to use a tripod.
55mm, 1/60sec, f8.

the next weeks whenever you have a spare frame or two on a roll, practice in the positions shown here. Make a conscious effort to control your breathing. Avoid holding your breath, as the muscular tension this

involves will actually increase camera shake; just exhale slightly as you release the shutter. Practice squeezing the shutter release gently – never jab it.

You will find that you can

hold the wide-angle lens steady at slower speeds than the other two, because the image is magnified less. With all three lenses, you should show great improvement after a week or two.

impression of fast movement, for instance – but, for the majority of shots, the aim is to freeze motion.

The choice of shutter speed, which in turn determines the aperture setting, often hinges on how fast the subject moves in the frame. The actual speed of a moving truck, for example, is less important than the time its image takes to pass across the viewfinder. This can be affected by how close the camera is to the subject, the focal length of the lens (the truck's image would be smaller through a wide-angle lens and so move more slowly) and the angle of approach (movement towards the camera appears slower than movement across it).

Speed and shake

It is also important to avoid camera shake at low shutter speeds. Even with a static subject, there is a limit to the slowness of shutter speed that can be used when holding

the camera. If the speed is too slow, camera shake will blur the entire image, usually with a characteristic 'ghosting' effect. Even with a small amount of shake, there is likely to be a slight overall lack of sharpness, even though the effect may not be striking.

The more magnified the image, the more pronounced is the effect of camera movement. In other words, a long-focus lens needs to be held more steadily than a wide-angle lens at the same shutter speed. Thus, the basic principle in holding any camera is to use whatever support is available. Under most conditions, a tripod is best, although it is often impractical and needs to be used with care. Resting the camera against any firm surface, preferably supporting it with padding, is a good alternative.

See p.24 for the various standing, kneeling, crouching or prone positions that can be adopted. Project 10 is designed to improve camera handling from this point of view.

Aperture and Shutter Together

KNOWING HOW TO combine the use of aperture and shutter effectively will improve the quality of your photographs immeasurably. There are a few basic rules worth noting. In low light conditions, there is usually no alternative to using the widest possible aperture and a slow shutter speed. In very bright light, a fast shutter speed and small aperture setting will be needed. A fast-moving subject usually dictates a high speed. Apart from specifics like these, however, you normally have a choice in the combination of aperture and shutter. Each controls the quantity of light reaching the film, so, provided that exposure conditions are within the normal range of photographic subjects, there may be several alternatives open to you.

On a fairly bright day, for instance, with ASA 125 film and a standard lens, you could choose 1/1000sec at f4, 1/60 sec at f16, or any of the intermediate settings. If the camera were well-supported on a tripod, the choice could be extended up to, say, 1/15sec at f32, depending on the minimum aperture of the lens. Because both the aperture and shutter speed controls are calibrated in single f-stops, it is easy to use them in combination. Altering each by one halves or doubles the exposure. It is a reciprocal arrangement.

Choosing your priorities

Given that both aperture and shutter can control the exposure level, choosing the best combination for the subject means deciding which of their other effects on the image

11 · APERTURE VERSUS SHUTTER

Because in most cases, you will be offered a choice of aperture/shutter speed combinations, establishing priorities between depth of field, control of movement and image quality is something that should be worked on constantly, not just in a single project. However, to demonstrate the different results that are possible, choose a subject that contains both depth and movement. If you can find a stream flowing over some rocks, for instance, position the camera on a tripod close to the water's edge and frame the shot to include everything from infinity to a foot or two from the camera. Another possibility might be to place the camera close to some moving leaves or branches on a windy day.

Using a standard lens, focus so that as much of the scene as possible will be sharp at the minimum aperture setting. Then make three exposures – one at minimum aperture, one at the maximum and one at the f-stop in the middle of the range between the two. Adjust the shutter speed to compensate for this. Choose a film with an ASA rating that allows a film speed of about 1/250 sec at maximum aperture; on a moderately bright day, a slow ASA 25 film would be suitable for a lens that opened up to f2.8.

Compare the three photographs. Although the exposure remains the same, depth of field and the ability to freeze movement are traded for each other. Decide for yourself which is the most acceptable

In order to capture the movement of the water flowing from a fountain in Trafalgar Square, London, the photographer had to get within a few feet of his subject. In the exposure taken at f16, 1/60 sec (**left**), the church tower in the background is very sharp, but the water has lost all recognizable characteristics and appears almost a blur. At the intermediate setting, f5.6, 1/125 sec (**center**), varying amounts of blur are visible. But at f2, 1/250 sec (**right**), while the depth of field has fallen, the water movement has been frozen.

PROJECT **12**

12 · OVERCOMING RECIPROCITY FAILURE

Find a scene that is dimly, but evenly, lit. Outdoors, dusk is a good time, but you will need to work quickly, as the light level can fall quite rapidly. Alternatively, an indoor setting could be used for the black and white stage of this project, but the color temperature difference of artificial lighting (see pp.76–7) would complicate the result with color film.

Look for a combination of light level and film speed that allows a shutter speed of 1/30 sec at maximum aperture. Then, with black and white film in the camera, make two exposures, the first at maximum aperture and the second at minimum aperture. Make no allowance for reciprocity failure, but simply adjust the shutter speed as in the previous project.

Now change to color transparency film. Calculate the settings in advance and make three exposures. The first should be at maximum aperture, according to the meter reading, and the second should be at minimum aperture, also according to the meter reading and without allowing for reciprocity failure. For the third shot, repeat the second one, but opening the aperture by the number of f-stops recommended in the film instructions, and also placing the recommended colored filter over the lens.

When processed, examine the transparencies side by side on a light box. The first slide is the baseline, so judge the others against it. The second will be darker, but by how much depends on the extent to which the particular brand of film you used suffers from reciprocity failure. Many

The church interior was extremely dark and even at full aperture, f3.5 (**top left**), the hand-held meter indicated a 10 second exposure with 50 ASA film. However, only the bright windows and the pews which they illuminate have appeared in the film. By increasing the exposure time to 50 seconds (**near left**), detail is retained even in the shadows – more detail, in fact, than was visible with the naked eye.

The pictures of the bluebells show how much more difficult it is to compensate for reciprocity failure with color film. Here the photographer made three exposures. In the first, $\frac{1}{15}$ sec, f5.6 (**bottom left**), the color and density are good, but there is insufficient depth of field. In the gathering dusk, the lens was stopped down to f32 (**bottom center**) so that foreground and background were in focus. The exposure was 8 seconds and the result is too dense. For the shot on the bottom right, the photographer followed the manufacturer's instructions by increasing exposure to 24 seconds and adding a 20B filter. Even so, color does not match the first attempt. For perfect results, color tests would be necessary (see page 76) to 'fine tune' the filtration.

tungsten-balanced films are designed to be used at relatively long exposures and so would not show reciprocity failure at the shutter speeds used in this test. The third transparency should have the same density as the first, with the correcting filter restoring the color balance.

What makes reciprocity failure complicated to deal with is the fact that the longer the exposure, the more it increases. There are **often times when you cannot or do not want to increase the aperture; in such cases, the only choice left is to increase exposure time. This simply magnifies the effect, meaning that extra compensation is needed and so on. For safety's sake, therefore, it is a good idea to bracket exposures.**

are important. This is one of the first and simplest of the multiple layers of decision involved in any photography you undertake. It means establishing priorities for the image. Is it more important, for example, to have great depth of field than for every moving part of the subject to be frozen? From the previous pages, here are the ways in which the aperture and shutter speed can affect the image.

Image	Control
Depth of field	Aperture
Lens aberrations/image quality	Aperture
Movement	Shutter
Camera shake/image quality	Shutter

Another way of looking at the alternatives is to use the subjective quality of sharpness. Many factors can contribute to whether an image is sharp or not, including the type of film, the design of the lens and lighting conditions. The ways in which the aperture and shutter speed can affect this are as follows.

Overall sharpness is improved by a broad depth of field (small aperture), minimum aberrations (medium aperture), minimum blurring (fast shutter speed) and absence of camera shake (fast shutter speed). Selective sharpness involves keeping a part of the image deliberately unsharp, usually to simplify and to help the main subject stand out. It is controlled by shallow depth of field (wide aperture) and controlled blur of subject or background (medium to slow shutter speed).

It is not often that the aperture setting and shutter speed that are precisely correct for all factors can be used. In most cases a compromise is necessary and this is why the priorities of the shot have to be decided.

Reciprocity failure

This tandem relationship between aperture and shutter speed is a form of reciprocity, as explained above. However, because of the nature of most films, it stops working if exposures are either very long or very short. Leaving the shutter open for eight seconds' exposure at f32 ought, in theory, to give the same exposure as 1/30 sec at f2, but, with most films, the image will be darker. In other words, the film needs additional exposure at very long exposure times. This is known as reciprocity failure. It can be complicated to compensate for, since each make of film has different characteristics, so it is best to follow the manufacturer's recommendations in the initial stages.

With black and white film, correcting reciprocity failure is simply a matter of making sure more light reaches the film, but color film presents more severe problems. Each of the three layers of emulsion (see p.34) suffers reciprocity failure to a different degree and the result is a color shift. With many makes, the shift is towards green, so that a red filter has to be used to compensate. Again, the manufacturer's recommendations are the best guide.

Black and White Film

13 · Differing film speeds

THE THEORY OF how film works is fairly straightforward to understand. Basically, any emulsion consists of small light-sensitive crystals, or grains, which are embedded in a layer of gelatin, normally with a tough sheet of acetate as a backing. Some emulsions are more complex than others, but the principles remain the same. The most basic film is black and white negative material. The normal light-sensitive material here is silver bromide, though some modern emulsions, notably in chromogenic films, work in a more sophisticated way.

For learning how film works, black and white film is invaluable. It has the advantage of simplicity over color, while it is easy to process in the home darkroom.

Forming an image

When film is exposed to light, changes happen at a molecular level. These are too small to be seen even under a microscope until the action of a developer magnifies them to produce a real image. Each silver bromide crystal – these are normally between 1/1000mm and 1/500mm in size – contains silver and bromide ions, plus small impurities that play an important part in the reaction that follows after light strikes the crystals. When this happens, electrons are released from the bromide and these settle around any impure specks, pulling the silver ions along with them. Each exposed crystal now contains a small, but invisible, clump of metallic silver.

Developing the film simply magnifies the change several million times. Grains that have received a large amount of light are almost completely converted into dark metallic silver. Unexposed parts of the film remain transparent, as no silver has been formed. Between these two extremes are infinite shades of grey, where the grains have received more or less light and have been converted into varying amounts of silver. Thus, the more exposed, the darker the film; hence, the reversed image on a negative.

Common black and white films

The following are the most commonly available black and white films that produce a silver image.

Slow (ASA 25–ASA 32)
Agfapan 25, Kodak Panatomic-X, Ilford Pan F
Medium (ASA 100–ASA 125)
Agfapan 100, Kodak Verichrome Pan, Kodak Plus-X Pan, Ilford FP4
Fast (ASA 400)
Ilford HP5, Kodak Tri-X Pan, Agfapan 400
Very fast (ASA 1000+)
Kodak Recording Film 2475

ASA stands for American Standards Association. With its German equivalent, DIN (Deutsche Industrie Norm), it is a standardized measure of how sensitive a film is to light, thus making comparisons straightforward. The International Standards Organization has recently devised a new rating convention, ISO, which will eventually be used universally.

13 · DIFFERING FILM SPEEDS

Take four rolls of film – slow, medium, fast and very fast – and photograph the same subject with each one, choosing something static so that the image remains identical throughout. Also take care to find a subject that will show up the differences in graininess and sharpness produced by the different films as clearly as possible; an ideal combination is fine detail against a large, plain mid-toned area. The fine detail is needed to judge sharpness and the mid-tone to evaluate graininess; a light surface contains too few grains to be useful, while a strong texture, such as brickwork or grass, will obscure the grain pattern.

Run through several exposures on each film, resetting the ASA rating for each individual film and bracketing the exposures by half a stop for safety each side of the light meter reading. Develop the films and examine the negatives on a light box with a magnifying glass. Choose one negative from each film, making sure that all four are similar in density – that is, that they have more or less the same range of grays and blacks.

First, check for graininess. Start with the very fast film, where this will be most obvious, and look at the speckled pattern in the plain mid-gray areas. The individual specks that you will see are not the individual grains – you would need a microscope for this – but clumps formed of many overlapping grains. Even in a thin layer of emulsion, large numbers of jumbled grains are stacked on top of each other. Now compare the graininess in the same part of the film on the other negatives. On the slow film, it should be hardly visible.

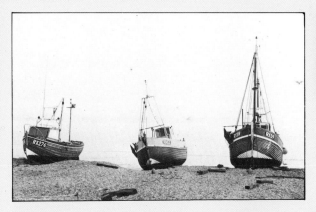

Slow film This ASA 32 film produces a fine-grain image and a wide range of tones, and is ideal for preserving detail when great enlargements are to be made. The lettering in the detail above is very sharp.
55mm, 1/15sec, f5.6

Medium film This ASA 125 film is also very fine-grained, and the detail in the enlargement is only slightly less sharp than with the slow film. It is fast enough to allow hand-held shooting in most lights.
55mm, 1/60sec, f5.6.

Fast film At ASA 400, this film is beginning to show a substantial increase in graininess. It is generally used in low-light situations or where a fast shutter speed is needed.
55mm, 1/125 sec, f5.6.

Very fast film This film has an ASA rating of 1000. The image details break up under enlargement and the effect is very grainy. It also shows less contrast than the slower films.
55mm, 1/500sec, f5.6.

You can print up an enlarged detail to see how the grain affects the positive image. Because of the extra stage involved, the grains will not be quite as sharp, but with the fast film they will still be pronounced. You may decide that strong graininess detracts from some subjects, as it hides texture and breaks up detail. On the other hand, there may be times when the 'gritty' appearance of the print can enhance an image. This is why graininess, in the end, is a subjective quality. Bear these possibilities in mind for later projects.

Next, check for sharpness. Because black and white films are made more sensitive by having larger grains incorporated in the emulsion, extra film speed generally works against sharpness. With the magnifying glass, look at some fine detail in the negatives. On the fast films, the lines and edges are partly broken up; these films, therefore, resolve less detail and so normally appear less sharp. However, the sharpness of fast film is actually helped by its graininess; because the specks themselves are sharp, the overall appearance may be crisp. This, again, is subjective.

Finally, check for contrast. This can be difficult to do by eye, as the differences are not likely to be very great, but slow films have less contrast than fast films. In other words, you should be able to see less of a difference in tone between the lightest and darkest areas of the fine grain negative than between those of the grainiest negative. Strong contrast often makes photographs look sharper.

How Black and White Film Reacts to Color

14 · How black and white film reacts to color
15 · Working with natural colors

NEITHER A HUMAN eye nor film responds to the different wavelengths of light completely efficiently, or in the same way. Balancing the differences between the eye and film, or at least appreciating them, is thus essential in black and white photography in order to have some control over the tones that appear in the final print.

To begin with, what we call light is only a small fraction of all the different types of radiation known collectively as the electromagnetic spectrum. The human eye perceives color from a wavelength of about 400 nanometers (deep violet) up to about 700 nanometers (deep red); though most modern films cover this range, they also have extra sensitivity to shorter wavelengths than violet – ultraviolet, in fact. This extra sensitivity frequently causes photographic problems, particularly in landscape photography, where ultraviolet scattering that passes unnoticed by the eye appears as a light haze on black and white film (blue on color film).

As well as covering slightly different ranges of the spectrum the eye and film also respond differently to particular colors. Not even the human eye gives a balanced view, since it is extremely sensitive to greens and yellows, yet reacts badly to deep blue or red. Film, though, has a surprisingly different response, reacting very strongly to blues, but very weakly to reds. In their natural state, the silver bromide crystals used in film hardly react at all to red light, so modern panchromatic emulsions incorporate dyes to extend the range. For some specialized purposes, such as graphic arts, uncorrected orthochromatic emulsions, which respond only to blue light, are still used.

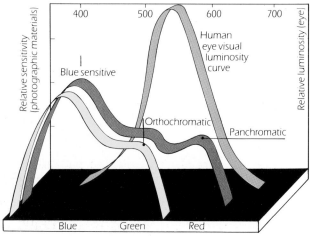

The graph (**above**) explains why film is more sensitive than the eye to blue, which produces a dense silver image on the negative and so prints very weakly. Conversely, film is fairly insensitive to red, which records weakly on the negative and so appears dark on the prints.

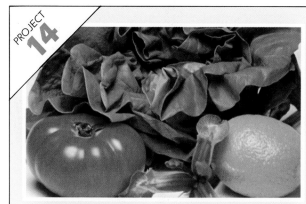

Still life in color.

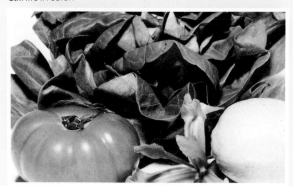

Still life in black and white.

Temple in Burma. 400mm, 1/125sec, f16.

15 · WORKING WITH NATURAL COLORS

Using filters to photograph bright, clear colors in a posed setting is one thing; working with the non-pure colors found in natural landscapes is quite another. The green of most vegetation, for instance, is not pure, but somewhat drab. As a result, a green

14 · HOW BLACK AND WHITE FILM REACTS TO COLOR

To ensure satisfactory results in this project, choose subjects and a setting that can be left undisturbed. A small still-life set in the corner of a room, next to a window, will work well. As the purpose of the project is to show the way that basic black and white film reacts to color, it is important to photograph in daylight and not to use household tungsten lamps, whose distinctly orange color will affect the results.

Collect conveniently-sized objects in red, yellow, green and blue. A tomato, lemon and lettuce serve well for the first three; the fourth choice is less immediately obvious, but a blue flower, for instance, would serve. What is important is that the colors are strong and pure – in other words, saturated. Using any regular black and white film, photograph the set. Then develop the film and print the negatives as soon as possible. If you have a

Polaroid camera that uses black and white film, so much the better, as its use speeds up the project.

Compare the black and white prints with your subject. The light tone of the yellow and the medium tone of the green both match their real-life counterparts, but the blue is distinctly light and the red is quite dark. The graph here explains why; film is more sensitive than the eye

to blue, which produces a dense silver image on the negative and so prints very weakly. Conversely, film is fairly insensitive to red, which records weakly on the negative and so appears dark on the prints.

Using colored filters

This project can be conveniently photographed at the same time as the first. For it, you will need four colored

filters – red, yellow, green and blue – the same colors as the objects in the set. Gelatin filters are the least expensive; Kodak Wratten 25 (red), 12 (yellow), 58 (green) and 47 (blue) are the most useful.

Holding the red filter to your eye, view the group of objects. Try to ignore the overall red cast, since, if you can do this, the tomato will appear much lighter. This is because the red filter passes red light and blocks most of the rest. The same principle applies to filters of any other color.

Photograph the group of objects in turn with each filter. Develop and print the results and compare the different tonal renderings. One of the most valuable uses of these filters is to control the way in which different colors appear against each other. Differentiating between red and green is a clear possibility here; either the tomato can be made lighter than the lettuce, using the red filter, or the lettuce lighter than the tomato, using the green one.

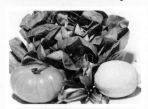
With red filter.

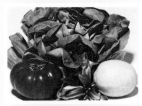
With green filter.

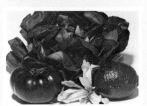
With blue filter.

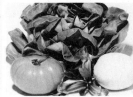
With yellow filter.

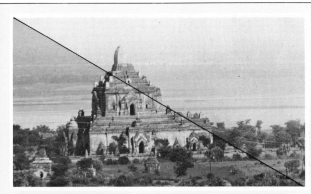
Lower diagonal: red filter. Upper diagonal: green filter.

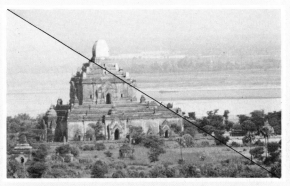
Lower diagonal: blue filter. Upper diagonal: yellow filter.

filter only slightly lightens it. Generally in such cases, the effect of filters is only moderate with black and white film; often only a blue sky is responsive.

Use the same four filters in any outdoor location, where you can see reasonably definite colors. Without filters, a blue sky appears rather light, the

culprit being film's extra sensitivity to blue. A yellow filter, however, blocks some of the blue light, rendering the sky darker. A red filter has an even

stronger effect. Which is better is a matter of personal taste.

Color Film

16 · **Choosing color film**
17 · **Batch differences**

COLOR FILM IS based on the same principles as black and white film. The difference is that three, not one, layers of emulsion are used, each sensitive to a different color. The key to this is the idea of splitting up the spectrum into three distinct, equally spaced wavelengths of red, green and blue. Each of the three layers in normal color film is sensitive to one of these primary colors.

As an analogy, study projects 14–16 on pp. 32–3 again. If very strong red, green and blue filters were used, each on a separate negative, it would be possible, if a little awkward, to reconstruct a colored image of the scene. Color film does this directly. Its three sandwiched layers are the equivalent of three separately filtered black and white films; development, by one means or another, produces dyes in place of the original silver images. How this happens is shown in the diagrams on the right.

The colored disc (**right**) was photographed and the film processed through the following steps to produce a transparency.

1. The exposure and first development of color film is the same as for black and white. During exposure, however, three separate images are formed simultaneously. At this stage, the negative image is converted by the developer into stable silver, while the parts of the film that have no image still contain unexposed silver halides.

2. The images are then 'reversed' by a brief exposure to either light or to a chemical. This starts a second image-forming process: the silver compounds that remained after the first development now form reverse positive images. During this stage, the developer oxidizes and combines with other compounds in the emulsions to produce complementary colored dyes in the positive areas of each layer.

3. Although everything which will form the full color image is now present in the film, the metallic silver formed by the two developments obscures the colors. This is now bleached out leaving a sandwich of the three transparent layers of pure color. When held against the light, these colored images give the effect of the original subject colors.

Visible spectrum The complete range of energy waves makes up the electro-magnetic spectrum. Only a small group of these waves are visible (as light) to the eye. Their color – determined by the wave's length – ranges from violet to red, ie, from 400 to 700 nanometers (see page 56).

Radio

Radar

Infra-red

Ultra-violet

X-rays

Gamma-rays

700nm
600nm
500nm
400nm

16 · CHOOSING COLOR FILM

Constant perfect reproduction is impossible with color film, so manufacturers design their films to work best under different conditions. One make of film may be particularly good at reproducing flesh tones accurately. Another may be designed to give neutral blacks, while yet another might produce a bright, saturated image of blue sky.

The aim of this project is to compare the different types. Take one roll of each of the following daylight-balanced color transparency films: Kodachrome 25, Kodachrome 64, Ektachrome 64, any non-Kodak ASA 64 film and Ektachrome 400. Find an outdoor location that contains a range of colors, including gray. You could include a person's face, if you desire. In stable lighting conditions, take the same shot with each roll of film, varying the exposure setting both up and down from the light meter reading. Compare the results.

Kodachrome 25 A sharp, well-balanced result.

Fujichrome 100 This shot looks warmer, with more yellow in the shadowed flesh tones.

Kodachrome 64 Similar to the Kodachrome 25 but shows more grain under great enlargement.

Ektachrome 400 Bluer in the shadows than the Kodachrome and cooler overall.

17 · BATCH DIFFERENCES

The color balance of color film can vary considerably between manufacturing batches (for color accuracy, manufacturing tolerances for most films are to within five per cent). Find three rolls of the same type of film, but from different batches. Photograph the same image with each roll. The results can be quite startling.

Three shots taken with different batches of the same make of ASA 64 film, all at 1/125sec f8, but their reactions to color vary greatly.

Basic Black and White Processing

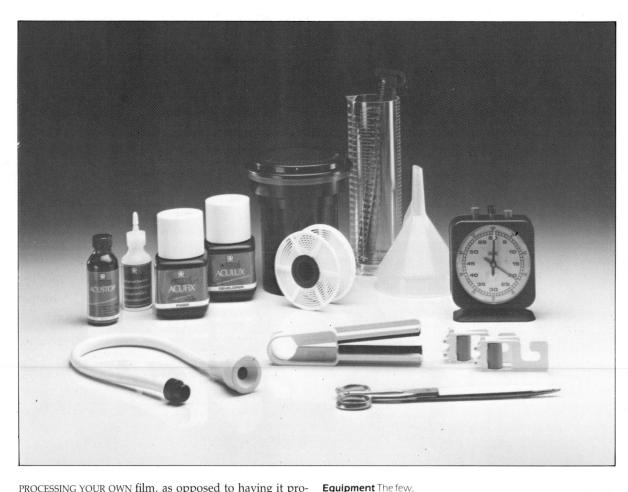

PROCESSING YOUR OWN film, as opposed to having it processed by a professional laboratory, has a number of advantages. It enables you to embrace the entire process of making a photograph and this will give you a better understanding of image formation. On a practical level, it is less expensive and it can be done immediately, which allows you to see the results of your photography while it is still fresh in your mind. It also allows you to exercise fine control over such things as contrast and density, which become important in later projects in this book.

With the equipment shown here, high quality black and white printing is possible even without a darkroom. All you need is a room from which all light can be blocked – a windowless closet or a bathroom, using cloth to block any gap under the door – or, if such a room is not available, even a changing bag can be used. The only part of the process that must be done in darkness is the removal of the film from the cassette and the loading of it on to the spiral of the developing tank.

Equipment The few, inexpensive, basic items needed for processing black and white film are shown above. The principal chemicals are fixer and developer, while stop bath and wetting agent are also useful. A funnel and graduate are used for mixing and measuring the chemicals and a thermometer for checking the developer temperature. Developer tanks are of plastic, with reels that are threaded from the outer edge, or of stainless steel, with reels threaded from the core outwards. Scissors are used to cut off the ends of the film in order to load it in the tank, and a filtered hose for washing it when developed. Clips for hanging the film, and squeegee tongs are also needed.

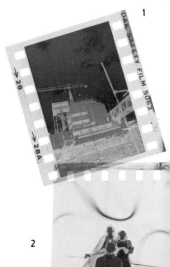

1

2

Developing 1 Pour out the correct amount of developer, and check it is at 20°C (68°F). Before removing the film from the cassette, make sure the room is in complete darkness. Cut off the end of the film (the tongue).

2 If using the stainless steel reel (shown here) attach the end of the film to the spike or clip at the core and rotate the reel to thread the film into the grooves. Always hold the film by its edges, and bow it carefully to fit it into the reel.

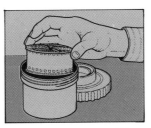

3 Cut the end of the film off the spool, lower the fully loaded reel into the developer tank and replace the lid. It is now safe to turn on the light.

4 Re-check the developer temperature and pour it quickly into the tank. Tap the tank lightly to disperse any air bubbles and fit the cap that covers the hole in the lid.

5 Start the time (preset for development time). For 15 seconds in every minute of development agitate the tank by rocking it backwards and forwards. This will ensure that the developer acts on all the film.

6 Quickly pour out the developer at the end of development time and pour in the stop bath. Agitate continuously for 30 seconds. Pour out the stop bath and refill the tank with fixer.

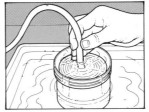

7 At the end of the time recommended by the manufacturer, pour out the fixer. Attach the filtered hose to a cold tap, the other end to the core of the reel, and wash for at least 30 minutes in *gently* running water. Strong water pressure may damage the film.

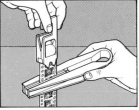

8 Add a few drops of wetting agent (to avoid drying streaks) before removing the reel. Unreel the film, attach it to a drying clip and use the squeegee tongs to remove excess moisture. Hang up to dry in a dust- and draft-free area.

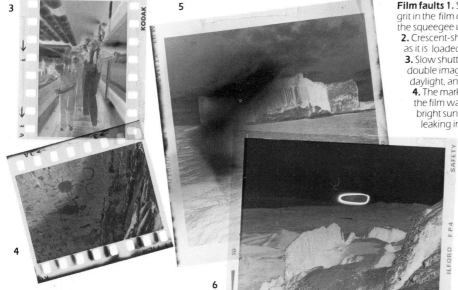

Film faults 1. Scratches on the negative, caused by grit in the film cassette's velvet light trap, or dirt on the squeegee used to wipe the film when wet.
2. Crescent-shaped marks caused by creasing film as it is loaded into a developing tank spiral.
3. Slow shutter speed with flash has resulted in a double image – one of which was formed by daylight, and the other by the flash.
4. The marks near the sprocket holes show that the film was either loaded or unloaded in bright sunlight; or light might have been leaking into the camera.
5. Fogged while the undeveloped film was being loaded on to the spiral, possibly through a crack in the door or a hole in the changing bag.
6. A patch on the negative is neither developed nor fixed because the spiral was loaded wrongly and the successive layers on the spiral touched during development.

Altered Processing

18 · **Black and white film**
19 · **Color film**

THE CONVENTIONAL WAY in which most standard films are processed is described on pp.36–7. However, by deliberately varying some parts of the process, the appearance of the final image can be changed in certain ways. This system of altered processing is an important control; it is essential, for instance, in order to make full use of the Zone System (see p.44–5).

Altering the processing basically means that you will end up with either overdeveloped or underdeveloped film. The result is that both the overall density and the contrast is altered, plus other minor effects. These two factors are the normal reasons for using the technique. Overdeveloping black and white film increases the density of the silver, so giving a stronger image. In addition, because the developer has a greater effect on the parts of the film that have been more thoroughly exposed to light, the image is more contrasty. Conversely, underdeveloping gives a weaker and less contrasty image.

Altered processing has two common uses. The first is if the film has not received the correct exposure, either through human error – as in forgetting to alter the meter's ASA rating when changing to a different roll of film – or because the right exposure cannot be achieved in the prevailing photographic conditions. A classic example of this is trying to shoot a moving subject that needs a certain minimum shutter speed in lighting that is too dim.

The second use is to change the tonal range of the image. On bright, sunny days, the contrast range between sunlight and shadow is often too great for film and paper to handle; here, underdevelopment will lower the contrast. Equally, under dull, flat lighting, the contrast can be sharpened by overdevelopment. When altering processing just to change the contrast, you must also alter the exposure to compensate; otherwise the overall result will be too dark or too light.

The four methods

There are four ways of altering development. Each of these has limitations beyond which processing errors creep in, while it may be necessary to use more than one of them. Depending on how much image quality you are prepared to sacrifice, the limits, measured in terms of f-stops, are approximately two stops over and two stops under the normal processing figure. The four methods involve either altering the dilution, altering the developing time, altering the temperature of the developer or altering the agitation.

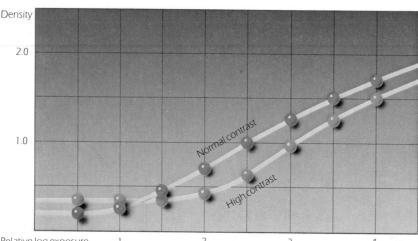

Density
2.0
1.0
Normal contrast
High contrast
Relative log exposure 1 2 3 4

19 · COLOR FILM

The principles of development are the same for color film as for black and white. However, as processing has to be more precise, it is generally better for color film to be developed professionally. In this project, use transparency film, but not Kodachrome, and do the same as in the black and white project. Make the following range of exposures on each roll – underexposed by one stop, normal and overexposed by one stop – and send the films to be processed. Instruct the laboratory to develop one roll normally, overdevelop another by one stop and underdevelop the third by the same amount. Overdevelopment is

Measuring contrast

There are a number of ways in which contrast can be described and compared, but the most useful technically is a line plotted on graph paper, known as the characteristic curve. This indicates the response of a particular emulsion to varying amounts of light. Increasing density is plotted vertically (so that the maximum density is at the top) and increasing exposure is plotted horizontally on such a scale as to compress the shape of the curve and make it more obvious. The typical curve is S-shaped, showing, with a short exposure, that the image-forming process is slow, while, with a long exposure, there are finally very few ions left in the silver bromide crystals to react to light.

The central slope of the curve shows the contrast. A steep slope means that the film has reacted rapidly to changes in exposure — the image will therefore be contrasty — while a shallow slope means less contrast than normal. On the graph here, the orange pins indicate the characteristic curve of a typical slow film and the red ones that of a fast film. Both were developed at 20°C (68°F), the developer being agitated intermittently. The increase in density relative to exposure is much more marked with fast film.

PROJECT 18

Prints below underdeveloped by 2 stops
1. Underexposed by 2 stops ¹/₁₅ sec, f3.5
2. Normal exposure ¼ sec, f3.5
3. Overexposed by 2 stops 1 sec, f3.5

Prints below at normal development
4. Underexposed by 2 stops ¹/₁₅ sec, f3.5
5. Normal exposure ¼ sec, f3.5
6. Overexposed by 2 stops 1 sec, f3.5

Prints below overdeveloped by 2 stops
7. Underexposed by 2 stops ¹/₁₅ sec, f3.5
8. Normal exposure ¼ sec, f3.5
9. Overexposed by 2 stops 1 sec, f3.5

18 · BLACK AND WHITE FILM

Select a subject containing different tones, the dominant one being a mid-tone. Shadows cast across a wall, for instance, give at least two tones; a door, windowframe and sky might make up more. You will also need three rolls of the same film. With the camera on a tripod, make a range of three exposures on each roll – underexposed by two stops, normal and overexposed by two stops – using the basic light meter readings as a starting point. Develop one roll normally. Overdevelop another by two stops and underdevelop the third by the same amount. Print all nine negatives and compare both negatives and prints.

Negative development The degree of development provides an invaluable control over the density and content of the negative. Look carefully at these nine pictures. The strip that was underdeveloped is lacking in contrast, and conversely the overdeveloped negatives are too contrasty. But changes in development have had another effect. To a certain extent, underdevelopment has partially compensated for overexposure and overdevelopment has produced a printable negative from an underexposed frame. Of the nine negatives, only those marked with a cross would be unprintable; the first underdeveloped pair because they are completely lacking in shadow detail, and the single overdeveloped negative because the highlights have become far too dense.

Compare the contrast in the photograph above, developed normally, with that in the examples on the right. 400mm, 1/60sec, f16.

This photograph has been 'pushed', or overdeveloped by one stop.

This version has been 'cut', or under-developed by one stop.

sometimes called 'pushing', while underdevelopment is known as 'cutting'.
 Assess the results, looking for the same comparisons as with black and white film. Also note the slight color shifts, which will vary between makes of film.

Test clips
If compensating for exposure error, you may not always know by how much to overdevelop or underdevelop. One safety measure is to make a test clip. This is simply a short length of film clipped from one end of the roll. In the

dark, cut off sufficient film to include two or three frames (if you are using 35mm film), or one or two (if 6cm x 6cm film is being used). Develop the clip normally. With 35mm film, which is wound back into the cassette, you will be

cutting off the first frames of the roll; 6cm x 6cm film, however, is wound on, so they will be the last frames.

Basic Exposure

ACCURACY IN EXPOSURE is extremely important. Intrinsically, this presents no great problem, as most films are designated with an ASA or DIN rating, which gives a measure of their sensitivity to light. An exposure meter – either hand-held or inside the camera – can be set to this figure; such a meter simply measures the amount of light falling on its sensor and presents the information, normally in terms of shutter speed and f-stop setting, for virtually any light level.

Accurate exposure, therefore, depends on how effectively you use your exposure meter. All models contain light-sensitive cells; these are either battery-powered, in the case of cadmium sulfide and the extremely sensitive silicon and gallium cells, or self-powered, as with the less sensitive, but reliable, selenium cells found in some hand-held meters.

Many modern cameras are fitted with automatic systems, which bypass the photographer by reacting directly to the through-the-lens (TTL) meter. Because of this, they can only respond in preset ways, which may not suit every photographic subject. The danger in relying on them exclusively is that they distance the photographer from the process and discourage even a basic understanding of the way film reacts to light.

Principles of exposure reading

What all exposure meters do is to average the light content of the scene in front of them, making an overall measurement of the combination of dark, light and in-between tones. They then calculate the shutter speed and aperture setting that will convert these into a mid-tone (in the case of black and white film, this is an average grey). For most purposes, a mid-tone will produce the most pleasing results, but everything depends on how you want the image to appear. There is no such thing as a 'correct' exposure. If you want the image to be darker or lighter, then you have to interpret the meter reading accordingly. Set for the speed of the film you are using, but remember the meter only shows how to produce a mid-toned photograph.

Thus, even at its simplest, calculating the exposure involves a decision by the photographer. In many cases, the most important decision is what tones to assign to particular parts of the image (see pp.44–5), but here simple subjects have been chosen to illustrate basic principles.

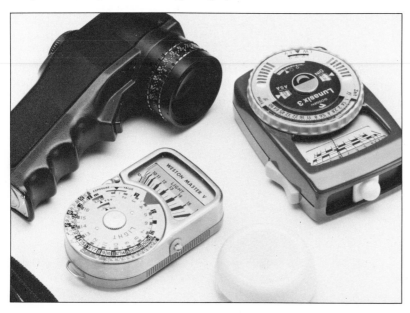

There are four basic methods of using a hand-held meter:
1. With the reflected-light method, point the meter directly towards the subject to measure the light.
2. With contrasty subjects, take readings from the brightest and darkest areas of the subject and then make a compromise between them.
3. An 18% gray card, which has average reflectance, can be substituted for the subject.
4. An incident-light reading measures the light falling on the subject only. A translucent plastic cover is fitted to the meter.

A spot meter, here an Asahi Pentax model (**left**), measures the amount of light reflected from a circle of 1° very precisely, and is the system to use when accuracy is more important than speed of operation. A meter such as the Gossen Lunasix (**center**), fulfils most needs, and can make both incident-light and reflected-light readings, as well as being capable of accepting specialized attachments (eg, a telephoto lens and flexible probes). The

Weston (**right**), is the most traditional meter design. It is relatively unsophisticated but rugged, and is self-powered by selenium cells, which are charged by the light they are measuring.

PROJECT **20**

1 stop over, 1/30sec, f2.8

1 stop under, 1/60sec, f4

20 · NORMAL EXPOSURE

This project is concerned with normal, uncomplicated exposure. Use either the camera's through-the-lens meter, a hand-held meter, or both. As a means of learning about light levels and exposure – as well as a way of exercising fine control – the latter is better than the former, but it is not essential.

Select an outdoor location with as little contrast as possible. A cloudy sky without any well-defined shadow is best for this project, but otherwise choose a shady setting. It is important to avoid bright sunshine, as this creates high contrast, which, in turn, frequently presents exposure problems. Set the exposure meter to the ASA rating of the film you are using.

There are three basic ways of measuring light, through reflected light readings, incident light readings and substitute light readings. In the first, you measure the light reflected from the scene in front of you – in other words, the amount of light that enters the camera or meter receptor. All TTL meters work on this principle. If you take an incident reading, you measure the amount of light actually falling on the scene. This is a fixed quantity, irrespective of whether the subject is dark or light, which makes this type of reading more accurate than any other. However, you cannot use a TTL meter for this; you need a hand-held meter, fitted with a milky diffusing dome.

A substitute light reading is an alternative to both these methods. If the subject is inaccessible for any reason, you can take a reading from some other surface that you are familiar with to obtain a substitute result. Kodak, for

Normal, 1/60sec, f2.8

This subject was chosen because it had a fairly wide range of tones – the bark of the tree is dark and ridged, and the house behind is much brighter. Because of this wide tonal range the correct exposure has to be a compromise. A reflected light meter reading – taken from the dark bark of the tree (**top left**) – would produce quite generous exposure, but a similar reading from the bright background area might suggest considerably less exposure. An incident reading taken from close to the trunk (**top right**) would again give an exposure recommendation which was fairly generous, because the meter would be shaded by the tree – a gray card reading would produce a similar result. In this particular case, the best compromise was arrived at (**left**) by taking a reflected light reading from the bark, a second from the background and averaging the two.

instance, supply a middle-gray card, known as '18% gray' because that is the proportion it reflects of any light falling on it, which serves this purpose. Otherwise, if your skin is moderately fair, you can take a reading of your hand. This will be probably one f-stop lighter than an average subject. Alternatively, spread a

piece of white paper, or a white handkerchief, on the ground and take a reading from it; this will be about three f-stops lighter than average.

Practice all these methods and note the results. If you are using ASA 125 film with an average subject, the reading on a dull day will be somewhere in the region of 1/125 sec at

f5.6. When taking reflected light readings – either with the camera's TTL meter, or a hand-held meter – be careful not to include the sky. Most TTL meters read only, or mainly, from the center of the frame; most hand-held meters, however, are less precise, so it is often a good idea to shade their tops from the sky.

Advanced Exposure

21 · **Making a key reading**
22 · **Measuring the contrast range**

MANY PHOTOGRAPHERS APPROACH the problem of exposure reading by making a basic, false, assumption. They believe that, for every image, a single 'best' setting exists and that the sole use of an exposure meter is simply to establish it. However, as the previous projects indicate, the question of exposure is not as rigid and predictable. It is true that, with average subjects, a standardized approach works well enough for most of the time – indeed, this is the principle upon which automatic cameras rely. As you search for more interesting or varied lighting conditions, however, you will find that this approach is less satisfactory.

Making exposure decisions

The basis of controlling exposure is that you, the photographer, must decide for yourself how the image should look. This may sound obvious, but it requires much more thought than the simple business of relying on the mid-tone translation of subject to camera setting.

The decision-making process starts when you visualize the subject – in other words, when you translate the scene in front of you, in your mind, into an image. With this as the ideal, you then need to be aware of the capabilities of the materials and equipment with which you are working. This particularly applies to film. In some cases, it may prove impossible to preserve the detail in shadows and highlights as you would wish, since it is common for the contrast range to be too great for the film to cover. In such circum-

stances, a compromise decision is inevitable.

High contrast

The majority of exposure problems occur when the contrast is too high. A scene can have high contrast either because there are large tonal differences within it – a pale hand against a black dress, for instance – or because the lighting is harsh, creating highlights and deep shadows. Such conditions are common around noon on a clear, bright, sunny day and in a dark studio, when a single light is being used.

Most regular film emulsions can cover a range of seven f-stops comfortably, but little more. If the contrast range in the subject exceeds this, therefore, under normal conditions something has to be forfeited – either shadows or highlights. Even when the contrast is within this limit, problems can still arise.

Key interest

In some cases, the center of visual interest occupies only a small part of the picture, yet is either much darker or lighter than its surroundings. In other words, a small subject is posed against a contrasting background. Here, any broad direct meter reading is totally inappropriate. The only sensible approach is to set the exposure for the small center of interest, disregarding the background. The procedure is known as a key reading; the decision in this case is to apply priority to one part of the image at the expense of the rest.

PROJECT 21

These two photographs were both taken indoors, using only the light from a north-facing window. For the one on the right, the exposure was increased

by half an f-stop, but it still appears distinctly darker.
135mm, 1/15sec, f5.6 (left), f6.3 (right).

21 · MAKING A KEY READING

For this project, choose two settings where the subject is small and the background contrasting. One background should be light and the other dark. Construct the proportions of the shot so that they are the same in both cases.

In each case, take a reading of the subject, not the background, and use this as the basis for exposure. An incident reading is often the most useful in such conditions; remember, if you are taking a direct reading from a fair complexion, to increase the exposure by about one f-stop, or the skin will appear too dark.

Take an overall reading of the entire scene for comparison. Note the difference.

22 · MEASURING THE CONTRAST RANGE

This project can be carried out either outdoors, or in a studio, according to preference. The ideal subject is one with a contrast range of at least seven f-stops, with a few well-defined blocks of different tones. Outdoors, for instance, look for a pale-colored building with plenty of angles and faces, lit by a strong sun. With the camera almost facing into the sun, the contrast will be high.

Compose the shot so that the image contains a fairly even balance of high and low tones. Use any of the three methods (see pp.40–41) to calculate the deepest area of shadow and the brightest part of the shot, excluding such obviously excessive highlights as the sun, or specular highlights. The two readings represent the extremes of contrast in the scene – that is, the contrast range.

If the contrast range is within the range of the film you are using (seven f-stops here), set the exposure halfway between the two readings to record the maximum amount of subject detail. However, if the contrast range is too great, you will have to sacrifice shadow details or highlights. In such a case, preserving the highlights is generally more acceptable, but your personal taste should be the final arbiter. Experiment for yourself to see which you prefer.

This castle tower in Dordogne, France, was bathed in very strong sunlight, which created a range of tones outside the capabilities of the film. The photographer highlighted the sunlit details, rather than those in shadow.
50mm, 1/125sec, f16.

The Zone System

THE ZONE SYSTEM, developed by the American photographer Ansel Adams and others, is the ultimate decision-making device as far as controlling exposure is concerned. In addition, the use it makes of various techniques for altering contrast encourages the development of control over the image.

As its cornerstone, the Zone System starts by refining the normal definition of contrast range in f-stops. Ranging from black to white, it assigns all tones to definite zones, all the possible gradations of tone being divided into ten zones, each one being one f-stop different from its neighbour. Through the use of this scale, you can decide into which zones the tones of a subject fit and immediately appreciate its contrast range.

Each zone has a special significance, which can be used to help decide what image tone a particular part of a shot should possess. Zone V, for instance, is, by its position in mid-scale, middle gray; it is the mid-tone to which all averaging light meters convert their results. Zone VI, one f-stop lighter, is the normal photographic tone for fair skin. Zone VIII is the lightest tone in which any detail can be seen. Conversely, Zone II is the darkest tone in which detail is visible, while Zone III is the usual tone for shadows containing significant recognizable detail.

Using the system

The basic procedure is first to measure the light levels in front of the camera and then to place one of the important tones in the shot into a zone. Having done this, the rest fall into place, though, if some of the highest or lowest tones

The Zones

0 Solid black; the same as the film rebate (edges).

I Nearly black; just recognizably different from Zone 0.

II The first hint of texture but nothing recognizable.

III Textured shadow; the first zone to show recognizable shadow detail.

IV Average shadow value on Caucasian skin, landscape foliage and buildings.

V Middle gray; 18% gray test card; the 'pivot' value; light foliage; dark skin.

VI Caucasian skin (36% reflectance); textured light gray; shadow on snow.

VII Pale skin; bright areas with texture, such as snow in low sunlight.

VIII Highest zone with any texture

IX Pure untextured white; little difference between this and unexposed print paper.

How the Zone System works 1 The rocky landscape used as an example is here illustrated to represent the scene as the photographer sees it.

2 The camera's TTL meter and a long-focus lens can be used to take aperture readings from the constituent parts of the landscape, film and shutter speed, of course, remaining constant (ASA 50, 1/60sec, in this case).

3 Here the photographer chooses where to place the tonal values by deciding what are the important elements of the scene. The key zone is often III, the darkest in which detail is recognizable. But here some texture is needed in the right foreground, which is therefore assigned to Zone II. The other zones then fall into their relative places.

CONTROLLING THE CONTRAST

Increasing and decreasing the contrast during the picture-taking process offers opportunities for improving the resulting images. Black-and-white film is more amenable to alterations.

In the subject
Decrease contrast by
1 adding fill-in lighting in a controlled situation such as a studio.
2 use fill-in flash for backlit subjects in an uncontrolled situation, eg outdoors.
Increase contrast by
1 reducing fill-in lighting in a controlled situation.
2 wait for a change in the available natural light.

In the film
Decrease contrast by
1 selecting a slower film.
2 select a filter that brings the color tones closer together. For example, with blue and yellow objects use a blue filter to lighten the blue and darken the yellow.*
3 reduce the development time for the film, or use a weaker solution of developer than that recommended. The weaker the solution the longer the initial exposure should be.
4 pre-expose the film.
5 contrast can be reduced on the negative by using a proportional reducing solution.*

6 skilful masking of areas of contrast on the negative during the printing.
Increase contrast by
1 selecting a faster film.
2 darken shadows by using a contrast-enhancing filter such as a 25 Red.*
3 increase the development time for the film, or use a stronger solution of developer than that recommended. The stronger the solution, the shorter the initial exposure should be.
4 use a solution to intensify the chromium on the finished negative.*
5 copy negatives or transparencies automatically have a higher contrast range.
6 re-touch.

In the print*
Decrease contrast by
1 choosing a softer grade of paper. This can compensate for variations in negative density and therefore contrast.
2 use a weaker solution of paper developer.
3 use a diffusing sheet with the negative in the carrier of a condenser enlarger, or use a diffusing enlarger.

4 shade highlights and print-in shadows using local contrast techniques and, ideally, with variable contrast paper.
5 re-touch.
Increase contrast by
1 choosing a harder grade of paper.
2 use a stronger solution of paper developer.
3 use a card with a small hole with the negative in the carrier of a condenser enlarger. This reduces the diameter of the light source.
4 shade shadow areas and print-in highlights using local contrast techniques, and, ideally, with variable contrast paper.

* denotes methods unsuitable for color work. There are three main areas in which control can be introduced: in the subject, in the film and in the print.

4 This print shows the result of placing the zones in this way. It reflects a common problem: the contrast range is too great, and one of the most interesting features of the picture, the foreground water, has lost its texture.

5 Unless the high contrast is reduced, by altering the subject, the negative or the print, a compromise has to be made which sacrifices detail at one end of the scale. Here it has been decided to move everything down one zone, and alter the lens aperture accordingly.

6 This placing of the zones will restore detail to the water (Zone VIII) and sacrifice detail on the rock (Zone I). Using the Zone System allows you to calculate how the image will look before making the exposure.

PROJECT **23**

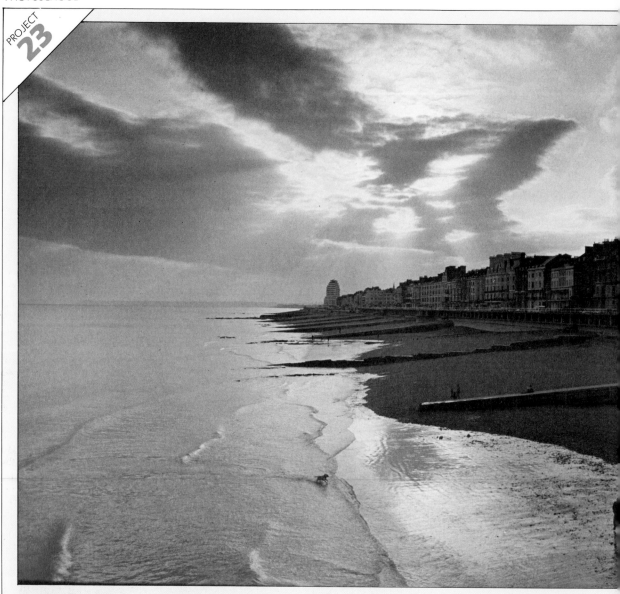

23 · PLACING TONAL VALUES

Because it takes time to apply the Zone System thoroughly, choose a static subject – a landscape, for instance – for this project. The shot should contain clear blocks of clearly differing tones.

First, as an aid, sketch the scene very simply, arranging it in blocks of tone. Measure the light levels from each part, using a direct, rather than an incident, light meter. With a TTL meter, the easiest method is to fit a long-focus lens temporarily to your camera to convert the TTL

to a spot meter. To simplify things still further, assume a fixed shutter speed and mark out on the sketch the different f-stop values.

The next, and most important, step is to decide on the most significant tone in the shot. Interestingly, this need not coincide with the centre of interest. In many cases, the important tone to reproduce precisely is the one containing shadow detail – a large area of shadow so dark that it is featureless usually looks wrong. As you experiment, you will find that placing the shadows in Zone III

more often than not produces the most natural result. Another tonal area to look for is the sky.

Clouds, in particular, need careful tonal rendering to avoid being either bleached out, or muddy.

exceed the scale, adjustment will have to be made. Although this seems complicated at first, it soon becomes straightforward with practice and is a very good exercise in assessing subjects and visualizing how they might appear as photographic images.

Use of the Zone System goes hand-in-hand with the technique of compressing or extending the contrast range of film by altering its development (see pp.38–9). By intentionally overexposing by one f-stop and then underdeveloping by one stop, the tonal range of the film is compressed to include approximately one extra zone. Equally, underexposing and overdeveloping by one stop eliminates one zone, which can improve the contrast of a flat subject.

PROJECT 24

To take this waterfront scene at Hastings (**above**), the photographer divided into five zones (**left**). He used a 500mm lens and a constant aperture of f22 to take initial spot readings from the sky, the sea, the beach, the buildings on the promenade and from the prominent tower in the center of the scene. Most signs of tonal interest were in the promenade buildings and he keyed this area to Zone III. The lens was changed to a 28mm wide-angle, and, in order to darken the key area and, at the same time, retain the detail, the photograph was shot with a faster exposure time (1/250sec instead of 1/90sec).

24 · HANDLING HIGH CONTRAST

Select a scene that contains a large contrast range. Go through the same procedure as in the previous project, noting the light levels and placing the most important tones. Because the contrast range in the subject is extreme, either the high values or the low ones will fall at the extremes of the Zone Scale. Overcome this by altering the development (see pp.38–9). Because the Zone System makes it easy to anticipate such problems, altered development can be planned in advance.

The photograph of Bodiam Castle in East Sussex (**above**) was shot on a bright day – this is why the final print has a bleached-out sky. The photographer metered the castle wall for middle gray (the equivalent of Zone V) and got a reading of 1/250sec at f22. To achieve the effect he wanted of a bright textured wall (Zone 7), he opened up two stops – to 1/125sec, f16 – which lightened the image and then he underdeveloped to lower the contrast.

Black and White Printing

IF YOU DO not possess your own enlarger and darkroom (the latter can be improvised in a closet, or even the bathroom), make every effort to gain access to a friend's facilities. Establishing control over the complete process of image formation – from making the exposure to the finished print – is extremely important if you are to become a complete photographer. In addition, the flexibility of black and white materials largely becomes apparent in the stages beyond the negative. Color printing is beyond the scope of this book and is generally best left to the professionals.

Basic black and white printing consists of the following distinct stages. The first is the exposure of a contact sheet, followed by the development of the prints, assessing the negatives and making an enlargement. You need a contact sheet both as reference for your files and as a means of checking the general appearance of the image. Although a great deal of information can be obtained from the negative – resolution and tonal range, for instance, can only be judged properly by examining the negative with a magnifying glass – a positive image is essential for seeing facial expressions and the basic picture content. Use the contact sheet to select frames for enlargement.

Making a test strip 1 Insert the dust-free negative in the carrier, emulsion side down, and fit in the enlarger head. Turn room lights out, enlarger lamp on and open lens aperture wide.

2 Adjust the enlarger head until the image is the size you want, and then the focus until it is sharp. A focus magnifier helps to give the sharpest possible print by enabling you to check the sharpness of the grain.

3 Reduce the lens aperture by two stops (in most cases to f11). With a normal negative this will allow a short exposure.
The extra depth of field compensates for minor focusing errors.

4 Shield most of the printing paper and expose the rest for five seconds. Moving the card along, expose again in stages until the entire sheet has been exposed. Expose the whole sheet for the final five seconds.

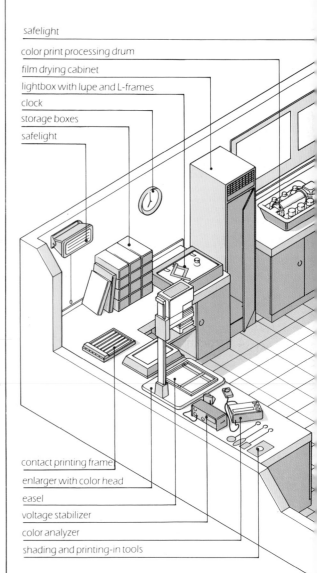

safelight

color print processing drum

film drying cabinet

lightbox with lupe and L-frames

clock

storage boxes

safelight

contact printing frame

enlarger with color head

easel

voltage stabilizer

color analyzer

shading and printing-in tools

The darkroom This is a specimen layout for a well-equipped photographer's darkroom. It contains all the equipment you will need for any of the techniques described in this book. On the other hand, however, you can produce high-quality prints with only the basic equipment shown on p.36 and an enlarger.
Whether you have your own

darkroom, or use such unlikely spaces as a bathroom, closet or understairs cupboard, the most important requirement is that it should be light-tight, yet also well-ventilated. Fumes from concentrated chemicals can be dangerous.
The better-planned and tidier a darkroom is the easier it is to find your way around in the dark. You should know where

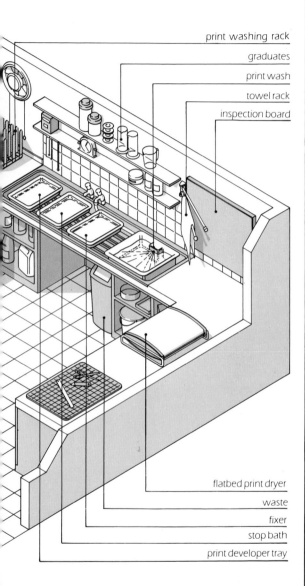

print washing rack
graduates
print wash
towel rack
inspection board

flatbed print dryer
waste
fixer
stop bath
print developer tray

everything is, and equipment should be positioned around the room in the sequence that you will need it. Separate the equipment needed for 'wet' processes from that for 'dry' ones. It is also a good idea to keep your printing paper in a closed drawer to avoid spilling anything on it.

The more shelves in a darkroom the better, on which you can store the extra equipment you are bound to accumulate. Another good idea is to install a print board, on which to display your finished prints. The layout of your darkroom is ultimately a question of individual opportunity and taste, but the more thought that goes into it, the more comfortable will be the many hours you spend there.

Processing a print 1 Check that the trays of developer, stop bath and fixer are in the right order, and the developer is at 20°C (68°F). Reduce the room lighting to the safelight and make the exposure.

2 Slide the paper, emulsion side down, into the tray of developer, and press it down with the developer tongs so that it is completely submerged.

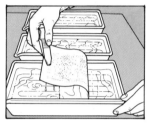

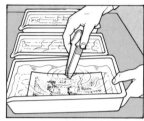

3 Turn over the paper so that the emulsion side is facing up and you can see the image developing.

4 Rock the tray gently to agitate the solution and so ensure even development. Develop for 90 seconds.

5 Use the tongs to lift the paper out of the developer tray and allow the excess solution to drip off. Put it in the stop bath, taking care to keep the tongs out of the solution. Rock the tray gently as before.

6 After 10 seconds, lift the print out, drain and transfer to the fixer tray for 10-20 minutes, agitating the solution at intervals. After one or two minutes, the print can be examined.

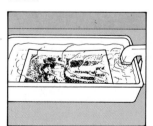

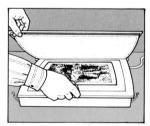

7 Wash the print in running water. For washing time, see what the paper manufacturer recommends: resin-coated papers need four minutes, paper-based papers need about 15 minutes.

Drying the print Paper-based prints should be dried in a flatbed print dryer (above). Glossy prints are glazed by placing face down on the metal plate. Most professionals use glossy paper unglazed.

Black and White Printing: Assessing the Negative

THE WAY YOU expose a print – exposure time, paper grade and the use of shading or printing-in (also known as dodging and burning-in) – depends on the quality of the negative. In assessing negatives for printing, experience is more valuable than anything else, so you should practice examining them on a light box, using a magnifying glass, until you become proficient. Here, various common types of negative have been selected for professional comment; compare them with negatives of your own and spot the similarities and differences. Make it a habit always to work out in advance the printing techniques that are required, rather than make enlargements by trial and error.

Faults

Refer back to the film processing exercise on p. 36. If it proved impossible to avoid the fault in the first place, or if the negative was damaged subsequently, you must first decide whether it is worth printing or not. With sufficient effort, virtually any negative fault can be overcome at a later stage – either in the printing or by retouching – but remember this will be time consuming. Small spots and scratches, for instance, do not present a major problem, but extensive stains and finger marks are very difficult to conceal. This is particularly the case in large, even, mid-toned picture areas, such as a cloudless sky.

Sharpness

This can be affected by the quality of the lens you are using, the accuracy of focusing, the type of film and camera shake. Judge for yourself by looking for fine lines in the picture; if they appear double, then camera shake is the culprit and if the sharpness deteriorates towards the edges of the frame, then the lens quality is suspect. A condenser enlarger increases the impression of sharpness.

Density

The overall thickness of the silver will give you an idea of whether the film has been overexposed or underexposed. This, in turn, will suggest what exposure time you should use when making the print and what paper grade.

Contrast

Practice will enable you to make a reasonable assessment of the tonal range. This is a measure of the contrast. A small tonal range suggests low contrast and vice versa. The negative's tonal range is greater than that of a print.

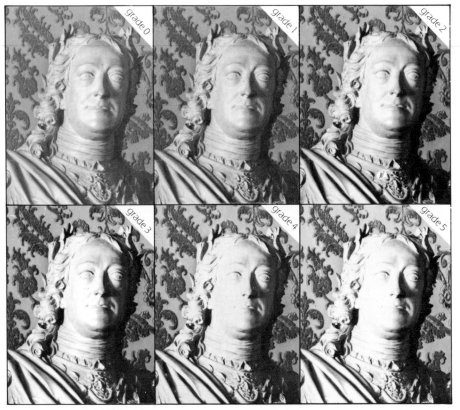

Paper types The traditional, most commonly-used, paper has a paper base with an emulsion coating on one side.
Resin-coated papers are plastic coated on both sides before the emulsion is applied. This seal shortens the washing and drying stages considerably. But there is a limited range of textures, none of which corresponds to the standard 'glossy unglazed', and they take retouching very poorly. Various paper weights are available – the thickest is less liable to crease. There is a range of special textured paper, but most have a gimmicky appearance. Each make of paper has its own subtle tone, and in addtion there are ranges of base tint which include cream and strong primary colors. Most papers are available in different contrast grades. In the photographs (**opposite**), a single negative, itself adequately exposed and with an average contrast range, has been printed on 6 different paper grades – from 0, which is very flat and intended for negatives with high contrast, to 5, which is extremely hard and is for use with soft negatives.

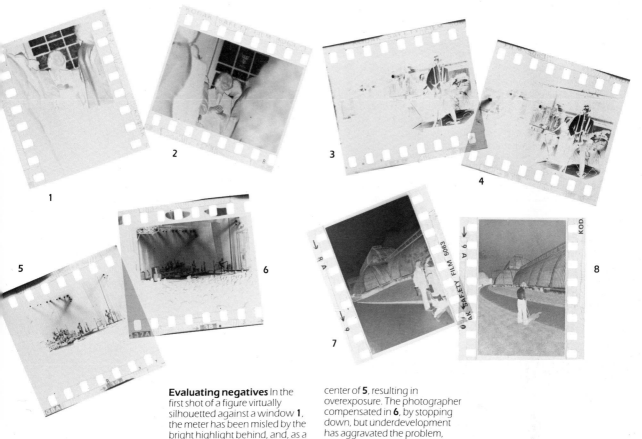

Evaluating negatives In the first shot of a figure virtually silhouetted against a window **1**, the meter has been misled by the bright highlight behind, and, as a result, the negative is underexposed. There is more detail in **2**, and it would be much easier to print. **3** and **4** have a 2-stop exposure difference between them. Note how the piano player, who is virtually invisible in **3**, appears when the exposure has been opened up. The metering has been misled by the small, brightly lit scene in the center of **5**, resulting in overexposure. The photographer compensated in **6**, by stopping down, but underdevelopment has aggravated the problem, causing burned out highlights. Negative **7** has a heavy sky (it was blue) and would print flat white. The sky area in **8** would print much darker because the photographer had fitted a red filter to the lens.

Making a contact sheet 1 Dust the strips of negative with an anti-static brush. Make sure your printing frame is clean, dry and free from dust.

2 The negatives and printing paper are best held together in a hinged contact printing frame, but a sheet of glass can be used. Put the strips in the frame emulsion side down.

3 Adjust the enlarger head until the frame is evenly covered with light. Under safelight, insert a sheet of normal (Grade 2) paper under the frame, emulsion side up.

4 The correct exposure time depends on the strength of the lamp and the density of the negatives. Begin with five seconds at the widest aperture.

Black and White Printing: Dodging and Burning-in

AS IN SOME of the examples on the previous two pages, frequently a negative will not print satisfactorily on any grade of paper without some form of manipulation. Often, the reason for this is a high contrast range, or because a small, but important, area of the photograph – a face, for instance – is either much brighter or darker than the rest of the image. In addition, there may be times when you simply want to improve on the image you have already exposed.

By giving your prints an exposure time in the enlarger of more than the usual few seconds, it is fairly straightforward to ensure different areas receive different amounts of light. Reducing the light on a particular area is known as 'shading' 'dodging' or 'holding back'; giving more illumination is called 'printing-in' or 'burning-in'. The secret of success in both techniques lies in being unobtrusive – calculating the extra or reduced amount of light so that the effect is not obviously artificial. This comes with experience. Another necessary precaution is to keep the edges of the shaded (dodged) or printed-in (burned-in) area soft enough to merge smoothly with the surrounding image. This is done by keeping the shading or dodging tool raised above the surface of the paper, so that it casts an out-of-focus shadow, and by moving it constantly during the exposure.

When planning the procedure, estimate the exposure times for the basic print, the areas to be shaded (dodged) and those which need extra printing-in (burning-in). Make a first exposure for the overall image, shading (dodging) for part of the time. Then, using your cupped hands or a large piece of card with a hole cut in it, make the additional exposure for the areas to be printed-in (burned-in).

The examples shown here follow on from the assessments made of the negatives on the previous pages. Study these and then practice with a negative of your own that needs similar manipulation.

Dodging tools These can be improvised from pieces of card and lengths of wire to the exact size you need. For burning-in on large prints, use a piece of card, print-size or larger, with a hole cut in it.

Dodging and burning-in To dodge or shade a large area, the best implement is your hand, moved continuously to give a soft edge to the shading.

For a smaller area, a dodging tool is used. This can be shaped to fit the exact area to be dodged. Hold it well above the print to cast an out-of-focus shadow and keep it moving.

Burning-in is often done with cupped hands, in which case a foot switch is needed to operate the enlarger light.

The original shot of this leopard (right), developed normally at f11 for 25 seconds, loses the interest of the animal's head in the heavy shadow. Taking a tracing and analyzing it (**far right**) helps you decide how to improve it. The basic exposure should obviously be shorter than in the original, but remember: the larger the print, the longer the exposure. If you are enlarging the original, allow longer than if you were printing same size. In this case the basic exposure is set at 15 seconds and it is decided to dodge the shadowed head and forefoot for five seconds and to burn-in the highlighted side and tail for 40 seconds. In the finished picture (**above**) the leopard stands out from the background.

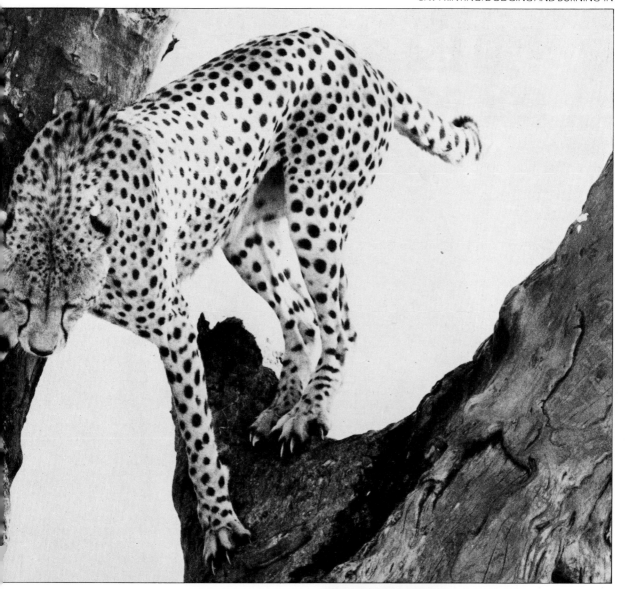

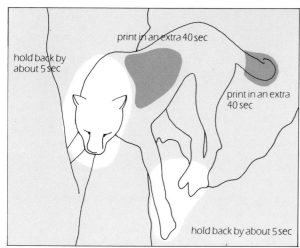

hold back by about 5 sec

print in an extra 40 sec

hold back by about 5 sec

print in an extra 40 sec

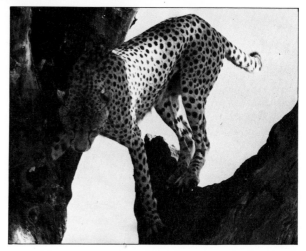

2 IMAGE MANAGEMENT

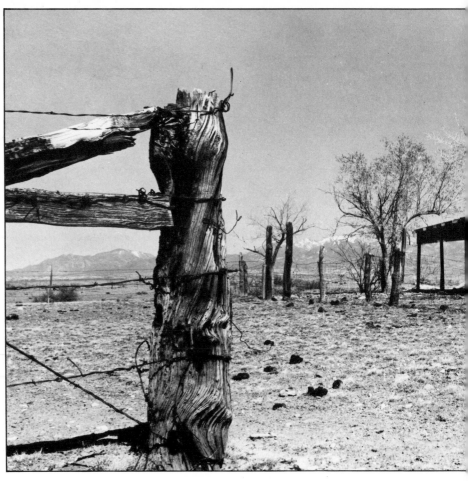

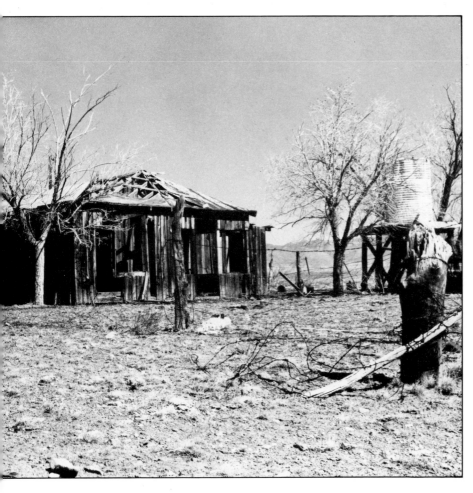

This section of Photoschool analyzes all the varied elements of the photographic image, so you can use the information to construct the photographs you require. Subjects covered range from natural and artificial types of light and the various graphic components of the image, such as line and shape, to the applications of color and the keys to success in the main subject areas.

Light Sources

ANY SOURCE OF light, whether it is natural or artificial, is potentially useful for photography. What is important is for you to realize what are the technical characteristics of all the types of lighting you are likely to encounter, from the various types of daylight to lamps designed specifically for photography through to 'problem' lights, such as fluorescent strip lamps.

The light with which we are most familiar – and to which our eyes have adapted – is daylight. It is against this that all other forms of lighting are judged. However, as daylight varies in many ways, according to the position of the sun, cloud cover and so on, direct sunlight at midday in a clear sky in middle latitudes is generally accepted as the standard. For the purposes of color temperature (see pp.68-69), Mean Noon Sunlight is fixed at 5400°K, as measured at Washington DC.

This concept of a lighting standard is an important one, because it affects many of the ways we look at photographs, as well as determining how materials and equipment are designed. To the human eye, standard daylight appears 'white' and therefore correct. When the light from a candle is described as 'orange', or that from a clear skylight as 'blue', these terms are in relation to what is considered normal. A large part of the technology of film and lighting is

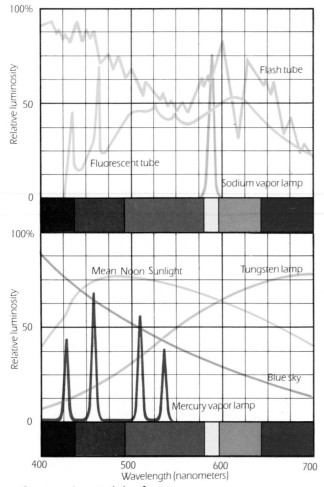

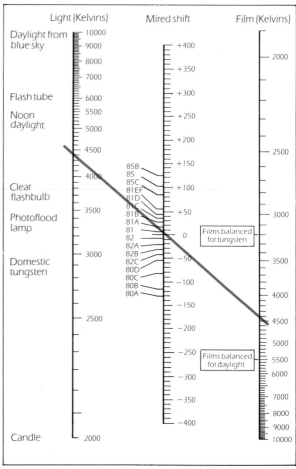

Spectrum characteristics of light sources The graphs (**above**) illustrate the different color components of the various types of light you are likely to encounter.

Color balancing filters To balance the film you are using to the light, hold a straight edge from the color temperature of the light source on the left of the table (**above**) to the film type on the right. Where the edge crosses the central scale, the correct filter is indicated, together with the mired shift value.

Tower Bridge, London (**top left**) was lit by floodlights and moonlight. This made it impossible to determine a filtration which would give 'perfect color rendition'. In the event, unfiltered daylight balanced film produced perfectly acceptable results. Daylight shining through the doorway and tungsten lighting reflected in the mirror of this bar (**top right**) caused the photographer difficulty, and he used daylight film to obtain a compromise color balance. For the shot of the Jai Alai players at the Miami Fronton (**bottom right**), a cc40 red filter was used to partially correct the blue-green cast produced by the mercury vapour lamps. Complete correction would not have been possible. The enclosed area of a space module (**bottom left**) was lit primarily by fluorescent light. Though this has produced a greenish cast in the picture, this does not distract from the claustrophobic feeling that the picture conjures up.

taken up with producing a balanced result, as close to standard daylight as possible. This is particularly true of color balance, to which the eye is very sensitive.

However, a cautionary note is necessary here. While balanced, normal lighting is frequently desirable, it is not the ruling principle for all photography. Uncorrected light from a typical fluorescent lamp will appear green on film; nevertheless, the deliberate use of a green cast by no means invalidates a photograph. An unthinking, rigid adherence to norms and standards is every bit as bad as failing to recognize that they exist.

Measuring light

In photography, there are five ways to describe a light source. If you think consciously of lighting in these terms, then the comparisons between seemingly unrelated light sources will become clearer and closer.

The first point to consider is intensity. With the help of various materials (neutral density filters in very bright light and highly sensitive film and wide aperture lenses in dim light) and techniques, photography is possible within a wide range of light intensity. However, although there are various ways of measuring this, no single one, covering all types of lighting, has been generally accepted, as far as photography is concerned. The ultimate practical device is the exposure setting on camera and lens – but this is a clumsy basis for comparison.

You must also be aware of the differences between continuous and pulsed light. The sun, together with other incandescent sources like tungsten lamps, emit light continuously. Others, notably flash and some vapor discharge lamps, emit light in pulses. A typical fluorescent lamp, for example, flickers in a way that may be invisible to the naked eye, but, obviously, the exposure will be affected at fast shutter speeds. Flash units deliver all their illumination in a single pulse; this can be as fast as 1/50,000sec for small, automatic, electronic units used over short distances.

Direction is another important factor. It is a threeway quality, involving the light source, the subject and the camera. Diffusion broadens the light source into an area and this softens shadow edges and weakens the shadows themselves. This is particularly important when the contrast is too high and the image appears harsh as a result. Diffuse light by placing something translucent in front of it – tracing paper, cloth or Plexiglas in the studio, or shooting in haze, mist, fog or cloudy conditions outdoors. Since the diffuser absorbs light, the intensity is also reduced.

The final factor is color balance. Light sources cover different parts of the spectrum and the color that they appear thus depends on the wavelengths at which they emit. The diagrams on this page show the spectra for some common light sources, most of which can be balanced, or in some way altered, by using the appropriate filters (see p.70).

Lighting Direction

LIGHTING DIRECTION is derived from an interrelationship between the light source, the subject and the camera, although the normal ways in which this is described – side lighting, back lighting and so on – mainly apply to the angle between the light and camera. In choosing the lighting direction for a photograph, there are two decisions for you to make. The first is the relationship between the light source and the subject, which can determine how such things as texture, form and detail are displayed. The second is the relationship between the light and the camera, which affects the basic quality of the image and such things as contrast, color saturation and mood.

Basic directions

The lighting direction can be from anywhere in 360° on any axis, at least in theory. To simplify the understanding of the process, think of your subject as being surrounded by a sphere. This can be divided into segments, each representing a number of lighting directions that have the same characteristics. The basic division, as shown here, is into six unequal segments – front, top, back, either side and bottom. Bottom lighting is uncommon and so does not merit further subdivision.

When extreme refinement of the lighting direction becomes important, as in studio still life shots, a more detailed subdivision can be made. At this point, the way that the segments are arranged – and even the terminology – varies according to personal preference. The division shown on the right, therefore, is just one method. Note that the segmentation is most detailed around the top of the sphere. This reflects the most commonly accepted and used directions.

How lighting direction affects the image

In general, the basic lighting direction you choose will have certain graphic, emotional and aesthetic effects on the image. These do not apply in every case, however, since they may well be submerged in the other elements of the shot. Think of them as tendencies, rather than rules.

Top lighting is the most common form of lighting direction we experience from day to day and so is considered normal and unremarkable. If the light is directly overhead, rather than slightly to one side, it may seem slightly harsh or dramatic, but this depends very much on the diffusion (see pp.64–7). Top lighting often gives high contrast, unless the subject is on a light-toned base. This helps fill in shadows. Strong shadows, particularly around the eyes and under the nose and chin in portraits, are common.

At about 90° to the camera axis, lighting from either side of the subject is sometimes known as 'hatchet' lighting. This is because of its tendency, particularly in the studio, to divide the image in half. It can be very effective and dramatic with tall subjects, such as standing people, high-rise buildings, and such still life objects as bottles and

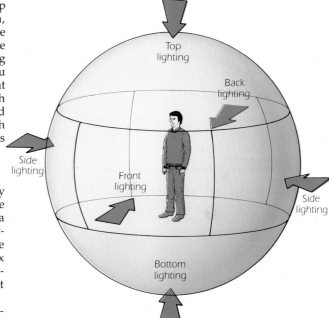

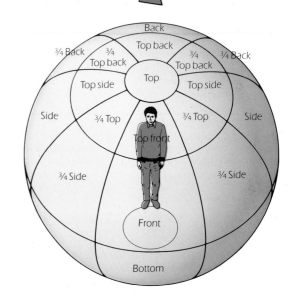

The lighting sphere As a guide to the effects of different lighting directions on a subject, the lighting sphere is divided into six basic directions (**top**). For studio still-life work in which the lighting needs to be closely controlled, it is subdivided further (**above**). There is no standard terminology for lighting directions but the wording shown here is used by the majority of photographers.

PROJECT 25

25 · CHANGING CAMERA POSITION

The only way you can control the direction of sunlight is either to wait for the right time of day, or to move the camera. In this project, choose a subject that you can photograph using the principal lighting directions shown in the examples – that is, front lighting (sun behind the camera), top lighting (sun more or less overhead), backlighting (sun behind the subject) and side lighting. Use black and white film to avoid the complication of changing color temperature (see pp.68–9). Which of the finished prints do you consider to reflect the nature of the subject the best and why?

The movement of the sun has produced very different results in these four photographs of an equestrian sculpture. The underbelly of the horse is interestingly-shaded in the shot taken when the sun was overhead, and emphasizes the three-dimensional essence of the subject. Interest shifts away from detail to shape and impact in the dramatic photograph taken from the side. Although detail can be seen clearly in the front lit shot, it has not the visual appeal of the top two potographs. for the back lit shot – the strong shape silhouetted against the autumn trees – the photographer had to move her camera.

Top lighting

Side lighting

Front lighting

Back lighting

glasses. Contrast is often high, while, with many subjects, it gives a good sense of form.

Front lighting – that is, lighting from the direction of the camera – gives little contrast, because there are very few shadows. As a result, it usually reveals a large amount of detail and the color saturation is good. However, it is poor at bringing out texture and form and so is frequently referred to as 'flat'.

For many subjects, backlighting offers the most dramatic possibilities, as it can add the dimension of excitement to the eventual image. Depending on whether the light source is diffused or not, the subject can be silhouetted, or

surrounded by a 'halo' through rim lighting. Contrast is extreme. It is normally impossible to record all the image's tones without resorting to secondary, fill-in, lighting. There is a surprisingly wide range of acceptable exposures, although the more general preference is underexposure. Backlighting can be very effective with translucent and transparent subjects.

As previously stated, bottom lighting is rarely encountered in natural conditions. It can thus seem unusual and sometimes bizarre. Portraits lit from below, for instance, can look menacing, but, more frequently, recall the overuse of the technique in low-budget horror movies.

1

26 · THE CHANGING ANGLE OF THE SUN

This project is time-consuming and depends very much on the weather. It is a valuable exercise, however, because few photographers take the trouble to think clearly about the sun as a light source. The best way to handle it is to combine it with project 31; by the time you complete these, you will have assembled a fascinating series of photographs, where the only variables are the weather and lighting conditions.

In this project, the aim is to photograph a single subject from a fixed camera position from sunrise to sunset on a clear, sunny day. Clouds and mist introduce the element of diffusion, which confuses the issue and so should be avoided. It may be necessary, therefore, to carry out the project over a number of days, so the chosen subject should be easily or regularly accessible. It should also be of a definite shape and reasonably isolated. A building standing on its own, or a rock formation, are both good choices.

Choose a convenient camera position that you can return to without difficulty and note the framing of the shot. If the sun is likely to shine into your lens at any point during the day, be prepared to shade it with a piece of card (see project 2).

Make a series of exposures at regular intervals – every one or two hours, say – and bracket them so you can assemble a precisely matched series later. You can shoot with either black and white or color transparency film; only the former is strictly necessary, but, as the shots can be useful for other studies, color could be used instead or in addition.

Compare the developed prints or transparencies. Decide for yourself which of the series you prefer, using as criteria the way it reveals the outline of the subject, the form and modeling, detail and texture. Finally, select the image you prefer overall. On what basis did you choose it?

4

7

10

11

2

3

5

6

8

9

12

The first set of shots here are more subtle than the second, but both serve their purpose well. Photographs 1-6 were shot over two days in sunny conditions, using a 200mm lens.

1 8.30am
1/30sec, f5.6
2 10.00am
1/60sec, f11
3 11.15am
1/60sec, f11
4 2.30pm
1/60sec, f16
5 3.30pm
1/60sec, f6
6 4.30pm
1/60sec, f4

Photographs 7—12 were taken in Spain in October. The photographer used a 400mm lens and chose his camera position to avoid the sun appearing in any of the shots.

7 Sunrise.
1/60sec, f5.6.
8 Mid-morning.
1/125sec, f8.
9 Midday.
1/125sec, f16.
10 Late afternoon; the sun has disappeared behind the cliff.
1/125sec, f5.6.
11 Dusk.
1/60sec, f5.6.
12 Sunset.
1/30sec, f5.6.

61

PROJECT **27**

PROJECT **28**

Top lighting

Right side lighting

Left side lighting

Right ¾ side lighting

Bottom lighting

Right ¾ back lighting

Left ¾ side lighting

Front lighting

Back lighting

27 · CONTROLLED LIGHTING IN THE STUDIO

The use of artificial light sources in the studio makes any lighting direction possible. To simplify this project, use a single spotlight (as this is a black and white project, this need not even be a photographic lamp) and take an egg as the subject. The uncomplicated shape and surface of the egg will help to demonstrate the fundamentals of controlling lighting direction. You will, however, need to find an unobtrusive way of supporting the egg on its end – a plain ring, for instance.

With no other lighting and with a black velvet backdrop, photograph the egg from the same camera position, using as many different lighting directions as possible. For bottom lighting, place the egg on a sheet of glass with empty space beneath it.

28 · CONTROLLING PORTRAIT LIGHTING

Having completed the previous project, take a more complicated structure – the head – and photograph it as before, using the same lighting directions. Assess the way the light affects the different planes and textures of the face and hair, looking at the advantages and disadvantages of each direction. Some will prove clearly to be quite unsuitable for use as portrait lighting.

Although diffusion has not yet been dealt with in detail (see pp.64–7), use a moderately diffused light for the project. The basic window light is shown on p.171.

There is an almost infinite choice of lighting combinations in studio portraiture, and depends as much on personal taste as on the subject. Here the results range from an almost draculean effect – achieved with bottom lighting – to a James Dean-ish look.

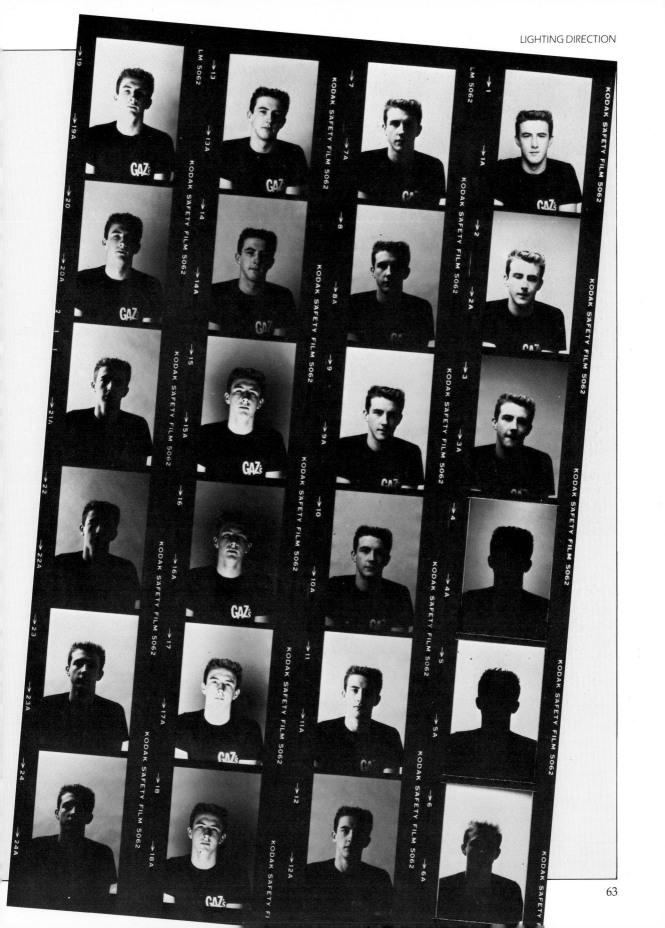

Diffusion

29 · **Controlling diffusion with small objects**
30 · **How weather diffuses sunlight**
31 · **Controlling diffusion in the studio**

THE BASIC DEFINITION of diffusion is an easy one; it simply increases the area of the light source. On a cloudy day, it occurs naturally, while it can be created artificially in the studio by using translucent materials in front of the lights. Its effect on a subject can be extreme, not only because it weakens and softens shadows, but because it also reduces the impression that the light is coming from a particular direction. In this way, diffusion lessens the prominence of the light source in a photograph.

With the exception of small objects – these can be shaded – diffusion is the one quality of natural light that cannot be controlled. It depends almost exclusively on weather conditions. In the studio, on the other hand, controlled diffusion is a necessary, standard technique, used to modify the harshness of small artificial sources.

A natural light model

The combined effects of atmosphere, changing weather and the varying angle of the sun can seem quite complex at times. To simplify how natural sunlight is diffused, think of an outdoor scene in terms of the model shown here. Compare it with a simple studio set. The light source is the sun. Covering only a small portion of the sky, it functions in the same way as a small naked lamp would do in a studio. However, the sunlight first has to pass through the atmosphere. When it passes through 'clear' air, it is only slightly diffused, but it is also reflected. What this means is that the light bounces back from atmospheric particles and is scattered in such a way as to make a cloudless sky blue (the shorter, blue wavelengths are scattered more). If there are larger particles in the atmosphere – water droplets or dust, for instance – the diffusion is more obvious. An unbroken layer of cloud diffuses the light so thoroughly that it is normally impossible to tell the direction of the sun, while a fog increases diffusion to such an extent that the light appears to come from all sides.

Diffusers in the studio

In studio photography, lighting is infinitely manageable and therefore the degree of diffusion can be adjusted precisely to suit the camera and subject. In black and white photography, anything translucent can be placed between the light and subject to act as a diffuser; in color photography, it is important to use only neutrally-tinted materials. Some plastics, for instance, can cause a color shift, even though they may be visually colorless. For any important shot, make a color test with and without a new diffuser.

In studio work, reflectors are just as important as diffusers and, because they increase the area of lighting and weaken shadows, they can be considered as producing a type of diffusion. They are used to bounce some of the light back into the shadowed side of the subject. The type of surface and how close it is placed determines the strength of the 'fill', as reflected light is sometimes called.

PROJECT 29

29 · CONTROLLING DIFFUSION WITH SMALL OBJECTS

Use the egg as in the lighting direction project (27), but with the light positioned to one side to create side lighting. Experiment with different diffusing and reflecting materials of varying strengths, making a note of what you use for each frame. Use a complete 36-exposure roll of black and white film and prepare the results as a contact sheet, marking on each frame the diffusers and reflectors used. Use this contact sheet as reference for other still-lifes.

Outdoors (left) You should be aware of the varying levels of diffusion and reflection at different times of day and under various weather conditions. **1** At sunset the violet afterglow can be effective, but generally only for silhouettes, due to the lack of light. **2** Fog and mist give a very diffused light that is almost directionless. **3** Scattered clouds on a sunny day reduce the light contrast slightly. **4** Like mist, a heat haze dissolves shadows and gives strong aerial perspective, objects appearing fainter and further away they are. **5** Midday sun gives stark lighting and heavy shadow, which is unsuitable for many subjects. **6** Mid-morning sun on a clear day gives very strong contrast off a flat, reflective surface such as water. **7** Sparse clouds at dawn always add drama to a sunrise shot, as they vividly reflect the direct sunlight and red sky.

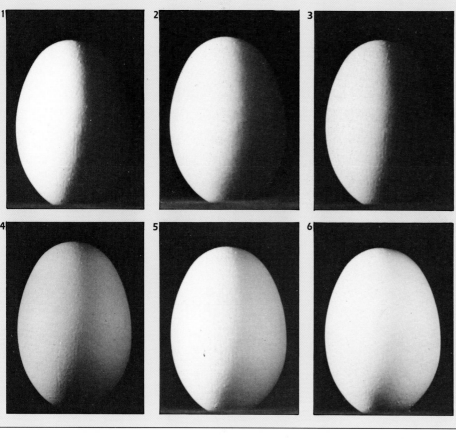

The harshest photograph **1** (1/30sec, f11) has only side lighting. Tracing paper was placed between the egg and the light source for **2** (1/15sec, f9); while in **3** (1/15sec, f5.6) a studio diffuser was used, and it was this which produced the softest image — it diffuses the light better than other materials. In shots 4-6, a reflector was placed on the opposite side of the egg to the light. A white card was used in **4** (1/30sec, f11); aluminium foil in **5** (1/30sec, f8); and a mirror — which gives fairly equal reflection and a harsh result — for **6** (1/30sec, f11). A 200mm macro lens was used for all the shots.

Indoors There are four basic ways of diffusing or reflecting light to make it more even and soften shadows.

1 Reflect the light off a white wall or ceiling by setting the head of the flash unit at an angle. If the head of the flash unit cannot be moved independently of the sensor, you will need to increase the exposure (by about two stops in a room with a normal height of ceiling). **2** Wrap a piece of white cloth around the flash head, taking care not to cover the sensor. With a manual unit, you will need an exposure increase of about one stop. **3** In the studio, set up a studio umbrella on a light stand. Measure the exposure with a flash meter. **4** Use a white card reflector on a stand to bounce light on to the subject. As with **3**, unless the sensor of an automatic unit can be directed independently towards the subject, use a flash meter to measure the exposure.

PROJECT **30**

Bright sunshine

Slightly hazy

Cloudy

Foggy

Cloudy bright

30 · HOW WEATHER DIFFUSES SUNLIGHT

Either use the same subject that you photographed for the lighting direction project (27), or a similar one. Set up the shot in the same way from a camera position you can return to easily. The aim is to record a single subject under different degrees of diffusion.

First look at the sequence of diagrams above right. Each represents a well-defined step in the process of diffusion, although there is no standard method of quantifying them. Nevertheless, the descriptions are reasonably clear and, if you make your own judgment as to what each looks like in real life,

they are relevant.

Photograph your selected subject in each of these weather conditions. Allow plenty of time and persevere. As you take each shot, make a note of the exposure setting and put the figures under the sketches to complete the diagram.

When you have all seven prints, compare the effects

of increasing diffusion, asking yourself what are the contrast ranges of each? At what stage do the shadow edges cease to be definite and at what stage do the shadows themselves disappear? Bearing in mind that the more the diffusion, the less the light intensity, does the sequence appear to be regular?

Bright sun

Slightly hazy

Very hazy

Cloudy bright

Cloudy

Heavily overcast

Foggy

The hard shadows and the strong white highlights in the shot taken in bright sunshine, using an aperture of f16 at 1/125 seconds, make a very dramatic picture. As the light becomes more diffused the contrast decreases. This can be seen in the slightly hazy shot – taken at f16, 1/60sec – where there are no hard shadows and the sky is completely bleached out. In foggy conditions the resulting photograph is very soft and there is a loss of detail in the tiles and brickwork of the building, and even in the immediate foreground. Much darker than the others, the shot taken on a cloudy day (f13, 1/60sec) has neither highlight nor depth, and conveys an oppressive feeling. In the shot taken in cloudy bright conditions, also at f13, 1/60sec, there are soft shadows and highlights and details can be seen fairly well in the tree in the foreground. All the photographs were taken using a 24mm lens.

PROJECT **31**

1. Front lighting/direct light only

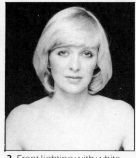

2. Front lighting with white card reflector/direct light only

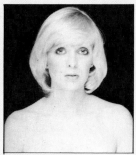

3. Front lighting with aluminium foil reflector/direct light only

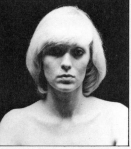

4. Top lighting/direct light only

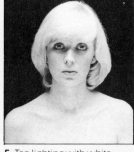

5. Top lighting with white card reflector/direct light only

6. Top lighting with aluminium foil reflector/direct light only

7. 3/4 Side lighting/direct light only

8. 3/4 Side lighting with white card reflector/direct light only

9. 3/4 Side lighting with aluminium foil reflector/direct light only

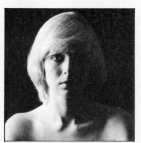

10. Side lighting/direct light only

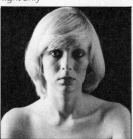

11. Side lighting with white card reflector/direct light only

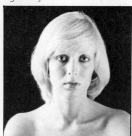

12. Side lighting with foil reflector/direct light only

31 · CONTROLLING DIFFUSION IN THE STUDIO

The object of this project is to familiarize you with the precise effect that basic studio lighting equipment has on shadows and contrast. Follow the instructions given to set up the portrait project (see pp. 166–7).

Photograph the subject using a permutation of different diffusers and bowl reflectors. Compare the results. Note how reflectors are more effective with an undiffused light source.

Light: Color

32 · Altering color temperature

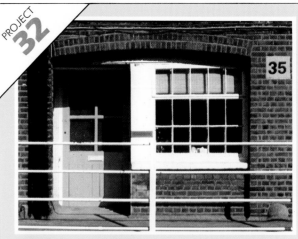

1 Midday sun, no filter. Color correct.

EACH SOURCE OF illumination has its own color characteristics. This is because different light sources emit at different wavelengths, which we perceive in terms of color. As has been already explained, the standard for 'white' light is the sun (Mean Noon Sunlight) and it is in comparison with this that other lighting appears to have a color bias. Most photographic film is balanced for noon sunlight.

Color temperature

In photography, the most widely accepted method of measuring the color of a light source is by its color temperature. Though this is not a completely consistent method – it cannot be used for fluorescent lamps and other types of

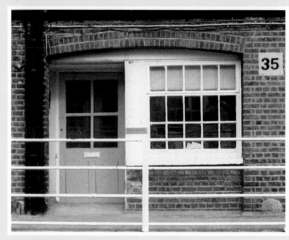

4 Overcast sky with 81C filter. Color correct.

Color temperature table This shows the color temperature of a wide range of natural and artificial light sources. Low color temperatures are at the red end of the scale and high ones are at the blue end, while midday daylight is in the middle. The human eye is so adaptable that we see all these types of light as white, but photographic film needs a different filter to adjust to each type of light.

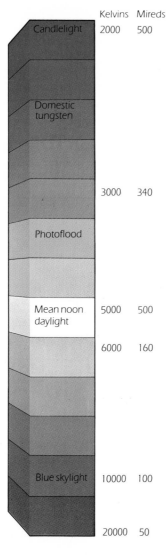

	Kelvins	Mireds
Candlelight	2000	500
Domestic tungsten		
	3000	340
Photoflood		
Mean noon daylight	5000	500
	6000	160
Blue skylight	10000	100
	20000	50

32 · ALTERING COLOR TEMPERATURE

For this project, you will need a set of gelatin color balancing filters. Six must be yellowish, to lower color temperature (81, 81A, 81B, 81C, 85, 85B); six must be bluish, to raise color temperature (82, 82A, 82B, 82C, 80A, 80B). Filters 75mm square are the most convenient size for most 35mm cameras. Although you can use the filters by simply holding them in front of the lens, they will quickly become marked and damaged. It is better to use a filter holder.

In addition to the filters, you will need some reference objects for comparing the color. The human eye judges most accurately the colors with which it is most familiar, so use either skin – someone's face, or hand – or some white objects. Select a daylight film with good reciprocity characteristics, such as Ektachrome 400. This avoids the problem of additional color shifts in low light. Photograph your subjects in the midday sun, blue skylight (in the shade on a clear day), overcast conditions, low sun, twilight and moonlight. For this last shot, wait for a full moon and bracket your exposures for safety.

For the second, fourth and fifth stages, take a straightforward shot, without any filtration, and then, with the help of the table, estimate the color temperature. Use the scale as described and take a second shot with the recommended filter. If in doubt, try two or three different filters. For the

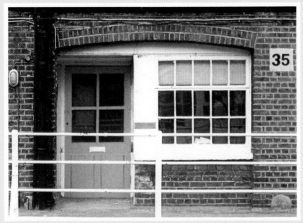

2 Overcast sky, no filter. Color incorrect.

3 One hour after dusk. 81C filter unable to correct.

5 Overcast sky with an 82 filter. Color incorrect.

6 Dusk with 81A and 81C filters. Color nearly correct.

overcast sky, try an 81 and an 81A filter. The midday sun should not need a filter, as the film is balanced for it, and neither should the moonlight shot, for moonlight is essentially only reflected sunlight.

While photographing this project, compare your visual estimates of the color temperature with the actual ones. The eye, which can accommodate itself easily to different light source colors, is notoriously unreliable when it comes to judging color temperature without a comparison. The effects of a blue skylight and a low sun will probably seem exaggerated in the processed transparency, in contrast to your memory of them.

COLOR TEMPERATURE FILTER CHART

Condition	Temperature	Corrective filter
Photographic daylight	5500	No filter
Overcast sky	6500	81B
Heavy overcast	7500	81C
Blue sky (in shade)	8500	85C
Early morning/late afternoon	5400	82C
Photoflood lamps	3400	80B
Domestic electric light bulb	2900	80A & 82B
Tungsten halogen & photolamps	3200	80A

Candlelight
Twilight
Sodium vapor
Streetlighting

The color temperatures of these light sources are so different from the light for which film is balanced, that it is impossible to compensate for the color casts that they produce. However if you use an 80A filter as a starting point, and make tests using progressively bluer filtration, you may produce a result that is reasonably acceptable.

Above These photographs show the effects of different lighting conditions on color film, and some attempts to correct them to the way they would appear in midday sunshine. Use the color temperature/filter chart on the left to choose the right filter for the conditions. It is a good idea to make up your own chart, as judgment of weather conditions is subjective, and you can be more confident of a guideline founded in your own experience. It is obviously impossible with a limited range of filters accurately to correct night-time shots **3**, but with experience you will be able to make a close approximation if you shoot no later than dusk **6**.

vapor discharge lighting – it is taken as standard for daylight and tungsten lamps. This means that films and filters can be compared in terms of color temperature.

The reason that the word 'temperature' is applied to color is a simple one. When heated strongly, most substances start to glow, the color depending on the temperature. Iron, for instance, first turns red, then orange, yellow and finally white as the temperature increases.

The notion of color temperature is based on the colors that an inert substance would turn, if heated to various temperatures. These fit into a scale, expressed in units called degrees Kelvin, from red through to blue. Red is at the bottom end of the scale and blue at the top.

Knowing what the color temperature is can become important when color accuracy is required. Quite frequently, this can be achieved only through altering the color temperature. There are three ways of doing this; you can either use a film balanced for a different color temperature, a color balancing filter over the lens, or a combination of both. Daylight color film is balanced for 5500°K, Type A film for 3400°K and Type B for 3200°K. The Kodak 80, 81, 82 and 85 series of filters, among others, are designed to raise or lower the color temperature by precise amounts.

For completely accurate color temperature measurement, a color temperature meter is essential. This works by comparing the intensity of blue light with that of red light – the more blue, the higher the temperature. However, for most purposes, the scale given on p.68 is accurate enough.

Discontinuous spectra

Vapor discharge lamps, including fluorescent lamps, mercury vapor lamps and sodium vapor lamps, are replacing the conventional tungsten lamps more and more, because they are more efficient in their use of electricity. As far as photography is concerned, however, their use poses serious disadvantages, since they emit light only at certain wavelengths. This means that there are large gaps in other parts of the spectrum, which in some instances makes it impossible to correct the color balance completely. To complicate things still further, the wavelength pattern for different makes and ages of lamp varies, so that the color cast they produce on film is not easy to predict.

Color conversion filters The table on the right shows you which filters you need to adjust your film to the prevailing lighting conditions. Adding filters has the effect of reducing the film speed and the table below shows you how much to compensate by increasing the exposure. It also enables you to work out further color temperature conversions by giving the mired shift values for the Kodak range of color filters. The mired scale, based on one million divided by Kelvins, gives a fixed value for each light source and type of film, so these can be balanced easily by calculating the difference and using the appropriate filter. For example, the mired shift between a tungsten lighting source of 2900°K (mired value = $\frac{1,000,000}{2900} = 345$) and daylight film of 5500°K (mired value 182) is 163. Raising the color temperature means lowering the mired value, so in this case you would correct with an 80A filter (mired value −131) and an 82B filter (mired value −32) combined.

Filters for normal lighting effects

Film type	Light source				
	5500°K	3400°K	3200°K	2900°K	2800°K
Daylight	No filter	80B	80A	80A + 82B	80A + 82C
Tungsten Type A	85	No filter	82A	82C + 82	82C + 82A
Tungsten Type B	85B	81A	No filter	82B	82C

Mired shift values for Kodak filters

Filter (yellowish)	Shift value	Approx. F-stop increase	Filter (bluish)	Shift value	Approx. F-stop increase
85B	+131	2/3	82	−10	1/3
85	+112	2/3	82A	−18	1/3
86A	+111	2/3	78C	−24	1/3
85C	+81	2/3	82B	−32	1/3
86B	+67	2/3	82C	−45	2/3
81EF	+53	2/3	80D	−56	2/3
81D	+42	1/3	78B	−67	1
81C	+35	1/3	80C	−81	1
81B	+37	1/3	78A	−111	1⅔
86C	+24	1/3	80B	−112	1⅔
81A	+18	1/3	80A	−131	2

Natural Light

THE PROJECTS ON the next few pages make practical use of the qualities of light that have just been examined. As far as natural light is concerned, this means making the best use of different lighting conditions and choosing, or waiting for, the most suitable light for particular subjects. In the studio, with artificial sources, the lighting can be controlled and manipulated easily; daylight demands more effort to make the most of given conditions. Remember, too, that there is no 'correct' lighting condition for any given subject, although, in terms of clarity, some conditions show up certain qualities, such as texture or shape, better than others. What is important in these projects is that you follow through your own tastes and decisions, using a particular lighting for definite reasons.

The effects of natural light
The effects of different qualities of natural light differ widely. Some of the principal effects are as follows.

Strong sunlight
Resolves fine detail very well. Looks 'sharp'. Accentuates texture when it strikes a surface at a shallow angle. Creates strong, well-marked shadows and therefore high contrast. Creates high contrast silhouettes when behind the subject. Gives good color saturation when frontal, but otherwise degraded by highlights. When deep shadows dominate, can be used to pick out isolated subjects. During the middle of the day, gives 'white' light, but increasingly orange when closer to the horizon.

Moderately diffused sunlight
Gives good modeling to reveal shapes clearly. Simplifies complicated surfaces. Gives softer edged, weaker shadows and therefore lower contrast. Gives good color saturation from most directions. Gives 'white' light for most of the day.

Strongly diffused sunlight
Shadows are ill-defined and contrast low. Gives very good color saturation, but without an impression of brightness. Can create a somber, leaden mood. Is efficient for lighting subjects with strong tonal variations. Tends to have a higher color temperature than direct sunlight, slightly bluish.

Fog and mist
Gives an enveloping light, virtually without shadows. Resolves detail poorly. Gives weak color saturation. Tends to cause flare. At a distance, simplifies outlines. Separates objects at different distances. Is unpredictable.

1

33 · MAKING THE BEST USE OF EXISTING CONDITIONS

Every type of natural light – even that of a dull, wet day – is useful for some kind of photography. Rather than wait for a particular type of light, make the effort to find the best use for conditions.

Read through the summary of qualities and think of a subject that would benefit from each one. Then choose a subject and treatment that makes the very best use of each of the following types of natural lighting. Plan the shots in advance, rather than working on impulse. The first shot should be in a bright midday sun, with a clear, cloudless sky, the second on a dull, overcast day, with or without rain, the third in fog or mist and the fourth at dawn or dusk, with the sun just below the horizon.

2

4

1 Bright sun There were a limited number of angles from which this church in the Dordogne, France, could be photographed without other buildings appearing in the shot. The bulk of the tower is emphasized with a dramatic upward shot making full use of the heavy shadow.
28mm, 1/125sec, f16.

2 Overcast — This castle in the Dordogne, France, was surrounded by forest. The lushness of the greenery is emphasized by the light rain that was falling.
200mm,1/125sec, f5.6.

3 Mist — This scene at Belfast Loch, Northern Ireland, is made more abstract by the light mist, the distant cranes appearing as graphic shapes.
50mm, 1/60sec, f3.5

4. Dusk The intention here was to silhouette this cliff in northern Spain against the evening sky.
50mm, 1/60sec, f4.

3

34 · CHOOSING THE BEST CONDITIONS FOR GIVEN SUBJECTS

The other side of the coin to the argument given in the previous project is when you have a subject that demands the best possible lighting. Use the examples of the projects on the last few pages and the summary of lighting characteristics to work out in advance what will suit certain subjects the best.

Choose between a head-and-shoulders portrait, a modern building and details of tree roots, deciding what qualities of the subject you want to convey and what problems are likely to arise. Then, decide on the best lighting conditions, wait for them, and go out to take the shot. Do not experiment with different conditions; the whole point of the project is the predecision you must make.

4

1 The cross light here was chosen as the best way of showing up the stark shapes of these iron girders.
50mm, 1/125sec, f16.
2 It was thought best to avoid bright sunlight for this portrait and take it in shade. The blue skylight had a high color temperature, so a yellow filter was used.
50mm, 1/125sec, f5.6.
3 This building was taken in bright sunlight, emphasizing its surface detail and its vertical thrust into the blue sky.
50mm, 1/125sec, f16.
4 The colors of the sunset sky enhance the rich tone of the gold-tinted glass on the front of this building in Atlanta, Georgia.
50mm, 1/60sec, f11.

Tungsten Lighting

TUNGSTEN LIGHTING IS designed for both domestic and photographic use. Domestic lamps have lower color temperatures than their photographic counterparts and are generally less consistent in color temperature and output. Photographic lamps, rated at either 3200°K or 3400°K, have greater intensity and can be adapted to different uses. However, even ordinary domestic lamps can serve quite well for photography; the only important precautions you must take when using color film is to establish their color temperature, so that you are able to correct it, if necessary. The first project here deals with this.

In professional studios, the development of cheaper and more reliable electronic flash units – these are more consistent and better at stopping movement – has led to a decline in tungsten's popularity. The chief advantages of tungsten lamps are that they are still relatively inexpensive and are much easier to use for lighting large areas.

PROJECT 35

The photographs here show the results of various types of lighting used with Type B tungsten-adjusted and ordinary daylight film. **Lighting:** 40W domestic and candles. **Exposure:** ¼sec, f4. **Film:** Type B tungsten-balanced ASA 160.

Lighting: tungsten lamp. **Exposure:** ⅟₃₀sec, f5.6. **Film:** Type B tungsten-balanced ASA 160.

Making a color test
A number of factors control color balance in studio photography. These include the film batch (see p.35), the lamp, any diffusers and reflectors you may use, and the surrounding surfaces in the room. In order to achieve color accuracy when you need it, you must learn how to test the conditions under which you will be working.

Take a Kodak Color Separation Guide, some white and gray objects and your hand and photograph them, using the basic still life set described on p.171. The overhead light and curving scoop will cause a smoothly graduated fall-off in illumination from foreground to background, the mid-grays in the transition area being very useful for judging the precise color balance. Make an exposure, using tungsten-balanced color film, and check the result on a light box. If the balance is not perfectly neutral, estimate what filter you will need by placing filters of different strengths and colors over the transparency. You can balance the color by using a complementary filter; if the transparency is a little blue, for instance, use a yellow filter, if green, use red and so on. Rephotograph the test with the filter you have selected.

35 · CONTROLLING COLOR TEMPERATURE
Tungsten lighting occupies the lower end of the color temperature scale (see p.68), normally between about 2700°K and 3400°K. For this project, take a selection of lamps and use each in turn to light a small still life. Use one or more candles for comparison, as well. Take the shots first on regular daylight film, then on Type B tungsten-balanced film.

Estimate the color temperature of each light source (see color temperature scale on p.68) and the filter(s) you would need to correct each to 'white' (5500°K) (see color-balancing filter scale on p.56). It is useful to make up your own temperature chart of which a simple version is shown on the right.

Lighting: 40W domestic and tungsten lamp. **Exposure:** ¹/₃₀sec, f5.6-f8. **Film:** Type B tungsten-balanced ASA 160.

Lighting: 60W domestic. **Exposure:** ¼sec, f8-f11. **Film:** Type B tungsten- balanced ASA 160.

Lighting: 60W domestic. **Exposure:** ¼sec, f4-f5.6. **Film:** ordinary daylight.

Lighting: 60W domestic and candles. **Exposure:** ¼sec, f4. **Film:** ordinary daylight with polarizing filter.

LIGHT SOURCE COLOR TEMPERATURE CHART

	Candles	60W domestic	Photographic tungsten lamp
Color temperature	2000°K	2800°K	3200°K
Filter(s) needed with daylight film	2 x 80A + 80D	80A + 82C	80A
Filter(s) needed with Type B film	80A + 80D	82C	None

36 · STREAKING EFFECTS

There is no need to use lighting conventionally all the time. Often, experiment can create interesting new images and techniques. Unlike flash, which is almost instantaneous, tungsten lighting normally needs long exposures to compensate for the lack of intensity of most lamps. With the aperture stopped down to a minimum and slow color film, the exposure time can easily be several seconds. Turn this fact to your advantage, particularly with static subjects.

For this project, you will need to set up a studio portrait, using a flash and a flashlight. The idea is to trace the outline of your subject with the flashlight during the exposure. Use color film.

Position your subject, the camera and the flash. Drape a piece of black velvet behind the subject, so the background is completely dark. Set the aperture for the flash and the shutter to 'T'. Turn off all the lights, open the shutter and make the flash exposure. Then, in darkness and with the shutter still open, stand behind the subject, switch on the flashlight and, aiming it towards the camera, move it steadily to outline the subject's head and shoulders.

The processed transparency should show a bright orange outline around the portrait. How bright this is depends not only on the aperture of the lens, but also on how slowly you move the flashlight. Try the shot with different speeds.

This is just one way of using tungsten light with a time exposure. Try and work out others for yourself. With practice, you can create almost any shape or design.

This photographer used a bottle and glass as his subject, making the most of the streaking effect by reflecting it in miniature in the glass.

37 · PAINTING WITH LIGHT

Another way in which you can use time exposure to overcome inadequate lighting is to use one lamp to illuminate different parts of the subject. This technique is quite commonly used by architectural and industrial photographers to light large interiors. Rather than position, say, 20 lamps to light the inside of a church or factory, the same effect can be achieved by using just one or two lamps, moving them to different positions during the exposure. You can try this out on a smaller scale with a spotlight, or even a flashlight; whichever you use, make sure you know its color temperature and use the right combination of film type and filters to compensate.

For the first stage of this project, use a still life set and a hand-held spotlight or flashlight. With the light in one position, the subject will be unevenly and harshly lit, with strong shadows. By moving the light during exposure, what you will be doing is broadening the light source into a pattern of streaks. If you move the light rapidly enough, you can create what is, in effect, an area light source, with softened shadows. The precise results can be determined only by experiment, but aim to produce two kinds of image – a well-diffused, almost shadowless photograph and one where the lighting is highly selective.

For the second part of the project, photograph a room with just one tungsten lamp. Place the lamp in at least five different positions to illuminate different parts of the room, covering the lens with a lens cap while you move the lamp from one position to another.

Left This picture of a teddy bear, lit with a moving flashlight, has very little shadow, resulting in a rather flat image.
50mm, shutter on 'T' (total lighting time approximately 1sec), f16.
Above This shot is lit from one source, giving a harsher, more dramatic image.
50mm, 1sec, f16.
Below This demonstrates the possibilities of using only one lamp and moving it about. This gives a similar result as an expensive studio set-up using several lamps.

Flash

TWO MAIN TYPES of flash unit are used in photography. There are small portable units that can be fitted to the camera's hot shoe, though this is not necessarily the best position from which to use them, and larger, house current-operated studio flash units. The latter can be very expensive, although the newer models, in which the flash head and power pack are integrated in one housing, are much cheaper and a good investment for even casual studio work.

Measuring flash output

Because the light from an electronic flash is pulsed, ordinary exposure meters cannot measure it. If you intend to do much work with flash, a flashmeter, though expensive, is a worthwhile investment. Use one in the same way as you would an incident light meter. Automatic flash units, using thyristor circuits, solve the exposure problem for most simple shots, but share with automatic cameras the disadvantage of always responding in an average, standardized way.

The basic system for calculating exposure with a portable flash unit is based on use of the guide number. Each flash unit is given a set of guide numbers by its manufacturer – one for each film speed. ASA guide numbers are in feet and DIN numbers in meters. To use the guide number, divide it by the distance between the flash and the subject; the result will be the aperture setting. If the guide number of your unit is 80, for instance, with ASA 64 film, with the subject 10 feet away the setting for an average exposure should be f8.

However, guide numbers simply reflect the manufacturer's judgment of exposure and so should not be universally relied on. Also, because most flash units are used in domestic interiors, quoted guide numbers usually allow for the extra light reflected from walls and ceiling. It is more useful to test your own flash unit and calculate your own guide number. To do this, photograph a subject at a distance of 10 feet, using the manufacturer's guide number as a starting point, but making exposures at different aperture settings. Make a note of each setting. Compare the developed frames – color transparency film is best for this test, as it has the least latitude for error – and choose the exposure that you prefer. Multiply the aperture setting that you used by 10 and the answer will be the guide number, in feet, for the ASA rating of film you used.

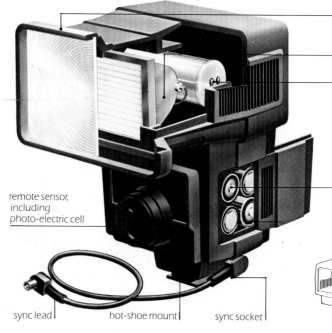

Right This automatic thyristor portable flash unit works by converting low voltage from the batteries into higher voltage and storing it in the capacitor.
To make the flash, the energy is released into the flash tube, ionizing the gas to produce a brilliant white light. The remote sensor contains a photo-cell which measures the amount of light reflected back from the subject. It is connected to a fast-acting electronic switch known as a thyristor, which cuts off the energy supply to the tube as soon as there is enough light.

adjustable difusing head for different lens angles of view

flash tube

capacitor

batteries (alkaline or nickle-cadmium)

remote sensor, including photo-electric cell

sync lead

hot-shoe mount

sync socket

Left A flash meter is essential for studio work. This Calcu-flash meter gives an exact f-stop reading for all flash, whether bounced or fill-in or used as main light.

Right Wet cell units have a large battery and give great power and a fast rate of recharge. They can be positioned anywhere, even some distance from the camera.

38 · MULTIPLE FLASH

With a static subject, you can increase the exposure simply by increasing the number of flashes. This can be a very useful technique to employ when photographing still life, as it enables you to achieve the maximum depth of field with the smallest aperture.

Set up a still life shot where considerable depth of field is needed – with a low camera angle, for instance. Position the flash at a distance that would allow only a middle aperture setting – f11, say – with the film you are using. Make one exposure. Now, with the studio in darkness, open the shutter at its 'T' setting with a cable release and make a second exposure, with the aperture closed down one f-stop. For this, you will need to trigger the flash separately twice. For the third exposure, reduce the lens aperture by a further stop and trigger the flash four times. The exposures of all three photographs should be identical, but the depth of field will be improved by the multiple flash shots. Remember that you must double the number of flashes for each f-stop you reduce the aperture.

Another use of multiple flash is for special effects, moving the subject, or part of it, during the exposure. With any light-toned subject against a dark background – black velvet is particularly effective – move the subject slightly between flashes. The result will be a stepped series of images on the same frame of film. In this case, because the subject is in a different position each time, you should give each shot the full exposure; in other words, adjust the aperture so that each flash gives the correct exposure.

For the photograph (**above**), the photographer varied the project instructions slightly, using an f11 aperture setting with eight flashes, rather than one. This shot clearly demonstrates the chief virtue of multiple flash – the increase in depth of field. The other photographs demonstrate the same principle; the shot (**top right**) was taken at f8 with four flashes, while the shot (**bottom right**) was taken at f5.6 with 1/60 sec synchronised flash. In all three instances, the photographer diffused the light to help overcome the common problem of hard shadows and small, bright highlights. This can be done either by bouncing the light off a suitable white background, or by aiming it through a translucent screen. One of the simplest methods is to wrap a thin piece of white cloth around the flash head, taking care not to cover the sensor if the unit is automatic.

39 · SYNCHRONIZING WITH SHUTTER SPEED

Indoors, in some daylight from a window, set up a focal plane camera. The choice of subject does not matter. Attach a portable flash unit either to the camera's hot shoe, or with a sync lead. Most cameras mark the synchronized shutter speed either with an 'X' or by coloring one of the speed settings red. The actual speed varies, according to make of camera, from 1/60sec to 1/125sec.

Adjust the aperture to the recommended setting for the distance and then make a short series of exposures at 1sec, 1/30sec, the flash sync speed and the two shutter speeds faster than that.

As the shutter blind of a focal plane camera moves across the film plane, the flash must be triggered when the entire film frame is exposed. However, because the higher speeds on a focal plane shutter are adjusted by narrowing the gap between the two blinds, synchronization is impossible at these speeds. The only shutter speeds that can be used with flash in this kind of camera are those where the widest gap is used. At fast speeds, the image is either unexposed, or shows a narrower gap. Slower shutter speeds present no problem, except that, at very slow speeds, the ambient lighting has an effect and can cause overexposure. You should see this effect in the exposure you made at 1sec.

Above The focal plane shutter is worked by means of a pair of roller blinds which travel across the film. The gap between them which exposes the film is variable, and at fast shutter speeds it is smaller than the film frame. This means that at any speed faster than the flash sync speed a truncated image is produced.

1 This shot, taken with a slow shutter speed of 1sec, is overexposed due to the effect of the natural daylight.
2 1/30sec.
3 1/60sec (flash sync speed).
4 At 1/125sec the focal planeshutter is cutting off half the image.
5 1/250sec.
6 1/500sec.
All photographs at f5.6.

40 · STOPPING POWER

The light output of electronic flashes is adjusted not by altering the intensity of the flash, but by controlling its duration. This is the principle on which automatic flash units work; a sensor detects the amount of light reflected from the subject and cuts off the flash when a certain level has been reached. Therefore, automatic flash units at short distances have a very short flash duration. Small flash units also have shorter flash durations than large studio units.

For this project, photograph a stream of liquid, using a flash unit as the light source. If you possess a house current-operated unit as well as a portable flash, you can make a useful comparison of their relative stopping power. Pour the liquid from a bottle into a glass, using a lighting set-up similar to the one illustrated below. Backlighting produces the clearest image of the stream, so place a Plexiglas diffuser between the light and the glass. Position the camera close to the glass for a close shot. This will cause the stream to move faster across the picture frame.

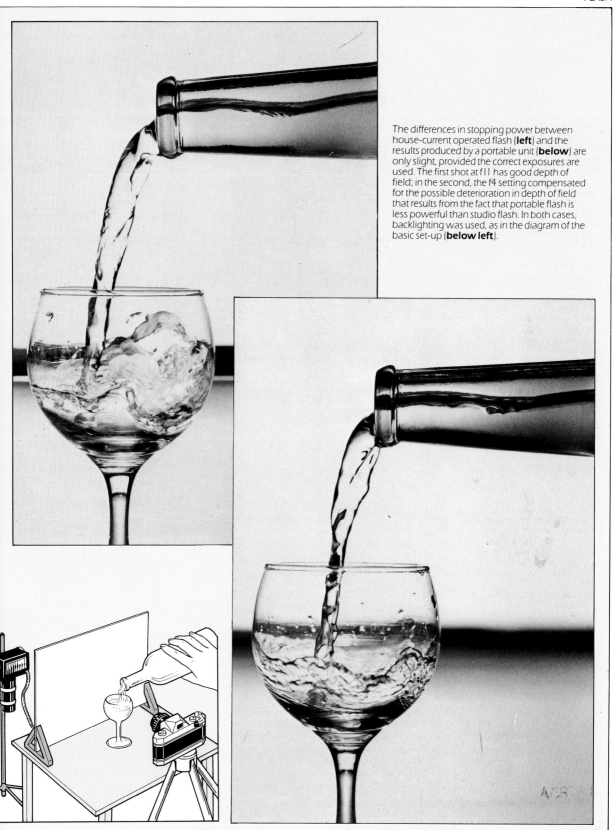

The differences in stopping power between house-current operated flash (**left**) and the results produced by a portable unit (**below**) are only slight, provided the correct exposures are used. The first shot at f11 has good depth of field; in the second, the f4 setting compensated for the possible deterioration in depth of field that results from the fact that portable flash is less powerful than studio flash. In both cases, backlighting was used, as in the diagram of the basic set-up (**below left**).

Available Light

THE TERM AVAILABLE light embraces all forms of 'found' artificial lighting not specifically designed for photography. It applies to both interiors and night exteriors and covers fluorescent, tungsten, mercury vapor or sodium lighting in any combination. It offers far from ideal conditions for photography, but, with modern fast films and certain basic techniques, the possibility of producing varied images is even greater than with daylight. As the projects here show, full color correction is not necessary in the majority of situations; in fact, the juxtaposition of green fluorescent lighting, yellow sodium lamps, orange tungsten and multi-colored neon displays can itself be rewarding.

Places where you will find available light are many and varied. They include household interiors, interiors of offices, supermarkets and other public buildings, streets at night, floodlit public buildings, concerts, theater and other indoor or night-time entertainments, firework displays, candle and firelight and neon displays.

Technical problems
The commonest problem you will face when trying to photograph in available light is simple insufficiency of light. With ASA 125 film, even a brightly lit city street at night would need an exposure of about 1/30sec at f2.8. Under such conditions – many are worse – it is difficult to avoid camera shake and to record a moving subject.

Part of the answer is to support the camera efficiently (see

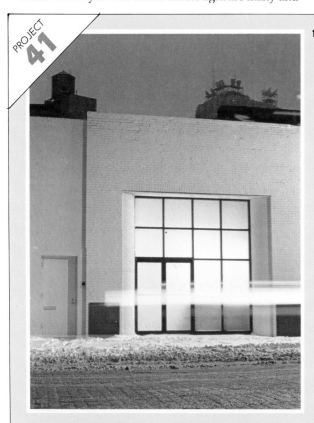

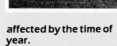

41 · PHOTOGRAPHING OUTDOORS AFTER DUSK
Shoot a small series of images, in color, of the best-lit buildings near to where you live. About three or four transparencies will be sufficient. Remember to plan this project in advance; for each shot, you should start making exposures as soon as the lighting is switched on and continue until the sky is completely dark. The exact timing will probably be affected by the time of year.

Use a tripod and shoot from the same camera position for each dusk-to-night sequence. Use daylight balanced film, but avoid the use of filters, either to correct the color balance of the light source or the effects of reciprocity failure. However, as measuring exposures in such conditions is never easy, bracket each shot.

When you look at the finished photographs, you will notice how your

pp.24–5). In addition, you will need a fast film, unless you plan to make time exposures on a tripod. A fast lens is the most useful piece of equipment, but is inevitably expensive. Most wide aperture lenses – around f1.2 and f1.4 – are of close-to-standard focal length for manufacturing reasons. Long-focus lenses, because of their magnified image, are particularly difficult to use at night; not only are their maximum apertures rather small, but any vibration is also magnified along with the image. Conversely, wide-angle lenses are useful in low light conditions, because camera shake is less noticeable in the reduced image.

Another problem is that the contrast in most shots tends to be very high, with pooling of light and dark shadows. You will see this for yourself during the projects. Careful composition and choice of camera position is one answer, avoiding the appearance of any naked light sources in the frame as much as possible. These cause flare and, at the same time, increase contrast. Of course, this assumes you are aiming to produce a conventional result; it is not relevant if you want to exploit the effect of high contrast.

Another valuable technique outdoors is to shoot when there is still some residual light left in the sky at dusk or dawn. This will help to define shapes and provide some fill-in illumination.

Finally, a problem can arise when there is one dominant light source, such as in an interior. The color shift in these circumstances is often objectionable and usually needs the help of a filter to bring it closer to 'white'.

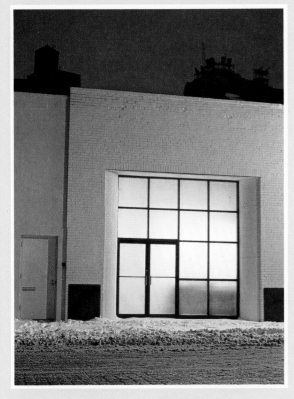

subjects show up much more clearly at dusk, when there is still some tone and color in the sky. Also note how, despite the obvious color imbalance, the effect is acceptable, particularly when there is more than one type of light source in **the picture. This demonstrates that rigorously trying to 'correct' the color of available lighting is usually not necessary.**

The four shots here demonstrate one of the chief hazards of shooting in failing light – the problem of reciprocity failure. The shadow areas clearly suffer the most. Color correction, too, would be necessary only for aesthetic reasons, rather than technical

ones. It is a matter of personal choice whether you prefer the faded, but more accurate, colors of the first shot to the strong colors of the last.

42 · HAND-HELD LOW LIGHT SHOOTING

A fast film is often the key to photographic success, if you are shooting in dim light without a tripod. The fastest film generally available for 35mm cameras is Kodak Recording Film 2475. Originally designed as a surveillance film, this has an extended red sensitivity, so that it is more efficient in tungsten lighting than any of its counterparts. It can be rated at various speeds – the normal one is ASA 1000 – and is naturally very grainy.

With your fastest lens, load a roll of Recording Film, rate it at ASA 2000 and hunt out poorly-lit subjects that you would normally consider impossible for photography. Use the camera-handling techniques described on p.24 and try shooting in, for instance, a restaurant, a bar, an amusement arcade or a theater district.

The shots here indicate the varied and dramatic effects produced by shooting with fast film in poor lighting conditions.

1. Foundry scene The long exposure necessary to capture the fine detail meant that the only available light would naturally become an important part of the picture, literally bleaching out detail where it fell. By shooting from an elevated position, the photographer managed to turn this to advantage, using the light to create an almost ghostly effect.

2. Birthday party This shot of a children's birthday party shows that this technique has particular advantages when the aim is a natural, rather than a posed, effect.

3. Snow in the park The snow here brought added brightness to the shot. The picture demonstrates the ability of fast film in optimum conditions to capture almost the qualities of a daylight shot.

4. Airport at night Another shot in which the use of fast film produces a result that would be difficult to achieve with a more conventional alternative.

5. Indian dancers In this shot, the only available light came from the make-up bulbs around the mirrors. Fast film was again essential if the maximum possible detail was to be captured.

43 · ALTERING THE BALANCE OF FLUORESCENT LIGHT

While fluorescent lighting may appear 'white' to the eye, it usually records green or greenish-blue on daylight color film. This is because it is strongly deficient in red. In an interior shot, lit completely or mainly with fluorescent strip lights, the overall greenish cast often looks wrong, particularly for portraits.

Start by taking a color transparency, using fast daylight balanced film, such as Ektachrome 400, in three different fluorescent-lit interiors without a filter. Supermarkets and offices normally use this kind of lighting. Examine the transparencies on a light box. From your memory of the scene, you will probably be surprised at how green the transparencies are. To correct the image to white, you will need a reddish filter; try to work out exactly what color and at what strength by laying different gelatin color correction filters over the transparencies. If possible, have to hand the following 75mm Kodak filters – CC10 Red, CC20 Red, CC30 Red, CC10 Magenta, CC20 Magenta, CC30 Magenta, CC10 Yellow and CC20 Yellow. Try different combinations until you neutralize the cast in each of the transparencies. One extra problem presented by fluorescent light is that lamps differ in color. This is hard to detect by eye but there may well be a difference between the three transparencies.

See how accurate your judgment was by returning to the three interiors and rephotographing them with filters. Remember that, on a light box, a color imbalance usually appears to need a stronger correction than when taking the shot.

The photographs here illustrate what happens if you take interior shots, using daylight color film, lit with fluorescent light and how the resulting greenish cast can be corrected. The problem arises because the light itself is deficient in red; the answer is to correct for this by using the appropriate filter or filters. The shot of a clerk entering up a ledger (**left**) shows all the standard characteristics of an uncorrected photograph, as does the interior of this barrel-aging room in a Californian winery (**far right**). Frequently, it is impossible to check such lamps to establish exactly what filters are required. The photographer here experimented with several filter combinations and shots, as suggested in the project text. He found that CC30 magenta was the most successful (**above**).

Elements of the Image

44 · Making the best use of different formats
45 · How frame size affects the subject
46 · Horizontal versus vertical

The four basic picture formats are shown here in diagramatic form. From top to bottom, these are horizontal vertical, square and panoramic. When you select a format, you should always consider the composition and construction of the shot carefully. As far as horizontal and panoramic images are concerned, it obviously makes sense to utilize the central part of the frame to achieve the best photographic results.

ALTHOUGH, IN ONE sense, photography is a record of unpredictable events in front of the camera, a very large amount of control is nearly always possible – and, in fact, is usually inescapable. Simply by choosing a viewpoint and a lens of specific focal length, you have already taken a major step towards establishing the nature of the final image. By the time you release the shutter, you will have effectively constructed the shot; how successful it is will reflect your decisions and your skill.

In practice, it is impossible to separate the content of a photograph from the way the image is organized, but, nevertheless, composition has its own distinct features. On the following pages, the purely graphic elements of a photograph are analyzed; in the projects, you can experiment with different ways of combining them. This is the essence of composition – understanding the function of points, lines and shapes and organizing them in such a way that the image is aesthetically satisfying.

Studying composition like this is necessary, but dangerous. It is all too easy to fall into the trap of thinking of composition as bound by rules and then assuming that all that is necessary is to apply them to create a successful photograph. On the contrary, the one certainty is that, if you take your photographs in this way, they will be bland, moderately pleasing and quite lacking in personality. Some of the more widely touted 'rules' of composition simply assure conventional images as an end result. They are useful to know when you need them, but you should always apply them with discretion. First, decide on the purpose of the photograph and then – and only then – apply your compositional knowledge, as you see fit; this may be to produce a well-balanced image, but, equally, you may want to create tension or discord instead.

Although the projects here deliberately ignore practically everything outside graphic effect, use them only as exercises and not as method. Very few subjects exhibit the pure characteristics of an element such as a diagonal line, or a rectangular shape. Most have quite complex associations and some have such a strong inherent interest that their graphic qualities are relegated to a minor role.

Images can be studied in a number of ways; here, they are broken down into distinct elements, such as point, line and color. In isolation, these have certain characteristics, but, when combined with each other, the results are not so easy to predict. Juggling them to produce an intentional effect is the skill of constructing an image. Most of the principles are the same as for painting, drawing and other forms of illustration, with the added complication that photographs are assumed to be a record of reality. As a result, photographic images tend to be taken literally.

What is meant by a frame?

Because any image lies on a two-dimensional surface, it needs a boundary – a framework within which it lies. This

44 · MAKING THE BEST USE OF DIFFERENT FORMATS
Take four photographs in black and white. Each of them should exploit the characteristics of 35mm horizontal, 35mm vertical, square and panoramic to the full.

1. Vertical This shot ideally demonstrates the general rule of suiting composition to format and vice versa. The background here, for instance and the vertical structure of the window frame is ideal.
2. Square This format is especially suitable for portraiture.
3. Horizontal As this shot demonstrates, the horizontal format sets off a busy composition well.
4. Panoramic Here, the composition and construction of the shot are totally in tune with the chosen format. The use of the beach umbrella in the foreground not only provides a focal point of interest, but also a sense of stability.

4

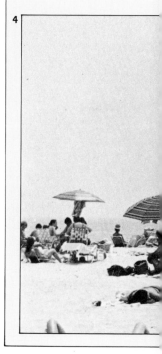

45 · HOW FRAME SIZE AFFECTS THE SUBJECT

For this project, take three separate black and white photographs – one of a single subject with a simple shape, almost filling the frame, and an uncomplicated background; another of a complex image with an abundance of detail; and a third of any outdoor scene, with a wide-angle lens. Make two prints of each photograph, one measuring 200mm (8in) x 250mm (10in) or larger and the other measuring about 50mm (2in) over the longer side of the frame. View each pair side by side from as close a position as is comfortable.

Your eyes should be able to take in the small print immediately, without having to move around the image. Because of this, the borders of the image are very prominent. The large print, on the other hand, takes more time to view, because it extends beyond the area that the eye can keep in focus at any one time. To see the photograph at this size, your eyes must move across it, gradually building up a composite impression. The frame borders seem to be far less a part of the image. The first photograph – of the single, clear subject – makes a perfectly acceptable image and may well actually benefit from miniaturization. The second, complex image, on the other hand, is hard to appreciate at this size. Similarly, the wide-angle shot probably looks better when larger, because of the small scale of the background detail. Note, too, that the distortion associated with wide-angle lenses is most obvious in a small image. When you view the photograph at an angle similar to the one at which it was taken, the distortion is no longer apparent.

This photograph of ritual bathers in the Ganges, India, loses most of its impact in miniature. The distinctive individuals in the large print become no more than an anonymous crowd in the small one, and the interesting details of facial expressions, jewelery and patterns on clothes are lost. The distortion of the wide-angle lens is also less apparent in the large picture, as the scale of the figures is closer to the size they must have appeared to the photographer when taking the shot. The effect of the lens here is to pull the viewer into the picture and give him the illusion of three-dimensional reality.

46 · HORIZONTAL VERSUS VERTICAL

Take any suitable subject and devise a satisfactory composition both vertically and horizontally, using the full frame of a 35mm camera.

Disused quarry cutting rooms These two shots of the cutting rooms in a disused slate quarry show the advantages of each type of composition. In both cases, the photographer used a 28mm wide angle lens and a film speed of ASA 400. The vertical format gives more emphasis to the height of the room; the horizontal one produces a more compressed result as far as the room's height is concerned, though the room is made to appear larger. In addition, the vertical shot possesses more detail and immediacy; the cropping inherent in the use of the horizontal format means, for instance, that the base structure of the cutting machines has been lost. Though both compositions are technically satisfactory, the vertical shot is probably the more pleasing.

enclosed border, called the frame, is hardly ever considered as part of the image, yet, by definition, it cannot help affecting the image inside it. How it influences the image depends mainly on size and format. The former is important not only in relation to the subject of the photograph, but also in relation to the person viewing the image. Format has a more complex influence.

The importance of format

By convention, the shape of the frame is rectangular. Anything else seems unusual and therefore distracting. The useful proportions, whether vertical or horizontal, are actually quite limited and hardly ever exceed 3:2 vertically and 1:3 horizontally. Though variations are possible, virtually all photographs fit into one of the categories illustrated here.

Of all these, it is most difficult to compose within the square format. This tends to impose a rigorous symmetry that can be very dull and few natural subjects fit comfortably into it. Often, the most successful way of using it is with a composition that is basically symmetrical, but contains some eccentricity to add interest. The principles that underlie the Golden Section (see p.97) are largely responsible for the format's problems; photographs taken with cameras that possess this format are more often than not cropped later in the printing.

A horizontal format is the most natural and least obtrusive of all frames. This is mainly because our binocular vision gives us a loosely horizontal view of the world and because the eyes, in scanning a scene, move most easily from side to side. It is possible that the horizon, which is an important part of our visual experience, is partly responsible for this visual preference. Even the elongated proportions of a panoramic format do not look unusual – the eye simply scans the picture in broader sweeps. The two most common horizontal formats in photography are 4:5 (most sheet film and printing papers are manufactured in these proportions).

Although necessary for certain subjects, such as standing figures, tall buildings and most portraits, the vertical format is used less frequently than the horizontal one. The eye finds it slightly more difficult to scan a vertical picture, so the top part of the frame tends to be ignored. There is also a practical reason for this – most 35mm cameras are easier to hold in the horizontal than in the vertical position.

Because vertical photographs are less easy to see in a glance, they can give the impression of being close to the viewer. The normal proportions are 5:4 and 3:2; anything more extended tends to look awkward, while even the proportions of a 35mm frame are sometimes difficult for composition. Generally, a vertical format is more active than a horizontal one.

Focus of Attention

An image such as this pair of eyes produces a slightly unsettling effect because the viewer is confronted with two equally balanced points of focus. This view of a human face is unusual because of the exclusion of the other elements to which the eye would usually travel to take in the full expression of the face. The eyes of the viewer are left to flicker from one eye to the other, unable to rest on either focus and uncertain of the emotion expressed.

ALTHOUGH THE SHAPE and size of a photograph's border are important, the eye's movement is controlled much more by the image than by the frame. The former contains both graphic elements and content, each working in a different way on the attention of the person looking at the photograph. The graphic elements, the subjects of the next pages, are two dimensional – things like lines and shapes, which, by themselves, have no meaning. The content of a photograph is its recognizable subject matter, such as a tree, a person or landscape.

Although composition is chiefly concerned with the arrangement of the graphic elements, it is never possible to divorce it from content in practice. A human face, for instance, always attracts attention in a photograph. Even though it may play a minor role in the composition, it will tend to be a strong element in the image.

The basic graphic elements of any image are point, line and shape. Not only can the effects of these constituents on the image be individually complex; most photographs are made up of a variety of intertwined elements.

The simplest of the three elements is the point. This normally provides the focus of attention. If there is no

PROJECT **47**

The Golden Section The Golden Section makes it possible to divide any image into proportions that, through experience, satisfy the eye, though it is better to take it as a general principle than as a strict rule. It works as well for dividing a line as for dividing a rectangular frame, or for positioning a dominant point. To find the vertical section divide AB in half to create C. Draw a radius from C and the top right corner to create D. Extend lines to create a rectangle, the point BG being the vertical section. Draw a radius from the top of G and the top right corner downwards. The point of intersection is the horizontal section.

The way we take in an image is by focusing on single points one at a time. The order in which we look at the elements in a photograph obviously varies from person to person, but is usually fairly predictable. In photograph **A**, for example, most people would focus on the elements in the following order: 1 dog, 2 motorcycle, 3 license plate. In photograph **B** it would be 1 clock, 2 lamp, 3 skyscraper, 4 cloud.

obvious point in the image, the eye will tend to imagine one – the way we see, in fact, is by focusing on one point at a time. A point is fixed and stable; it tends to restrict the movement of the eyes.

The focus of attention
If a photographic subject is small and dominant, then it functions as a point and becomes the undisputed focus of attention. Its position will affect the viewer's sense of equilibrium, however, since a point always interacts with the frame.

The most predictable position is in the center of the image – the pivot point for the rest of the picture – but this is rarely satisfactory (see diagram to the right). Although the image is not thrown out of balance, the result is usually too symmetrical to be interested. This may change when other elements are included in the photograph, but, for a solitary point, the center is a dull location. At the other extreme, a point placed near the edge of the frame seems awkward and wrong (diagram B). A good reason is needed for such an extreme position.

The third alternative is a position that is just off-center (diagram C). This, for reasons of balance that are discussed later, is generally more aesthetically satisfying. The best-known rule of composition – the Golden Section – formalizes this proposition.

Secondary points
Every point in an image attracts the attention to some degree. Even when one is dominant, the eye will eventually stray to others.

A

B

C

PROJECT **48**

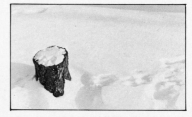

48 · PLACING A SINGLE POINT

Choose a setting containing a small, dominant subject against a relatively featureless background. A person on a large area of pavement, viewed from above, is a good choice. Make a series of exposures, with the subject in a different position in each one – central, close to a corner and in various intermediate positions. Do not calculate the proportions at the time; compose intuitively.

Examine the finished prints and select the one that you feel is most satisfactory in terms of composition. Divide this print according to the Golden Section. If the division and the subject do not agree, there is no question of the composition being wrong. Can you explain why, for this photograph, they are not in the same place?

The varying possibilities for the position of the single dominant point have been explored here through the use of a tree stump half-buried in a snowy field. The shot (**top**) is the most satisfying, since it is almost in accord with the principles of the Golden Section. Positioning the stump at the left is not as unsatisfactory as it might be in another shot, since it draws attention to the footprints. Similarly, positioning the stump at the right means that the shadow enhances the image. The central composition, though conventional, lacks the interest of the other shots.

The main picture analyzed in terms of the Golden Section

In simple cases, it becomes fairly easy to predict the sequence in which someone will look at a picture. Composing an image with this in mind, so that these points are deliberately placed, is one of the most basic ways of controlling attention. However, when a secondary point occurs unintentionally – in particular, close to the edge of the frame – it can be so distracting as to throw the image out of balance.

If a secondary point is almost equal in attraction to the focus of attention, then the eye tends to move to and fro between them, unable to decide which to settle on. In a full face portrait, for instance, cropped so closely that the eyes are widely spaced across the frame, this effect can be slightly unsettling.

With more than two points in the picture, then, the relationships are less easy to predict, except when the points appear to form a sequence. In this case, they function as an implied line (see p.103).

49 · SECONDARY POINTS

Look back through your files and find prints containing both a dominant and a secondary point. Having identified them, consider how the secondary points affect the way you expect the photographs to be seen.

These two shots illustrate how the careful consideration of dominant and secondary points can enhance the overall effect of the final composition. The lighthouse (**left**), for instance, is the dominant feature of the seascape, with the house as the secondary point. However, the house has a vital role to play. Without it, there would be no means of judging the size of the lighthouse and the scale of the composition. It also provides the necessary sense of balance in the shot. The same principles apply to the other example (**above**).

Line

Horizontal
line

Vertical line

Diagonal line

Converging
diagonal
lines

THE SECOND ELEMENT of the image is the line. More complex than the point, which can vary only in its position, a line affects the image differently, according to its angle, length, form, such as curved, straight or crooked, and its position in the frame. Because of these extra qualities, lines have more associations for the eye; in particular, they tend to produce a sense of movement, which contrasts with the stability of a point.

The chief way in which lines add movement is by drawing the eyes along them. Used deliberately, they can control the way in which a photograph is seen to some extent; at their strongest, they can create dynamic tensions in an image, making it active rather than passive.

Angle

Exactly how dynamic a line is depends largely on its angle. There are three categories – horizontal, vertical and diagonal – each with different characteristics and associations.

A horizontal line is the most stable, its associations being placid and restful. Consider, for instance, the horizon, one of the most constant features of our visual experience. Without being conscious of it for most of the time, we grow up with it as the standard reference for our vision. Used in a picture with lines at different angles, it tends to have a balancing, stabilizing effect; thus, it often has an important role in forming a solid base in an image.

A vertical line has more aggressive associations than a horizontal one, forcing the eye to move in a less comfortable direction. On a single, uncomplicated vertical, the natural place for the eye to come to rest is below the midpoint. In some circumstances, particularly when the upper border of the frame cuts off the top of a vertical subject, or when there are a number of vertical lines, this angle of line produces the sense of a barrier.

Graphically, a diagonal line is more interesting than the other two. It tends to give dynamic tension. Whereas a horizontal, or vertical, line is in accord with two edges of the frame, a diagonal is always in contrast and so has a more dominating effect on the attention. Because the eye tends to drift from left to right, a simple diagonal appears to have this direction. When the angle is from upper left to lower right, this matches the movement of the eye across a blank surface and so has the effect of controlling the gaze very strongly indeed.

Through familiarity, we associate diagonals with perspective and they often encourage a sense of depth. A diagonal ascending from lower left, for instance, seems to be receding.

The strong movement implicit in a diagonal can be halted by a contrasting horizontal, vertical, or counter-diagonal. Contrasting lines can have interesting relationships; they can either reinforce each other's sense of movement, or create a balance.

50 · EXPLOITING THE ASSOCIATIONS OF LINES
Produce three photographs, each emphasizing one of the chief characteristics of a particular line. The subjects of the photographs should be, in order, edge-to-edge horizontal, a series of verticals, and diagonals in combination with counter-diagonals.

The photographers here have succeeded in finding less obvious subjects in the course of completing this project and the results show how imagination can transform what might otherwise have been conventional, obvious results.
1. Starting stalls The white horizontal framework dominates the picture, but the jockeys humanize what might have proved an arid shot. The use of a telephoto lens meant it was possible to get close to the subject, while shooting slightly from above added to the strength of the composition as a whole.
2. Greek columns Close cropping here enables the columns of this Athenian temple to dominate the photograph, as the photographer intended.
3. Chain fence Again, imagination has made what could have been a dry subject interesting. Getting in close for the shot strengthened the sense of geometry conveyed by the diagonals and counter-diagonals, while the snow is an interesting added touch.

51 · ANALYZING LINES
Select suitable subjects for
analysis in terms of line and
study the results. What
types of line do the
photographs contain?
Which are dominant?

1

2

3

4

Each shot has extremely marked directional characteristics. It also shows how other lines that, strictly speaking, should unbalance these characteristics, actually strengthen the images.

1. Beach huts Here, the position of the rows of huts produces a geometric, disciplined effect. The direction is strongly to the left, almost as though an arrowhead was cutting across the picture. Though the people walking to the right should lessen the overall effect, their presence actually strengthens the composition.

2. College building This medieval building in Cambridge, UK, has all the attributes of Gothic architecture, with its emphasis on verticals. The bold lines of the main buttresses add strength to the image, while, the meandering horizontals contribute to the effect.

3. Clothes lines The line-to-line arrangement of the drying sheets means that the shot is a classic diagonal study, reading from top left to bottom right.

4. Radiator and icicles The use of a long-focus lens produces the flattened, compressed effect of the shot. Here, the metal horizontals of the radiator and the vertical icicles combine to produce twin centers of equal interest.

Lengths

The longer a line, the more pronounced its effect. When a line cuts the edge of the frame, it tends to switch attention away from the picture by implying that the subject extends beyond it. This effect is more marked with diagonals and verticals than with horizontals.

Form

A straight line is the simplest form of line. Others are curved, angular, irregular and rhythmic. It depends on the particular image as to whether angular or rhythmic lines appear as a single element, or as made up of a number of short lines.

Any line other than a straight one shows that there are different forces at work. A curved line, for instance, may appear to be pushed into shape, or to be formed by a deflection of its movement. Similarly, when it comes to associations, a curve is often thought to be graceful and yielding, while an angular line appears aggressive, the result of a strong counterforce. Irregular lines have no fixed associations, rhythmic lines strongly imply the idea of continuation and fluctuation.

Position

The tendency of a line to control the movement of the eye is dependent on its position in the frame to some extent. Basically, the more central the line, the stronger this effect. In the illustrations here, the dynamics of the corner-to-corner diagonal are reduced when the line is off-center; the imbalance gives an impression of an opposing direction to the diagonal.

Implied line

Implied line is one of the most important types of line in composition. As the definition implies, it relies heavily on suggestion. Points in sequence encourage the eye to fill in the gaps, with the result that many photographs contain lines that are optically induced from points in the composition, rather than real.

The importance of these implied lines lies not so much in their ubiquity, but in the fact that they are not painstakingly obvious. In the same way that any retreat from the obvious in composition can only add interest to the image, the presence of an implied line asks for more attention – and therefore more involvement – from the person looking at the photograph.

Lines can be implied in two basic ways. Either a reasonably ordered progression of points, or short lines, can produce the effect, or the sense of direction, or movement, associated with the subject. Examples of the second are the aiming of a rifle, the movement of a truck and the direction in which a person appears to be looking – known as the 'eye line'.

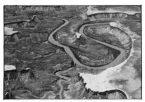

Lengths The line of huts in the photograph above draws the eye out of the frame by appearing to continue beyond it.

Form The irregular curves of the river above give a graceful and relaxed effect. Other types of line are shown in the diagrams on the left.

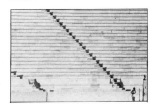

Position In this photograph the central diagonal line is stronger than the corner one. This strong line leads the eye to the figure and the statue, the main points of interest.

52 · FORMING LINES

For this project, photograph lines formed in the following four ways.

Real line A line that has a distinctly different tone from its background, such as a fence, branch, or drainpipe, is the most clearly-stated of all lines.

Edge A more common line formation is the border between two areas of contrasting tone, such as the edge of a building against the sky. When photographing this, minimize the sense of shape and focus attention on a single line.

Streak The type of line created by points and a slow shutter speed is a purely photographic line. Whichever moves – subject or camera – the image will contain streaks in the direction of the movement, provided that the shutter stays open long enough for the points to cross the frame. Moving lights against a dark background, such as headlights on a road at night, give particularly strong streaked lines.

Implied For this, use not only ready-made sequences, such as a row of streetlights, but also progressions of points that depend on the camera position for their existence.

Again, the results of this project show how imagination can make all the difference in visual terms between an interesting image and a dull one.

1. Chair The sculpted construction of this garden chair makes the demonstration of the use of edge extremely telling. By getting in close to the subject, the drops of water become an interesting part of the composition.

2. Post Office Tower, London Here, zooming in on a particular section of the tower, rather than shooting the whole structure, has emphasized the dominant nature of the lines.

3. Curtain This is a well-planned line study, making clever use of lighting and shadow, particularly as far as the curtain cord is concerned.

1

2

3

4. Suspension bridge This night shot shows the possibilities of streaking to the full, an effect achieved here by a simple camera movement.

5. Silver Birch This edge study is a more conventional choice of subject than the chair, but the photographer has used light carefully to stress the line.

6. Scaffolding This is an example of a ready-made implied line shot. The scaffolding's position clearly established the idea of a path.

7. Trees Here, the camera position has created the sense of line. The trees themselves have been blown to the left by the wind – giving the shot added direction – while the snow piled up around them serves to strengthen the shot.

Shape

Shape and frame 1 and **2** show complementary relationships between shape and frame. The lines in **1** are parallel to the frame, and both **1** and **2** have even proportions. **3** shows a contrasting relationship, with contrasting lines and uneven proportions. **4** is the least stable, the shape lying partly outside the frame.

Frame within a frame The tunnel illustration **1** gives a strong impression of looking out from the darkness. **2** and **3** increase the interest of the figures by vignetting them.

Negative shape The above illustration of a vase shows this phenomenon clearly. Because of the equal proportions of subject and background, and the strong contrast between them, the two faces appear as strong as the vase.

SHAPE IS THE most complex of the three image elements, with the most associations and giving the clearest representation of reality. Shapes can be formed by contrasting blocks of tone or color, by an enclosing line, or both factors together. The edge of shape is literally a line, but whether it functions as one or not depends largely on how dominant is the contrast between tone or color.

The relationship between a shape and the frame of a photograph is nearly always important, the more so when the shape is relatively large and well-defined. Shapes that lie entirely within the frame tend to give an impression of completeness and stability. A plain background also helps to clarify the appearance of a shape. This relationship can be complementary, when the overall proportions or the individual lines reinforce each other, or contrasting, when they are in opposition to each other.

A variation of this potentially strong relationship is the graphic construction of a frame within a frame. One of the commonest examples of this technique is the use of a doorframe, or window, either looking in or out. The vignetting of the remainder of the photograph reduces the importance of the picture frame, while at the same time implying that the area between the two frames extends outwards. Its effect is strongest when the area surrounding the inner frame is black. This tends to give the viewer the feeling of being hidden, looking out from a dark space.

Negative shape

Each shape automatically creates a negative shape, made up of the area that interlocks with it. At times this complementary shape can be as important as the intended subject. The optical phenomenon known as 'figure-background reversal' shows this clearly. The simple line image illustrated here can be seen either as a vase, or as a pair of opposing faces; each of the two areas of the picture are of equal importance. Similarly in photography, when the shape is strongly differentiated in tone from its background – as in the case of a silhouette – and when the subject and its background occupy more or less equal areas, the negative shape then appears at its strongest.

Classifications of shape

Shapes and their associations can be classified as follows. A triangle is the most dynamic of all shapes, because it contains at least two diagonals and has three opposing points. These act as focuses for the sense of movement which the diagonals create. It is also the simplest of all shapes, with only three sides, and is always in contrast with the frame of the photograph.

The attitude that the eye considers normal for a triangle is with the longest side as the base horizontal, therefore adding an element of stability. In this position, the triangle has one prominent point, the apex at the top, which implies that the triangle is pointing upwards. In photography,

53 · ANALYZING SHAPES

Taking the example as your model, pick out the principal shapes in the photographs below. In each case, how important are the negative, complementary shapes?

Most of the pictures here have clear, well-defined shapes that are relatively easy to analyze. The importance of negative shapes, however, is as much an aesthetic judgement for the individual as a technical one.
1. Mosque, Samarkand The symmetry of this shot makes it solid and stable. There are four obvious squares within the main shape, while the shadow areas are also forming clearly-defined squares of their own.
2. Gateway, London Again, the structure of the composition gives it a strong sense of symmetry. The dominant shapes are obviously triangular, while there is also a sense of squareness.
3. Port of Piraeus, Athens By shooting from a height, the photographer has emphasized the circular shape of Athens's natural harbour.
4. Evening rush hour, Athens The shapes in this shot are not as clearly defined as in the other examples. However, there is a strong sense of flow across the picture from left to right, heightened by the pronounced shadows. This makes the focus of interest generally diagonal.

1

54 · FRAME WITHIN A FRAME

Photograph two scenes, each contained within an interior frame. Only one of the shots should use a door or window; for the second, try a more imaginative construction.

3

2

The examples here show two imaginative uses of a window as an interior frame and two other striking solutions.

1. Stately home, Scotland One of the problems the photographer faced with this unusually constructed shot was achieving the correct balance between the reflections on the wooden paneling and the outside detail. The way the shot was printed has intensified the areas of shadow to deep black to concentrate the focal point of interest.

2. Boat windows Here, clever camera positioning and careful thought about the nature of the composition has created a multiple series of images, rather than a single one. This means that the character of this attractive quayside is clearly captured. The slight reflections in the right of the shot could have been overcome by the use of a polarizing filter, but they do not detract from the overall impact of the image.

3. Sculpture, Serpentine, London Close cropping has heightened the effect of this evening shot, the trees being silhouetted in the background.

4. Arches National Park, Utah Here, an aperture setting of f16 was deliberately used to exclude the interior detail of the cave walls. The result looks extremely striking and dynamic as a consequence.

4

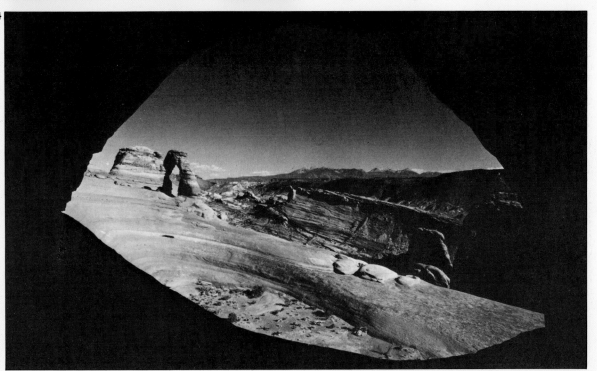

PROJECT 55

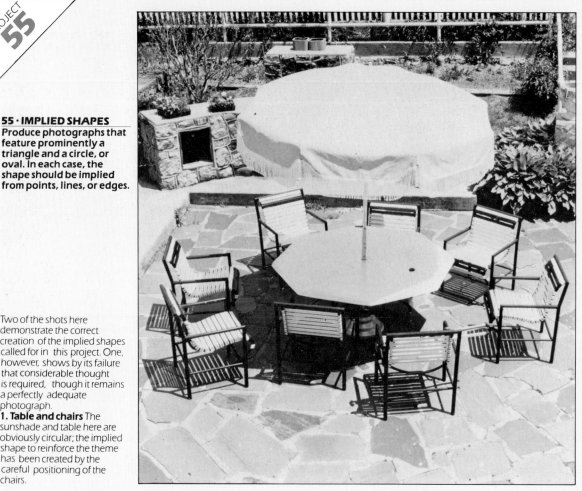

55 · IMPLIED SHAPES
Produce photographs that
feature prominently a
triangle and a circle, or
oval. In each case, the
shape should be implied
from points, lines, or edges.

Two of the shots here
demonstrate the correct
creation of the implied shapes
called for in this project. One,
however, shows by its failure
that considerable thought
is required, though it remains
a perfectly adequate
photograph.

1. Table and chairs The
sunshade and table here are
obviously circular; the implied
shape to reinforce the theme
has been created by the
careful positioning of the
chairs.

Triangle

Square

Rectangle

however, because many scenes contain converging lines as
one of the ways in which a photograph conveys perspec-
tive, triangular shapes frequently have associations of
depth, with the apex receding.

Square shapes are not as difficult to use as elements
within a photograph as they are when they form the frame.
This is because their position in the picture usually can be
adjusted to avoid complete symmetry. Nevertheless, the
square has ponderous, dull associations. It also has a
greater sense of weight than other shapes.

The qualities governing the use of the rectangle as format
apply just as much when it is an element of the image. The
longer or wider the proportions of a rectangle, the more of
the qualities of a line it possesses; it can therefore either
complement the shape of the frame so closely that a repeti-
tive relationship is formed, or, at the other end of the scale,
it can contrast quite strongly.

The circle and its less symmetrical oval derivatives carry
strong associations of completeness, rest, infinity and
smoothness. In the correct context, they frequently have
sensual connotations. The symmetry of a circle accustoms
the eye to look at its center. In addition, depending on the
position of the circle in the frame and on its relationship
with other parts of the image, it can sometimes have

Circle The associations carried
by the circle are many, and
include wholeness and
tranquillity. The focus for the eye
is at its center, but when
juxtaposed with another
element, the circle acquires an
implied point on its
circumference (**above right**).

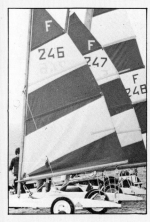

2. Sand yachts The photographer aimed to create the implied shape of a triangle, but, in fact, the result is the opposite of what was intended. The triangular sails dominate the image to such an extent that the implication of a continuation down to the hulls of the boats is lost.

3. Parthenon, Athens In contrast, careful camera placement here, so that the shot was taken at an angle, has created strongly implied triangles. The photographer shot upwards to exaggerate the effect of converging verticals.

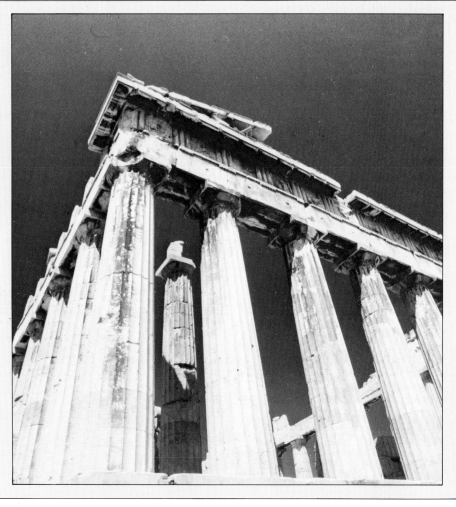

Implied circle A common shape in photography, the implied circle has weaker associations than the full circle.

implied points, especially at the top, bottom and wherever it touches another shape or line.

The majority of shapes you will meet in photography, however, are a combination of the simple shapes that have just been described. As such, they will have weaker associations. However, the eye has a natural tendency to simplify images and quite often an irregular shape will appear to be broken down into more basic elements.

Implied shape

Just as there are implied lines, built up from a sequence of points, so there are implied shapes, their boundaries defined by points, broken lines, or a combination of both. Any associations that a shape may possess are naturally stronger when the edges are complete, rather than implied.

The commonest implied shape is the triangle, formed by three points, one point and a line, or by three edges. Other shapes can be formed by similar combinations.

When shapes cut the edge of the frame, they, by implication, extend beyond it. Thus, a semicircle is perceived as being part of a circle and a triangle rising from the lower edge of the frame is seen as the tip of a larger triangle. The eye attempts to force such truncated shapes into their simplest version.

Implied triangle This is another very common shape, often used as a subtle way of imposing structure on the composition.

Balance

BALANCE IN PHOTOGRAPHY is an aesthetic concept. It assumes that each element of the image has a certain weight and so affects the equilibrium of the photograph. To simplify the thought, think of the elements of the image as having real substance and the surface of the print as being balanced on a point. Notionally, there is one position at which this assembly could be balanced, as in the illustrations below. In actual photography, however, because the distribution of 'weight' is controlled by the interplay of many factors, there is no formula for calculating the point of balance precisely – in any case, this would be a pointless exercise. What is important is solely the general position of this pivot.

Though, thus far, we have treated each element of the image more or less in isolation, most images are made up of a complex association of elements, open to different interpretations. As an exercise, consider one of your own photographs. Depending on whether you analyze it in terms of points, lines or shapes, it has different constructions. All these elements mean that the only sensible way to balance any composition is intuitively, based on a general knowledge of the forces and weights involved.

Principles of balance

As a principle, eccentric or dynamic elements can be balanced by stabilizing elements. The momentum of a diagonal, for instance, can be stopped by a horizontal base (stabilizing element), or by a counter-diagonal (opposing element). A horizontal line at the bottom of the frame, for its part, can be balanced by vertical lines that tend to drag the eye upwards. On the whole balance is most easily accomplished with the same class of elements, such as line against line, or shape against shape, but it is possible to combine different elements. An additional element, also subject to the concept of balance, is color (see p.133).

Determining where the balance should lie is linked to the aesthetic standards involved in placing the focus of attention. If the pivot lies in the center of the frame, the result will be perfect equilibrium, but this is rarely as aesthetically satisfying as a slightly off-center position. Equally, eccentric positioning is justifiable, provided that there is a logical aesthetic reason for it.

Base and weight

Because most of our visual experience is in a more or less horizontal direction from ground level, we are accustomed to seeing objects resting or standing on a level base. In photography, this base reinforces the idea of weight and gravity; it is a support for objects in contact with it. Visually, it also acts as a reference point for other elements, in much the same way that a key in music is the base for the notes of a particular scale.

When a base appears in a photograph, it is usually composed of a single line. It therefore shares some of the

features of all lines – direction and control of eye movement – but its associative context still dominates. In fact, as a symbol, a single horizontal line, with no other visual information, suggests a horizon more frequently than anything else. As a horizon, it has solidity and also encourages the eye to focus on a narrow band above it, so that fine detail on the line is easily resolved.

Pattern and repetition

In most photographs, balance is achieved as a result of the

competition between different elements for attention. Because most photographs are constructed around a distinct subject, there is nearly always at least one center of interest in the picture. However, when the entire frame is filled with so many similar elements that no single one stands out, balance plays a much smaller role. This type of image – a pattern – has a distinct appeal. It relies on the inability of the eye to find a focus of attention. Any attempt by a viewer to find a center of interest is defeated by the distraction of a continuous series.

Patterns are often, but not necessarily, repetitive. In other words a pattern may be an ordered sequence, with equal spacing between the elements, but equally it may be a continuation of a random, disordered, assembly. What all patterns have in common is a lack of focus of attention and the impression of extending, unaltered, beyond the frame. By inference, the subject of the photograph is actually larger than the picture area and the pattern is usually interpreted as part of a surface. This involves the concept of infinity.

Left An example of eccentric balance, this photograph of grazing zebras contains an abnormal amount of foreground. This is justified by the aesthetic intention to increase the drama in the shot by suggesting a hunter/hunted relationship. The view through the long grass is that of a crouching predator, be it lion, hunter or cameraman, waiting to pounce.
400mm, 1/125sec, f5.6

Below left This random pattern of stacked crates implies a continuation in all directions, as the diagram below it demonstrates.
180mm, 1/125sec, f16.

Above right These three praying figures make up a strong, well-balanced image. Removing any of the figures would seriously unbalance it. The pivotal point is just slightly off-center and on the main point of interest, around the foreground girl's shoulder. It is at the center of the inverted triangle formed by the two heads in the background and the girl's feet in the foreground. The stronger color in the foreground figure increases the sense of dimension and emphasizes the principal interest.
20mm, 1/60sec, f8.

Above One method of determining the compositional balance of your photographs is to imagine the pictorial elements in terms of weight **1.** By balancing these elements against one another you can estimate where you would position a fulcrum for perfect equilibrium **2.** This gives you the pivotal point of the photograph **3.** In a pleasing composition, the point of balance is usually just off-center.

56 · PLACING THE HORIZON

Using other elements, such as clouds or foreground detail to balance the image, take a series of photographs with the horizon in the positions shown on the right, using a horizontal format.

You will probably have the most difficulty with the central position. This is hardly ever satisfactory. The first two positions, which correspond to the Golden Section, should be straightforward and satisfactory. The very low horizon lines will give a sense of open space and stability, while the high placement will produce a more confined impression, focusing attention on the foreground and giving a greater sense of solidity.

Golden Section
1/3 horizon

Golden Section
2/3 horizon

Mid horizon

Low horizon

High horizon

Golden Section
2/3 horizon

Mid horizon

Left This, the most satisfactory of these five photographs of Hong Kong harbor, is composed with the horizon one-third the height of the format, conforming to the Golden Section. The brightly colored boats are dominated by the angularity of the gray, modern skyscrapers in the background. The contrasts are of color and neutrality, line and curve, old and new. The composition follows the proportions of the Golden Section not only in the placing of the horizon but also in its overall balance, as the diagram above shows. The photographs below show the harbor with the horizon placed in the other four positions required for this project.

Low horizon

High horizon

1

3

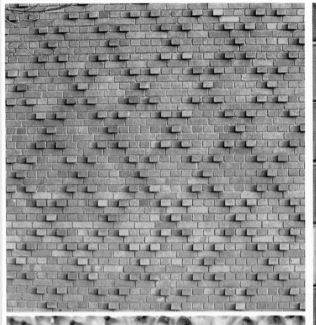

57 · PATTERNS

Photograph both repetitive and random patterns, at different scales. The smaller the scale, the more pronounced the sense of pattern will be, but the finer texture may detract from the interest of the image.

1 Repetitive pattern of bricks.
50mm, 1/125sec, f8.
2 One of nature's random patterns — the surface of a jackfruit from Thailand.
200mm, 1/125sec, f8.
3 Repetitive tile pattern with random color pattern.
50mm, 1/250sec, f8.
4 Side of car park, taken diagonally upwards.
Infra-red film, 28mm, 1/60sec, f11.
5 Random pattern of a fire escape, from below.
50mm, 1/125sec, f16.
6 The stadium in Athens, Greece.
50mm, 1/125sec, f11.

2

4

5

6

Perspective and Depth

THE TERM PERSPECTIVE describes what we mean by the appearance of objects in space, with the effect of depth, volume and distance. In photography and illustration, it is also the means used to represent a three-dimensional impression on the flat surface of a print.

The more strongly a photograph conveys perspective, the more realistic an impression it gives. In other words, by expressing the three-dimensional nature of a scene, the photograph becomes more successful as a representative image. This is only one objective among many in photography, however, since depth is by no means always desirable. Another point of view is that a photograph is a two-dimensional object in its own right and that it succeeds through an artificial arrangement of dark and light tones. Thus, a representation of reality is itself one of photography's more common illusions.

Conveying perspective

There are many ways of conveying perspective in photography, the following being the commonest. The use of converging lines – linear perspective – is the most readily acceptable symbol of depth. It is most noticeable with lenses that possess a wide field of view. The effect is common to all horizontal surfaces leading away from the camera; in the image, the lines are converted into verticals. Even when there are no such horizontal surfaces in the subject, they are often implied.

Haze is also defined, somewhat confusingly, as aerial perspective. Its effect comes about through the progressive weakening of an image when seen, or photographed, at a distance. The image of a mountain range on the horizon, for instance, is weaker than that of a tree only a few yards away, because the greater thickness of the atmosphere causes more scattering of the light.

This effect is usually less noticeable with a wide-angle lens than with a telephoto lens. With the former, most of the image area is occupied by the foreground, where haze is scarcely noticeable.

Another phenomenon associated with perspective is diminishing sequence. Similar objects at different distances from the camera naturally produce images of different sizes. The best example is a row of regularly spaced, identical objects, leading away from the camera. Their diminishing size gives the eye sufficient information to perceive depth. When well-defined objects overlap each other, the eye can usually appreciate which is closer to the camera.

Color can also greatly influence our sense of perspective. As a general rule, 'hot' colors, such as red and orange, are seen as emergent, while 'cold' colors, such as blue and green, appear to recede. Much depends on their tone and intensity, but, for instance, a red figure on a green or blue ground will nearly always create a good sensation of depth, irrespective of the subject. In landscapes, this principle is

Linear perspective Converging lines create a feeling of depth. All horizontal views away from the camera possess this effect to a greater or lesser degree.

Aerial perspective This is bound up with the natural phenomenon of haze, leading to the progressive weakening of an image the further it is away from the camera.

Diminishing perspective Same-size objects at different distances from the camera appear to lessen in size the further away they are. Again, this creates depth.

Color perspective When strong colors, such as red, are combined with cold colors, like green and blue, the latter appear to recede, creating depth.

58 · CONTROLLING PERSPECTIVE

By using, or suppressing, any of the methods of conveying perspective described in the text, produce two photographs to demonstrate the extremes of perspective, at its strongest and weakest.

Right, top The downward angle of this shot makes for a short distance between foreground and background, and the two elements of perspective present here are weakened as a consequence. The difference in the size of the tables and chairs in the foreground and background of the shot is not pronounced, and the lines of the paving stones do not converge sharply. The fact that they are diagonal in the photograph helps to disguise the fact that they converge at all. 28mm, 1/125sec, f11.

Right, bottom This photograph uses each of the four methods of conveying perspective listed on the facing page. While the narrowing road on the left demonstrates linear perspective, the hazy shapes of the buildings in the background show aerial perspective. The fence posts are in a diminishing sequence, and the bright yellows and reds of the objects in the foreground pick them out of the blue and bring them further forward. 28mm, 1/125sec, f16.

59 · CONVEYING PERSPECTIVE BY DIFFERENT MEANS

Using only one method at a time and deliberately avoiding the others, produce photographs which use any three of the methods of conveying perspective described in the text.

Four shots here illustrate the individual methods that can be used to convey perspective. The fifth shows how these various methods can be combined to produce an extremely effective photographic image.

1. Trawlers This carefully composed shot makes good use of the potential of aerial perspective. The immediate impact of the foreground contrasts with the misty image of the trawler coming into shore to create a sense of distance.

2. New York park The striking blue color of the children's swings conveys the perspective here, since it is the only strong color in the picture. The snow is white and the sky light gray.

3. Park tables This shot of a line of tables receding directly into the picture also shows that it is difficult to produce linear perspective without producing diminishing perspective at the same time.

4. Pebble shore This is a good example of the use of diminishing perspective. Though, in reality, the rocks are all of a similar size, in the photograph they clearly get smaller the nearer they are to the shore.

5. Power line Here, all the methods are combined to produce an exciting photographic result.

1

2

3

4

5

reinforced by the associations of blues and violets with distant haze.

Although less definite in effect than color, tone too is important. Dark subjects tend to stand forward, while lighter tones recede.

Perspective and focal length

Different focal lengths give different impressions of perspective (see p.15). Wide-angle lenses strengthen perspective, chiefly because they create a more pronounced convergence of lines and also because they exaggerate the differences in size between the foreground and the background. In contrast, a long-focus lens, because it magnifies only a small part of the scene in front of the camera, shows much less convergence and compresses the scale between near and far objects.

Because the impression of perspective contributes to, or detracts from, the feeling of realism, long-focus lenses, which diminish it, can be used to make an image seem more abstract.

The flattening of perspective in this long-focus shot of cars and shrubbery in California creates an image that is almost abstract. 400mm, 1/125sec, f16.

PROJECT
60

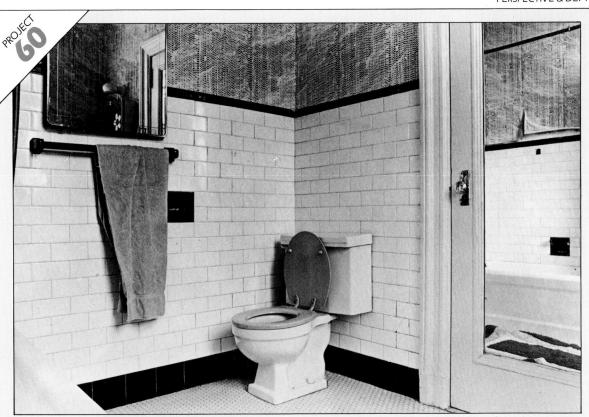

60 · CHANGING THE FOCAL LENGTH TO CHANGE PERSPECTIVE

Fix your camera on a tripod and, from the same position, take two photographs, choosing a subject with converging lines. Use a wide-angle lens for one shot, a long-focus lens for the other, and black and white film. From the developed negatives, make a full-frame print of each shot and then enlarge the central part of the wide-angle shot to the same proportions as the image taken with the long-focus lens. Apart from having more pronounced grain and weaker contrast, the convergence – and therefore the perspective – is the same. In other words, the stronger perspective associated with the wide-angle lens is due purely to its wider field of view.

The converging lines of the tiling on the wall of this bathroom seem to give a strong sense of perspective in photograph **1**, taken with a 28mm wide-angle lens. Photograph **2** is an enlarged detail from **1**, and shows exactly the same image as photograph **3**, shot with a 135mm long-focus lens. The greater impression of perspective in the wide-angle shot is therefore shown to be due not to the angle of convergence of the lines, but simply to its wider field of view.

All photographs at 1/15sec, f5.6.

Color Theory

EVERY PHOTOGRAPHER SHOULD have a basic understanding of color theory, starting with the fundamental principles. One of color's most noticeable qualities is the ease with which it can create strong emotive associations, which are much stronger than the graphical elements dealt with so far in this book. As a result, we tend to react to color in a highly intuitive way, without stopping to think how it actually works in a given image. The exercises that follow are intended to improve the accuracy of your color intuition. The emotive associations of color are explored later in the interpretative section.

The perception of color is not purely physiological. It also involves a number of psychological factors, all of which are not completely understood. It is not surprising, therefore, that there are different theories of color. The version given here is an amalgam of some of the most widely used

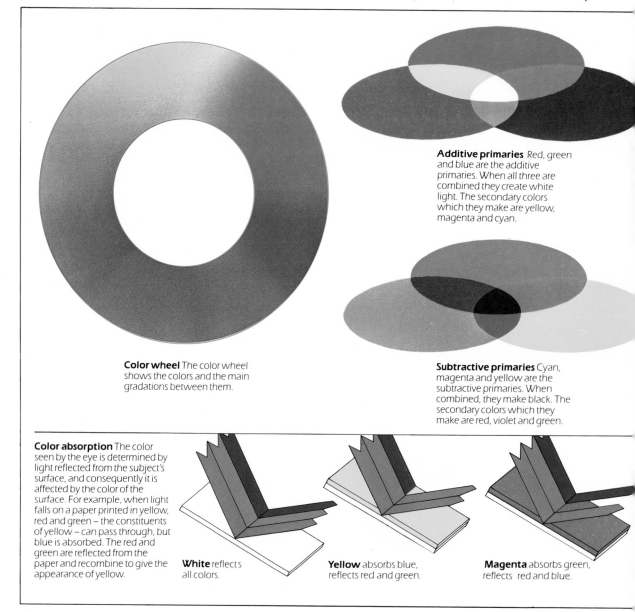

Color wheel The color wheel shows the colors and the main gradations between them.

Additive primaries Red, green and blue are the additive primaries. When all three are combined they create white light. The secondary colors which they make are yellow, magenta and cyan.

Subtractive primaries Cyan, magenta and yellow are the subtractive primaries. When combined, they make black. The secondary colors which they make are red, violet and green.

Color absorption The color seen by the eye is determined by light reflected from the subject's surface, and consequently it is affected by the color of the surface. For example, when light falls on a paper printed in yellow, red and green – the constituents of yellow – can pass through, but blue is absorbed. The red and green are reflected from the paper and recombine to give the appearance of yellow.

White reflects all colors.

Yellow absorbs blue, reflects red and green.

Magenta absorbs green, reflects red and blue.

theories; it is presented in a way that is useful from the point of view of photography. In contrast to the illustrator, who can use pigments to produce his colors, the photographer is usually limited to those of reality.

The attributes of color

A color can be defined in terms of three attributes – hue, chroma and value. The basis of color hue is the spectrum.

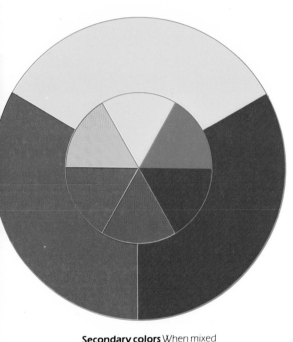

Secondary colors When mixed together, the three primary colors – red, yellow and blue – create the secondary colors of green, violet and orange.

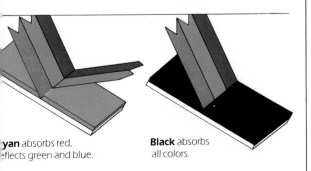

yan absorbs red, eflects green and blue.

Black absorbs all colors.

For convenience, this is normally divided into six individual hues, from violet through to red. These are pure colors, undegraded and fully saturated. Chroma is the term used to describe color intensity; value describes color tone.

The primary colors

The three primary colors are red, yellow and blue. They are equally spaced around the color circle (see facing page) and, from them the other colors of the spectrum are created.

If the three primary colors were mixed thoroughly, a neutral color would result. See this for yourself by taking the three appropriate gelatin filters, making sure they are of equal densities, and laying them on top of each other on a light box. The result is neutral.

Each primary color has its own characteristics. To the human eye, red is extremely radiant and strong. It is also resistant to changes brought about by impurity; an addition of a small amount of blue or green, for instance, will not alter the basic appearance of red significantly. Yellow is luminous, clear and bright. Of all the colors of the spectrum, it is the closest to white. Even the slightest admixture of another color causes it to lose its character, however, and thus it is usually extremely difficult to find a pure yellow. Blue is the darkest and deepest of the three primaries. It is moderately affected by impurities – more so than red, but much less than yellow.

The secondary colors

The three secondary colors – orange, green and violet – are also equally spaced around the circle in the intervals between the primaries. Each is produced by combining a pair of primary colors in equal proportions; orange is a mixture of red and yellow, green a mixture of yellow and blue and violet a mixture of blue and red. They therefore alternate around the color circle with the primary colors.

Secondary color characteristics

Orange is both luminous (a quality derived from its yellow component) and radiant (from its red component). When impure, it tends to appear earthy. Green is a very common photographic color. It possesses a wide variety of shades, between yellow-green and blue-green, the eye being particularly sensitive to the differences. Violet appears as the darkest of all colors, diametrically opposite yellow, the brightest color, on the color circle. The human eye finds it difficult to distinguish the proportions of red and blue in any particular shade of violet.

Although primary and secondary hues are the basis of all other colors, very few photographic subjects contain pure color. Most 'found' colors are either mixed, or contain neutral elements, chiefly grays. The characteristics of such colors are usually less well-defined than those of the primaries and secondaries, but, by definition, the variety of nuance is extremely wide.

1

61 · COLOR LIBRARY: PURE COLORS

The aim of this project is recognizing and finding pure colors. Some, like green, are quite common; others, such as pure yellow, will probably be more difficult to find. Nevertheless, try your hardest to use natural colors, rather than man-made ones. Photograph painted surfaces, for instance, only as a last resort.

Take six photographs, each of a different color, using red, yellow, blue, orange, green and violet. Avoid including other colors in the shots, but retain texture and shadows to give recognizable substance to the image. Achieving purity is the most difficult part of the project, so refer to the blocks of color printed here. Photograph several examples in order to appreciate slight impurities.

So that you can make direct comparisons between the developed transparencies, bracket the exposures for each shot. You can then select equal values later. File the transparencies in order and use them as your own reference when undertaking further color projects.

1 Red rose.
200mm macro, 1/60sec, f16.
2 Water-lily leaves in Thailand.
400mm, 1/250sec, f16.
3 Pub sign in the City of London.
400mm, 1/15sec, f5.6.
4 Violet petals.
200mm macro, 1/30sec, f5.6.
5 Leaves in the fall.
180mm, 1/125sec, f8.
6 Papayas in a Thai street market.
200mm macro, 1/125sec, f8.

2

6

5

3

4

Neutral and Broken Colors

EARLIER, IN THE projects on the Zone System (see pp.44–7), white, black and all the intermediate grays were described in terms of their tonal qualities – lightness, or darkness. In color photography, they have different characteristics and can be treated as colors in their own right.

Black is an extremely difficult color to reproduce photographically. This is because it is limited by the maximum density of the print or transparency; since the contrast range of an emulsion is never as high as that in a real scene, photographic blacks are usually weak. You can check this by taking a transparency containing a large area of black, holding it close to your eye and looking towards a naked lamp. The light will be visible even through the darkest part of the film. This test will also give you an idea of how neutral the black is; very probably, it will be slightly reddish or greenish. Quite apart from the purity of a black as you see it,

few color transparency films are able to reproduce it as completely neutral.

As in black and white photography, pure white is featureless. It therefore tends to appear bleached out and even incorrectly exposed. In practice, an extremely pale shade of gray, which allows a hint of texture and thus an impression of substance is perfectly acceptable, provided that no really pure white, such as a print border, is available for reference. As with the other neutral colors – black and gray – white only exists as a color in relation to something else. Where it appears in a photograph, it fixes one end of the contrast range, so that, by comparison, all other colors and tones appear darker. Its chief characteristic, therefore, is its extreme brightness.

Under normal viewing conditions, however, impurities inside the black are rarely visible. The impression of a color

These two photographs of Canyonlands USA demonstrate the direct comparison that can be made between a color shot and one in black and white. The colors here are subdued and largely broken. They establish the tonal differences in the landscape, which is lost in black and white; in the latter, for instance, the rock on the right loses its prominence without its brown coloring. The subtle blue tints are also lost. On the other hand, the black and white gains in some respects from the non-distraction of color. The graphic shapes, such as the gullies in the center of the picture, stand out more clearly, for instance. Which of the two shots is more aesthetically satisfactory, however, is ultimately a matter of personal preference. The photographer prefers the colored version.

bias, if one exists, is given by the border of the black area, particularly if it shades gradually from another tone, or color. If, for instance, the gray edge of a deep shadow is tinged with blue, then the eye assumes that this impurity carries through into the black, even though it cannot actually be seen. Similarly, black appears deeper when there are very bright areas in the picture.

Gray is the most susceptible of all colors to impurities and is the most sensitive yardstick by which the eye can judge color accuracy. The slightest addition of another color will destroy its neutrality (although this is most apparent with a mid-gray, the effect is noticeable over an extremely wide range of tones).

Because of its sensitivity, gray easily picks up impurities, such as reflections from the sky or nearby objects, and any slight inaccuracy in the film itself. Also, when associated

How broken colors are produced In photography, as in nature, broken colors occur when secondary colors are mixed, as shown in the adapted color circle (**above**). Here, the secondaries shown in the central circle combine together to produce these characteristic earth colors. Such colors are a primary element in much photography and only a few of the possibilities are shown here. The relationship between each shade is subtle, since they often resemble each other closely.

with a strong color, gray tends to acquire a complementary cast. A single gray over the whole image appears unbalanced, if it is not completely neutral; a mixture of colored grays in one photograph is usually more acceptable.

Broken colors

In the natural environment, most colors are impure, showing little trace of their primary origins. In most landscapes, browns and dull greens predominate – colors which are at least two stages of mixing away from the three primaries, red, yellow and blue. The color circle can be adapted to show what happens when secondaries are mixed; they do not recreate the primaries lying between them, but produce the earth colors instead. These are ocher, reddish-brown and olive green. Further mixing with other colors produces an even greater range of broken colors. Because these are so common in nature, they are the principal components of most photography.

Since broken colors are so mixed, they have less definite characteristics than those of the color circle. They lack purity and brightness, often resembling each other closely. In combination with a pure color, they appear even more subdued.

62 · COLOR LIBRARY: NEUTRALS

This is an extension of the color library project, described on the preceding pages. Photograph white, black and a small selection of grays in separate shots. With white and black, it will be impossible, as with the previous colors, to exclude other elements from the image. You will need to include some pale gray to act as reference for the white and some transitional tones for the black. The normal problem of achieving a perfect color balance with color film (see pp.34–5) will probably make this project slightly more difficult; the purity of the white, in particular, will be affected by any tinge of color in the surrounding grays.

Take several shots of grays and compare the developed transparencies to see what a surprising variation there can be in both impurity and tone.

1 This shot of a temple in Sri Lanka shows the darker areas tinged with blue reflected from the sky.
400mm, 1/500sec, f16.
2 These clouds vary between white and gray, and cover most of the shades in between, though again with a bluish cast.
180mm, 1/250sec, f22.
3 The darker grays in these carved elephants' heads show traces of red and blue. Innumerable shades of gray exist, but it is extremely difficult to find one that is completely neutral, lacking traces of any other color.
400mm, 1/250sec, f22.
4 This line of black taxicabs, taken on a sunny day in London, also reflects the blue sky in the gleaming metal.
180mm, 1/125sec, f16.
5 The only certain way to judge the density and purity of your blacks, whites and grays is to compare them with a photographic gray scale. The photograph of one shown here, however, is not a safe guide, as the color film has tinged the middle-gray with red.

5

63 · COLOR LIBRARY: BROKEN COLORS

Photograph a selection of single broken colors for the files of your color library. This is a straightforward exercise, as all are common. Order the transparencies according to whether they are predominantly ocher, reddish-brown or olive green.

1 This Philippines landscape is predominantly olive-green. Notice how the brighter green of the rice terraces and the red trees at center right stand out against the drabness of the forest.
180mm, 1/250sec, f16.
2 This detail of a house in Sri Lanka shows the reddish-brown color of weather-beaten wood.
180mm, 1/125sec, f8.
3 The ocher color of sand and earth is predominant in this photograph of cliff-dwellings in Arizona.
180mm, 1/125sec, f11.

Color Harmony

VERY FEW PHOTOGRAPHS use a single color; it is normally the relationship between different hues that gives color photography its real interest. The combination of colors in an image can affect its balance, dynamic tension and all the other qualities that are influenced by points, lines and shapes. Even more than these graphic elements, color also appeals strongly to human emotion; this is a valuable effect that is explored later in the interpretative section of this book (pp.186–217).

The simplest type of color relationship is one of opposites. Any two colors that lie opposite each other on the color circle will normally give an impression of harmony and balance when they are used together. Because of the way the circle is arranged, this means using a primary color with a secondary – yellow and violet, red and green, blue and orange. Each pair is said to be complementary.

The principle behind this is that a complementary pair of colors, if they were mixed thoroughly as on a painter's palette, would produce gray. With the set of gelatin filters that you used for the projects on p.33, you can see the effect for yourself on a light box. Take a red and a green filter of equal strengths and lay one over the other. The effect is neutral because the two colors are diametrically opposed. Gray is thus the pivot of the color circle – the point of equilibrium for color in the same way that the center of the picture frame is the graphic pivot.

Many of the principles of composition can therefore be translated into ways of using color. Just as the center of the frame is not a particularly interesting position for the focus of attention, so a perfect balance of two complimentary colors can be a little dull, although harmonious. Color theory has a scientific basis, but this does not mean that it lays down any aesthetic rules. There is absolutely no compulsion to combine colors in a harmonious way, or in any prescribed relationship for that matter. The theory of color simply explains how the relationships work.

Quantitative relationships

It needs rather more control to achieve color harmony than just choosing the colors. As the color library project on p.126 showed, different colors leave stronger or weaker

This chart is a version of the color wheel, modified to give the proportions of complementary colors which should be combined to maintain the balance of color harmony. Two-color harmony is produced by mixing a primary with a secondary (any two colors opposite each other on the color wheel, e.g. yellow and violet).

But violet is much less bright than yellow, and so balances it only in a ratio of three to one. One part orange balances two parts blue, and red and green balance equally. These proportions only work with pure colors of the same value.

impressions on the human eye. In color photography, the make of film you use has an additional effect; many, for instance, record red very strongly, while yellow is often weaker than in real life. Normally, yellow is the brightest of all colors in appearance, followed by orange, red, green, blue and finally violet.

Because the impression of brightness is partly subjective, it is not possible to assign precise values to each color, but the illustration above gives a working scale. The colors are shown with normal values; if they are individually lighter or darker than this, the impression naturally changes. In photography, it is usually difficult to alter the value of a

There is an obvious color imbalance here, the orange far outweighing the blue in the image.

Here the balance is corrected, with twice as much blue as orange.

Red and green balance each other in equal parts.

Three parts of the dullest color, violet, balances one part of the brightest, yellow.

The diagrams here show varying ways in which three-color harmony can be achieved, both in terms of what actual colors can be used and in the proportions in which each color has to relate to the other. The test is that the colors would produce gray, if mixed; to achieve this, they have to be in the right proportions.

64 · THREE-COLOR HARMONY
Produce at least two photographs, showing three-color harmony. Use both equally-spaced colors and unequal combinations.

1 This well-composed shot combines action and interest with its main intention of demonstrating three-color harmony. Especially ingenious is the capturing of the blue reflection in the telephone box. According to the rules of color harmony, there should be more blue and slightly more red. This, however, is a good example of a successful photograph that breaks the rules.
2 This pleasing combination of green, violet and orange, found as decoration on a London pub, is an idealization of the colors of nature.
400mm, 1/15sec, f5.6
3 This shot of a temple in Burma emphasizes the main point of interest by allowing it a large proportion of the picture area. The fact that the spire is gold, not pure yellow, makes this acceptable in terms of color harmony.
24mm, 1/500sec, f19.
4 Detail from inside the Burmese temple.
180mm, 1/125sec, f16.

1

2

color, except when the light falling on different parts of the scene can be adjusted. Normally, the only way of altering these quantitative relationships is by altering the composition, so that the colors occupy different areas of the image. For example, in the first of the diagrams on p.133, the orange outweighs the blue and the image is not harmoniously balanced. By recomposing, as in the second diagram, the balance is restored.

Following the proportions given in the working scale, the finest balance for complementary pairs is 1:1 for red and green, 1:2 for orange and red and 1:3 for yellow and violet. This works for pure colors of the same value. However, because few photographic subjects contain pure colors, these proportions will obviously differ, depending on the nature of the photograph. Measurement is hardly ever possible, so, in common with the composition of graphic elements, balancing colors must usually be done intuitively.

Three-color harmony
The principles of color combination apply just as easily to more than two colors. Harmony is achieved by using colors that would produce gray if mixed. For instance, three equally spaced colors in the right proportions balance each other – the three primaries, red, yellow and blue, or the three secondaries, orange, green, and violet. The spacing of the colors does not even need to be regular, provided that the proportions in which they are used take account of this. Orange and red, for instance, could be set against the intermediate color blue-green.

4

65 · TWO-COLOR HARMONY

Find and photograph subjects containing the basic two-color harmonies – red/green, orange/blue and yellow/violet. Use any compositional technique to bring each pair into the proportions shown opposite. As far as possible, use pure colors.

1

2

3

5

4

1 Orange on plate. This has
been cropped to give the colors
their correct proportions.
50mm, 1/125sec, f11.
2 Wild orchids in Thailand.
Close-up is another technique
for achieving color harmony.
200mm macro, 1/125 sec, f16.
3 Wine bar sign in London.
180mm, 1/125sec, f4.
4 Pedestrian crossing beacon,
London.
24mm, 1/1000sec, f22.
5 A violet flower.
200mm macro, 1/30sec, f5.6.

Color Discord
66 · **After-image**
67 · **Color discord**

Examples of adjacent colors
(**above**).

Examples of alternating colors
(**above**).

A DISCORDANT RELATIONSHIP is one in which the colors clash and appear to fight one another. As with color harmony, the reasons for this are a mixture of the psychological and physiological and are therefore not easy to state precisely. Nonetheless, they are real; any colors combined discordantly leave an impression of awkwardness and imbalance.

This has its graphic equivalent in the eccentric placement of the center of interest and in any strongly asymmetrical use of point, line or shape. Sometimes, unusual optical effects, such as vibration and after image, are produced; whereas, if they are included unintentionally they may spoil a photograph, they can be used for deliberate effect.

Types of discord
Two of the commonest ways in which colors clash are through adjacent discord, when two colors next to each other on the color circle are present, and alternating discord, which occurs with two primaries or two secondaries. Discordancy, however, is not inevitable with these combinations.

The secret of making colors clash is to reverse slightly the normal, expected tones. This technique – brightening the weaker color and subduing the stronger – is relatively straightforward in art, but, in photography, must depend on found situations. Because it is the tone that controls discordancy more than the choice of colors, it is possible, in fact, to make any two colors clash, even complementaries.

When two colors clash strongly – this can be used as a measure of how discordant the relationship is – they produce an optical effect known as vibration. The blue and red image on the left shows this clearly; the edge between the two colors appears to oscillate up and down.

After image
Another optical effect that can sometimes influence the way we see a color photograph is the phenomenon of after image. The easiest way to understand this is to experi-

Color vibration When two pure colors clash strongly they produce color vibration. The edge between the blue and red on the left, for example, appears to vibrate up and down. The stronger the color clash and the greater the expanse of colors, the more pronounced is this effect.

After image Stare at the black spot in the center of the colored circle on the right for at least 30 seconds. Then focus quickly on the black spot in the center of the gray circle. Momentarily, the gray circle will appear orange, with a ring of violet.

66 · AFTER IMAGE
Photograph a scene in which a small neutral gray area is surrounded by a simple, strong color. A stone wall cutting across a bright green field is a good example. Look for the complementary after image in the developed transparency.

This aerial shot of a glider in flight over a forest is a good illustration of the principles this project is designed to illustrate. The gray-white color of the glider contrast with the dominant green through careful control of the photograph.

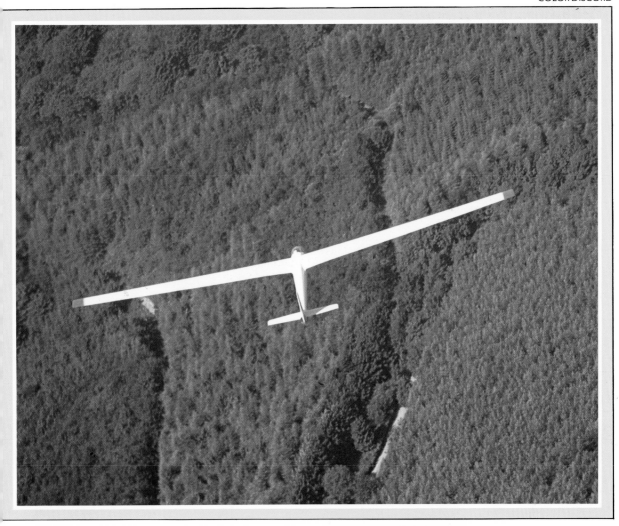

ence it; look at the colored circle on the facing page, fixing your eyes on the central black spot to stop them wandering. Stare at it for 30 seconds and then immediately focus on the black spot in the center of the gray circle. What you should see, fleetingly, is a circle with complementary colors – green in the center, surrounded by a ring of violet.

Our vision tends to react to colors by producing a complementary hue, which, under the right circumstances, becomes visible when the eye moves. When you examine a photograph, particularly a large print, the eye scans rapidly, moving between centers of interest. If the photograph contains a small area of strong, pure color, a complementary after image tends to persist as the eye looks elsewhere, modifying the impression of the other colors.

While this is only of passing importance in most scenes, it has a noticeable effect on neutral colors. Look at the red and green images below. The shape in the center of each is an identical gray, yet the surrounding color produces the impression of a slightly complementary cast. The gray shape in the red setting appears to be tinged with green, while the one in the green setting seems a little reddish. Because red and green are opposite each other on the color circle, the effect is here more noticeable by comparison.

Complementary cast In the red image on the left, the gray shape will appear green, while in the green image it will appear red.

67 · COLOUR DISCORD

Find the strongest examples you can of adjacent discord and alternating discord. Look for subjects that particularly possess a clean, simple line separating the two colors to achieve the maximum vibration.

These shots offer three distinctly different solutions to the problem of color discord. Each of them, though, has one thing in common; the photographer has concentrated on detail, getting close to the subject to reduce the risk of other colors weakening the desired effect. The blue and red of the leg and wall (**above**) is an unposed, adventurous choice, which works as a composition in its own right. The sharp edges of the signs (**top left**) accentuate the color discord.

Color as Graphic Element

A red or green filter will make the yellow square almost invisible.

An orange filter over the green line produces the same effect as above.

IN THE PROJECTS on pp.96–111, the graphic elements of point, line and shape were created mainly by differences in tone – dark against light. With color, similar effects can be created just by using differences in hue, although the results are complicated slightly by the emotive associations of color and the effects of harmony or discord.

A point, for instance, can be formed from two colors with identical values, something which would be invisible in a black and white photograph. In the first image here, the yellow-orange spot and the blue-violet background have the same tone; a monochrome version would be feature-less. You can see this for yourself by viewing the shot through a filter that affects both colors equally. Refer to the color circle and you will see that either a red, or a green, filter will achieve this. From the set of filters that you used for the project on p.33, use either the 58 (green) or the 25 (red). Given that there will be some printing differences between individual copies of this book, the yellow-orange point should be almost invisible. For the same effect, look at the green line through an orange filter and the yellow star through a blue filter. Color blindness tests use the same principle.

A blue filter over the yellow star will leave the background dominant.

68 · COLOR VERSUS BLACK AND WHITE

For this project, choose a subject that relies entirely on color differences.

Take identical photographs in color and black and white. The aim is to produce a result that is effective in color, but irrelevant in monochrome. The project is slightly complicated since you must take into account the way in which black and white film reacts to color and allow for this. For instance, even though a red flower may have the same tonal value as the green meadow in which it is growing, regular black and white film will over react to the red, so producing a false result. Correct by using the appropriate filter.

These two shots show clearly how much this image depends on color. In the black and white shot, the blue sky and clouds – both essential elements – are bleached to pure white. Ektachrome, 1/125sec, f11.

1

69 · COMPOSING WITH COLOR ALONE

Select three examples from the range of compositional projects on pp. 96–123. Repeat them, choosing situations where the tonal differences are small and where you have to rely on color to construct the image. One of the examples should use an implied line or shape.

These four shots show how careful consideration of the possibilities of color can produce an effectively constructed image.

1. Rice fields, N. Thailand
The dark blue of this Thai peasant-woman's jacket combines with the dominant green background and foreground to striking effect. The sun highlights her hat to make it the prominent feature.

3

2

2. Goods at the dockside, Piraeus, Greece
The symmetrical base pattern created by the piled-up arrangement of the blue drums is given added asymmetrical interest by their red caps.
3. Lakeside scene, Tanzania These wading birds create an implied line within a complete block of solid color. The composition is made up entirely of blue, with the exception of the birds. This shades down to the darker tones of the hills in the background, thus creating the sense of perspective in the shot.
4. Fire hydrant The colors of red, yellow and green are used to good effect in this interesting shot.

Landscape Photography

70 · Distant view
71 · Panoramic view
72 · Time of day

LANDSCAPES ARE AMONG the most popular photographic subjects, yet rarely receive the thought and attention that is necessary to produce striking, effective images. The essence of landscape photography is the translation of all the different sensory impressions that give the scene its immediate appeal into purely visual terms – to distill several elements into one.

A landscape can be appreciated in a number of ways. Our eyes scan the scene to gradually build up a picture, taking in the horizon, the close foreground, small distant details and the complete panorama. At the same time, the movement of light and clouds, the sounds and the smells all contribute to the overall impression. The task of a photograph is to produce a visual equivalent of these sensations. This, in turn, involves analyzing the qualities of the landscape, selecting the most important ones and then finding photographic ways of interpreting them. In this way, a landscape photograph becomes your personal view, thus assuming a character that snapshots inevitably lack.

Panoramic views

Although it is dangerous to classify treatments too rigidly, there are two distinct, useful and quite common approaches to landscape photography, each using a different angle of view. Because it often comes closest to the way people experience landscapes, the panoramic view is one of the most popular. This approach tries to convey the broad sweep of a scene with great depth and detail through the use of a wide-angle lens.

In most panoramic views, the relationship between foreground and background is an essential element. By establishing a graphic relationship between an object close to the camera and the horizon, a sense of scale is created and the eye is encouraged to see the image in depth. To achieve this, you must not only choose the camera viewpoint with care – normally quite close to the ground – but also achieve great depth of field, so that both foreground and background are sharp. Fortunately, wide-angle lenses have good depth of field; a small aperture and therefore slow shutter speed are often necessary, however.

To establish this foreground/background relationship, composition becomes extremely important, the more so because wide-angle lenses tend to include large areas of sky, due to their field of view. Some alternatives are shown here, but these are intended to show only useful possibilities; they are not meant to be copied. In each case, the foreground and background are connected graphically; see if you can analyze the connection by referring back to the image projects on p. 118.

The foreground/background relationship is not used in one circumstance, however. This is when the sky is the dominant element in the composition. Although such a treatment is possible with different focal lengths, it is particularly useful with a wide-angle lens, where there is

Setting the scene The diagrams above show the typical relationships which can exist in landscapes between foreground and background and they also show how closely related perspective is to the viewer's perception of the scene.

70 · DISTANT VIEW
The aim of this project is to find a scene that enables you to make the best use of compressed planes. Mountains are among the easiest of subjects to demonstrate this approach; flat scenery, however, can be a problem. As a general rule, an elevated viewpoint will give you the best opportunity to produce an effective result.

Because the compressed plane effect is strongest at local focal lengths, a powerful telephoto lens is best for the exercise. This can be rented. There should be at least two, and preferably more, distinct planes in the shot. Careful choice of lighting and weather conditions will help; hazy conditions and backlighting, for instance, reduce local detail and separate planes.

Pay close attention to the depth of field. This is limited with a long-focus lens. It may be necessary to use a tripod; if there is even a slight breeze, this will have to be stable and sheltered. If you are using an SLR camera, lock up the instant return mirror to avoid camera shake.

These shots, all using a 400mm lens, demonstrate the characteristic qualities of compressed planes. In the river scene (**above**), due largely to the strong sunlight, the colors are subtle, faint and almost washed out. The hazy effect is characteristic of compressed plane shots taken in such conditions, because the picture area is bigger than normal. The shot of the houses (**above left**) shows the flattening process on a lesser scale. Note how the perspective appears altered, so that the houses are all the same size. The trees in the shot of the cove (**bottom left**) are the most compressed element in the composition. This is the only shot of the tree to use an elevated viewpoint.

71 · PANORAMIC VIEW

For this project, choose a well-known local view, but do not limit yourself by standing and photographing in exactly the same spot as every other visitor. Look for existing postcard views – these will make an interesting comparison with your own results. Decide why and how the professional photographer produced the image that he did; what is your opinion of it?

First, you must decide what it is about the view that makes it attractive – in other words, what are its best qualities? This decision will determine the rest of the project. With a wide-angle lens fitted to the camera, look for a camera position that enables you to include both the far background and a close foreground in the image. Look for flowers, rocks or tree roots, for instance, or anything specific close to the camera. Place the camera on a tripod and make the final adjustments to its position so that, at the smallest aperture setting, both the background and foreground will be within the depth of field. Use a fine-grain film – this can be either black and white or color. If you are in any doubt about what is the best composition and viewpoint, take more than one shot.

These three shots were two photographers' answers to the project.
1. Welsh landscape Here, the photographer was trying to capture the massive qualities of a characteristic mid-Wales landscape, with its mountains and lakes, in an unconventional way. He achieved this by looking down on his subject and by including the detail of the disused slate quarry in the shot.

2. Trawlers To keep the detail of the hull of the trawler in the foreground, the photographer took a meter reading of the pebble beach. He also used a graduated filter to capture the effect of the sky. There is some unavoidable sun flare, but this does not mar the effect of the composition.

3. Estuary The conventional shot here would be an aerial view to capture the meandering nature of the river as it approaches the sea. The virtue of this shot, taken from very close to the ground, is its obvious simplicity.

72 · TIME OF DAY

You can carry out this project separately, or incorporate it into one of the two other projects here. The aim is to see for yourself the importance of choosing the right lighting conditions. Despite the natural desire to shoot immediately, there are many instances where it is better to wait for a different angle of the sun, or changes in the weather.

Choose any view and compose the image carefully. Then take the same shot at different times of day, including one when the sun is just below the horizon. Because the changing angle of light will probably affect the composition, you may have to alter the camera viewpoint slightly for different shots.

Two different approaches to shooting at various times of day, the first from a static camera position and the second moving the position to suit the prevailing lighting conditions. The first solution works well for this landscape, but it would not have been as satisfactory for the second sequence of shots.

1. Sunrise A silhouette, with little detail.

2. Early morning The mist combines with the very subdued colors to create considerable atmosphere.

3. Early afternoon The colors are flattened by the sun.

4. Late afternoon The colors are richer by comparison, while the long shadows are attractive.

5, 6 Early morning The position of the sun here means that the close-up is more satisfactory.

7, 8 Late afternoon For both these silhouettes, the camera position was dictated by the angle of the sunlight through the window, the dominant feature fo the shot.

little foreground interest. Again referring back to the image projects, what are the graphic principles involved?

Distant views

A long-focus lens conveys quite a different impression of a landscape. One of its advantages is its ability to magnify and select detail, in the same way that the human eye looks intently at individual elements in a landscape. Whereas the panoramic view is involving – it draws the viewer in to be a part of the scene – the distant view that a long-focus lens produces is objective. It carries a feeling of detachment.

The diagram (**left**) demonstrates one way in which the sky can be used to establish the relationship between foreground and background. This is particularly important in wide-angle landscape shots, where large areas of sky are normally part of the composition. The diagrams (**right**) show different ways of compressing planes.

Because the angle of view is small, there is more opportunity to select different images from a single viewpoint than there is with a wide-angle lens, so there is more choice of composition. Two important qualities in this kind of landscape image are the compressed planes and altered proportions. The perspective in long-focus images appears to be squeezed, while various elements of the landscape tend to arrange themselves into distinct planes, stacked one behind the other. In addition, the proportions of objects at different distances are more accurately rendered. The sun, moon, or a range of mountains on the horizon, for instance, will appear more imposing.

Nature Photography

NATURE PHOTOGRAPHY INCLUDES a wide range of subjects, from wildlife to flowers, plants, insects and even microscopic life. At times, it can be highly specialized; the purpose of including it here, however, is not to teach esoteric techniques, but to present a broad area of photography, within which everyone can find some personal area of interest.

So far, we have dealt with subjects in a general way, concentrating almost entirely on the image and its various elements. Now, however, the idea of dealing with specific subjects means that you can begin to apply the basic photographic techniques to them. Nature photography is a particularly useful field at this stage, because it demands some knowledge of the subjects you are setting out to photograph. In fact, from now on, the emphasis of the book shifts towards the content of the photographs.

You are not expected to become a wildlife expert or botanist overnight. However, within this broad field, you should be able to find at least one area of interest. For many non-specialists, the easiest subjects are flowers, plants and such accessible creatures as spiders on webs. Whatever aspect you choose, the important thing is that you learn a little about the subject beforehand.

Below is a summery of the more important areas of nature photography and the equipment necessary to photograph them.

Wildlife – stalking
Stalking elusive, shy animals and birds demands a combination of fieldcraft and familiarity with the camera controls. The former means that you should have some know-ledge of the animal's habits, patterns of behaviour and senses. Most birds, for instance, have good eyesight, whereas most mammals rely more on their sense of smell. The ability to move inconspicuously, by walking quietly and taking advantage of cover and shade, is also important. Because photographic opportunities tend to occur quickly, it is vital to be well-prepared, with as many of the camera controls as possible pre-set. This means, for instance, anticipating the distance and light levels of a shot.

Wildlife – hides
The alternative to stalking is to shoot from one concealed position. This is a more painstaking and time-consuming process, but with many creatures – birds, in particular – it is the only effective method. Hides vary in type from elaborate permanent shelters, of the kind found in nature reserves, to simple, makeshift screens of branches and leaves.

Using a hide successfully needs some practice. It is often necessary to enter with someone else and then have them exit conspicuously to fool the subject into believing that the hide is unoccupied. Inside, it is essential to keep quiet and motionless for as long a period as necessary. Hides should be positioned in front of regular visiting places, but moved and entered only when the animals or birds are absent.

Flowers and plants
Here, equipment and techniques depend largely on the scale of the shot. There are three basic types of flower shot – close-up, the complete flower, or the bloom in its setting.

The diagrams (**right**) illustrate the three basic ways of composing a flower shot. The first is close-up, the second is to put the bloom in its immediate setting and the third is to shoot the whole flower in its context. The same principles can be used in other areas of nature photography as well. The shot of the spider (**right**) is an extremely effective photograph, putting the insect clearly in the context of its setting. The depth of field is deliberately minimal, so that the background would be blurred. 200mm macro, 1/125sec, f5.6.

It would have been impossible to photograph the painted stork (**top**) without the aid of a hide. The typical portable hide (**below**) consists of canvas, supported on a tubular aluminum frame. This is light, which makes the hide easily transportable. The hide shown here is slightly bigger than normal to allow enough room for equipment to be stored. When positioning it, remember that the first priority is to get the best possible view of your subject you can without disturbing it. Nesting, feeding, drinking, or bathing places are good choices. Avoid open spaces and upwind locations and always check the hide does not appear in silhouette. 400mm, 1/250sec, f8.

Close-up photography is dealt with in detail on pp.180-185. A photograph of a single flower filling the frame still makes use of some close-up techniques; a macro or close-focusing lens is best. As the setting for most wild flowers will be cluttered with other vegetation, you will need to take some care to isolate the flower from its surroundings. One method is to clear away other leaves and blades of grass; another is to choose a low camera position that sets the flower against a plainer, more suitable background. By adjusting the aperture setting so that the depth of field covers only the subject, the background can be thrown out of focus; this is particularly effective with a long-focus lens.

To prevent the movement that even a slight breeze can create, it may be necessary to support the stem of the flower gently with a coiled length of thick wire embedded in the ground. Alternatively, a piece of card can be propped up as a windbreak.

Insects and other small creatures

These subjects fall within the realm of photomacrography and close-up photography; the specialized techniques required are dealt with on pp.180-185. Depth of field is one of the greatest problems; a small aperture is the obvious solution, but this calls for strong illumination. Here, portable flash is often useful. Nevertheless, by careful focusing and through good use of available light, many insect photographs can be created without resorting to artificial lighting. Try, for instance, using the sun to backlight a spider's web.

73 · NATURE ESSAY

To cater for different interests, this project is open-ended, with considerable room for choice. Concentrate on the subjects that interest you, but, wherever possible, try to acquire some knowledge of natural history and apply it to your photography. If flowers particularly interest you, for instance, you will need to identify the specimens you photograph. In the course of this, you will also find out when and where they will be in bloom.

Choose a fairly small and well-defined natural area. This could be a copse, a field, a city park, a stream or a small island. Simply decide on its boundaries in advance. Then, over as long a period as you like, photograph all of its aspects that are of interest to you. Ideally, you should cover the whole range of its natural history, from plant life to birds and insects, ranging in scale from the entire ecosystem down to close-up detail. However, such a task may prove too ambitious for all but the most enthusiastic nature lovers; a limited essay is all that is needed.

Nevertheless, because the final product of this project is an essay, you should plan to assemble a range of varied images. This means not only varying the scale (an overall view of your selected habitat as well as details) and content (animals and plants) of what you shoot, but also the graphic elements — lighting, composition, color and so on. Refer back to earlier projects, particularly those dealing with the use of natural light and the elements of the image. You should aim to produce about a dozen selected photographs at the end of the project; these can be in color, black and white, or both.

This is a long-term project, so you should not be disappointed if one visit does not produce a single photograph that satisfies

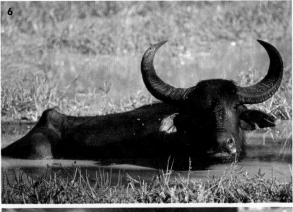

you. Conversely, if you make one successful visit, do not be overconfident. Keep returning to see if you can improve on what you have already shot.

After each visit, review the photographs you have taken so far and edit them loosely. This means eliminating the rejects (out of focus, wrongly exposed or otherwise technically inferior shots) and separating the remainder into your preferred shots (the 'selects') and those that might possibly be useful (the 'seconds'). Leave the final editing until you decide to close the project; your preferences may change and you may find that a shot which you might not have chosen to stand on its own is ideal in juxtaposition with others. When you make the final selection, try to think constantly of the photographs as an assembled group, reinforcing each other.

Presentation is an important element of this project. Caption each photograph to give the maximum information about the content of the shot. If the captions give a coherent theme to the essay, so much the better; the theme could be as general as the effect of changing seasons, or as specific as the influence of a particular kind of tree on the environment.

This photographer was able to choose an exotic setting for her nature essay — the Wimpattu National Park, Sri Lanka.
1 Doomed forest rising out of a lake.
24mm, 1/125sec, f11.
2 Birds at sunset.
400mm, 1/500sec, f8.
3 This close-up shot of an orchid was taken with a macro-photographic lens.
200mm macro, 1/60sec, f8.
4 Cormorants perching on branches.
400mm, 1/60sec, f4.5.
5 Waterlilies.
400mm, 1/500sec, f11.
6 A water-buffalo.
400mm, 1/250sec, f8.

Photographing Architecture

TRADITIONALLY, MOST ARCHITECTURAL photography is representational. In other words, it presents a more or less faithful, accurate image of a building. The reason for this is clear; buildings are designed with a particular function in mind and to be seen from certain obvious viewpoints.

With a well-designed building, the problems of proportion, balance, texture and so on have already been worked out by the architect. This normally places some responsibility on the photographer to convey these qualities. However, from another point of view, a building can simply be raw material for fashioning whatever image you have in mind; while two of the three projects here deal with the more traditional and technical aspects of architectural photography, do not ignore the more basic graphic possibilities.

The representational approach

To take an effective, straightforward photograph of a building, follow this procedure. Firstly, establish the function of the building, or its facade, and work out the best way of showing this. Is it best seen in isolation, or in its setting in juxtaposition with other buildings? In cluttered surroundings, of course, there may be little choice.

Walk around the building, at different distances from it, and make a mental note of all the possible viewpoints, along with the focal lengths of lens that each would need. Consider whether the architect intended that the building should be seen from one particular viewpoint and, in the case of an old building, whether subsequent construction around the site has interfered with this.

Establish what would be the ideal lighting conditions for each viewpoint. Consider both the time of day and the weather conditions (see p.64). Are these conditions predictable? Is the building lit at night and how does artificial lighting affect it?

Corrective lens

Normal lens

Shift lenses

View cameras and so-called perspective-correction lenses (P-C lenses) both use the principle of lateral shift to correct converging verticals. In both cases, the principle is one of using a lens that gives much wider coverage than the film format needs. By shifting the lens up or down, therefore, different parts of a large image can be recorded at the film plane. To keep the vertical lines of a building vertical in the image, the plane itself must be vertical; in other words, the camera must not be tilted upwards. So, aiming the camera horizontally may exclude the top of a tall building from the picture area, but, by shifting the lens upwards, the upper part of the inverted image is brought into view.

Wide-angle lenses This 24mm lens (**right**) has an angle of view of 84°. It is so designed that its extremely short focus can be lengthened to allow it to be used with the reflex mirror in the camera housing. The elements 'float' inside the housing and their relative positions can be altered to overcome the problem of reduced image quality at close focus.

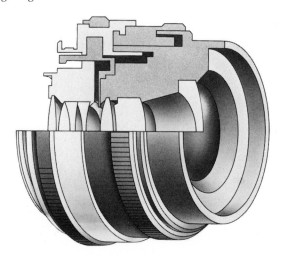

74 · LEARNING FROM COMPARISON

For this project, choose a well-known – and therefore frequently photographed – building. Use the standard procedure for planning the shot, taking particular care over viewpoint and lighting. If you see more than one possibility', take more than one shot.

Having created the best image that you can, print up the results. Look for as many published photographs of the same building as you can find in guidebooks, historical or architectural books, magazines and on postcards. Analyze each published photograph. Did you overlook any opportunities? Did the photographers who took the other shots miss or overlook anything themselves?

Four photographs show how four photographers approached this project. Each of them has found something individual to say photographically about their much-photographed subjects.

1, 2. St Paul's Cathedral, London The first shot of St Paul's is slightly conventional, but the photographer has managed to eliminate the anachronistic modern buildings surrounding the church from his composition. The second shot is highly artistic and moody.

3. Pompidou Center, Paris Rather than photograph the exterior of the center, this photographer's decision to shoot an interior tunnel serves just as well to emphasize the modernistic nature of the building and has the added merit of being less clichéd.

4. Best Supermarket, Sacramento, USA The architectural point of the building is its highly unusual sliding entrance, which limits any photographic approach. Here, however, the photographer has used the sky to vary his composition.

1

2

3

4

75 · CREATING AN ABSTRACT IMAGE

For this project, any building can be used as subject, though a strong, modern piece of architecture will give you the greatest opportunity, and deliberately produce an image that is not representational. Aim for a strong graphic image, using techniques from the image projects on pp. 90 – 123 You may find that the distortion produced by a wide-angle lens helps to give strong diagonals, or that a long-focus lens enables you to select an abstract detail. Make a note of the principles of image construction you have used and include an overall shot of the building for reference.

1

3

2

4

Two of the photographers here used the same device – photographing reflections in glass – to produce their results. These work extremely well in color. The black and white shots, too, capture the theme of the project to good effect.

1. New York This is the first shot in which the reflective technique was used. The photographer worked at a slight distance from the subject and deliberately sought the resulting distortions in the reflections.

2. New York Here, in contrast, the photographer has gone close in to capture as much detail as possible. The composition is carefully planned; note the effectiveness of the lights, as well as the contrast between old and new.

3, 4. Multi-storey car park, Bristol Concentrating on parts of the building has created the abstract effect. The grainy quality was created deliberately by pushing the contrast in the printing.

157

76 · DEALING WITH CONVERGING VERTICALS

When photographing buildings, a recurrent technical problem is caused by the fact that most buildings are seen from ground level, which means having to look upwards. As a result, vertical walls appear to converge; while our bi-focal vision makes this acceptable in real life, it normally looks wrong in a two-dimensional image and must be corrected, unless it is used as deliberate effect.

Try to complete this project using one building, so that you can directly compare the results. However, as the requirements are specific – the need for an elevated position opposite, for instance – you may need to use more than one. Choose a building of fairly simple design and with vertical walls. It should be reasonably isolated and have some open space in front of it; for the shot using a long-focus lens, you will need a clear view from at least 100 metres (92 yards). Use black and white film and print to the same size.

1. Photograph the building from ground level with a standard lens (about 50mm on a 35mm camera), so that it almost fills the frame. To do this, you will have to tilt the camera upwards, so causing the distortion that creates converging verticals.

1

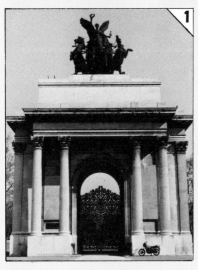

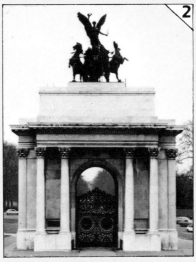

1 50mm, ¼sec, f11.
2 80-200mm, 1/15sec, f22.
3 One problem the photographer had was in lining up the camera horizontally, due to sloping ground. Her solution was to use a spirit-level. 24mm, 1/30 sec, f22
4 This nearby statue in the foreground makes for an interesting composition. 24mm, 1/30sec, f22.
5 80-200mm, 1/15sec, f22.
6 This was shot at dusk, exploiting the added atmosphere from the building's floodlights. 24mm, ½sec, f11.

2. Fit a long-focus lens – the longer the better – and move the camera back until the building occupies the same space in the picture frame as before. Because the lens needs only to be tilted very slightly upwards, there will be much less distortion; it may not even be noticeable if a 400mm or 500mm lens is used with a 35mm camera.

3. Use a wide-angle lens – the wider the better. Concentrate solely on aiming the camera horizontally; the most accurate way to achieve this is to note a point on the wall of a building, such as a window ledge, that is the same height as the camera and center this in the

viewfinder. Do not worry about the wasted space in the foreground, as this will be cropped during printing. Move the camera as close to the building as you can without losing the top of the building from the picture frame. When you come to print the negative, crop the frame so that the building occupies the same area as in the other shots – in other words, ignore the

foreground. By using the edge of the image formed by the lens, rather than the center, the film plane remains vertical and so the vertical walls do not appear distorted. This is the same principle on which a perspective control lens works.

4. Use the same wide-angle lens, keeping it aimed horizontally but selecting a viewpoint that allows you to create an effective composition. In practice, this means finding an interesting foreground subject, such as a fountain or flower bed.

5. Elevating the camera position until it is at the height of the building's mid-point is another answer. For this, there usually needs to be a building opposite, with a convenient balcony or window and not so close that the image will not fit the frame with a wide-angle lens. Aim the camera horizontally.

6. It is sometimes possible to make the most of the distortion by using a wide-angle lens, moving close to the building's base and creating a strong, graphic image with deliberate convergence. As a general rule, this approach can work with modern, geometrically-designed buildings, but not with older, more formal architecture.

159

Photographing People

PEOPLE ARE THE richest source of photographic subject and there are as many ways of approaching this subject as there are photographers. The projects here are concerned chiefly with candid photography, which uses some special techniques. In very many situations, it is the only way that spontaneity and the normal flow of human interaction can be captured effectively.

If you are not practiced in candid photography, the first hurdle to overcome is the sense of embarrassment you may feel at pointing your camera at strangers. You may think, quite rightly, that this is something of an intrusion; in practice, however, there will be few, if any, objections, since, provided they do not feel they have been caught in a silly, or unflattering pose, most people are flattered by the attention.

Concealment
The prerequisite of all candid photography is that you and your camera should be as unobtrusive as possible. Dress inconspicuously, try to keep your equipment out of sight except when taking a shot and use a shoulder bag that does not look like a camera case. Despite the normal temptation to display cameras, lenses and photographic gadgets, taking candid photographs is one time when it pays not to look like a photographer. If it is possible to shoot from a concealed position, do so; use doorways and shadows, rather than stand in the middle of the street. In some situations, you can find somewhere to sit down – a park bench, or a café – and so become part of the scenery. Another useful concealed position is a balcony, or upper window; most people do not bother to look upwards.

Long-focus technique
For the majority of candid shots, a telephoto lens is standard equipment, because it enables you to shoot from a distance. In many ways, the longer the focal length of the

77 · PEOPLE AT WORK
At work, most people are preoccupied with the activity at hand, which can thus provide good opportunities for candid photography. Choose an outdoor location, such as a construction site or dockyard. Try and capture some interesting quality of the work, such as an expression of concentration, or some movement of hand or body that is related to the job.

Alternatively, find a small workshop, or one person doing a particular job, and enlist their cooperation, rather than attempting true candid photography. Then produce a short sequence of shots that explain the process of the job clearly and interestingly. A craftsman, for instance, would make an interesting subject for the exercise.

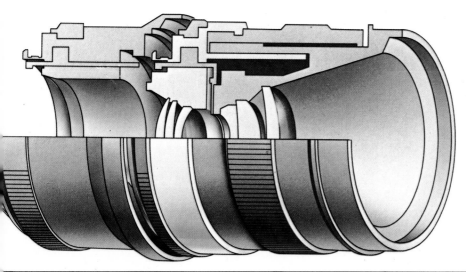

Long focus lenses The fast 180mm lens (**left**) is used extensively in photo-journalism. It is an ideal telephoto lens for shooting in color in poor lighting conditions. Its maximum aperture of f2.8 makes it reasonably easy to hand-hold at relatively low speeds. It is quite heavy for its size, but this, too, is an advantage, since the weight helps keep the lens steady in the hand.

These shots (**left**) capture the essence of a tree-feller's work well. All were taken with a telephoto lens; the change from color to black and white was made deliberately to give more impression of the stark shape of the tree – almost a silhouette – and eliminate the distraction of color. The shot (**above**) shows what might have been produced by lack of thought. Excessive detail detracts from the main story, which shooting upwards into the tree has served to heighten. 1/250 sec, f11.

lens, the better, as it aids concealment, but this depends on the setting in which you are taking photographs. The slowest useful shutter speed for most candid shots is 1/125 sec, so you should use a combination of lens and film that allows you to work at that speed without the risk of camera shake. With a 35mm camera, a focal length of 150mm to 200mm is the most popular.

Wide-angle technique

A wide-angle lens is equally useful in candid photography, but in quite a different way to a long-focus lens. The disadvantage is that working at such short range gives only a single opportunity to shoot, but there are three main pluses. First, in a crowd, such a lens gives good coverage from a close distance. Second, the great depth of field and wide angle of view make it possible to use the lens very quickly, without careful focusing and framing. Third, by aiming slightly away from your subject and making a show of being interested in something else, you can include a face, or figure, at the edge of the picture frame without it being apparent to the person concerned.

Right-angled viewing

If your camera has a removable prism head, you can compose and focus directly on to the ground glass screen, with a little difficulty. As most people are accustomed to seeing cameras used at eyelevel, shooting without the prism head can usually pass unnoticed.

The aim of all candid photographers should be to remain inconspicuous to take advantage of opportunity by, say, seeming to play with your camera at a bar table (**left**).

The chief tool of candid photography is the telephoto lens. Its length may make it difficult to support, so explore all available ways of coping with this (**above**).

78 · STREET PHOTOGRAPHY

Having tackled people at work, try a single session of basic candid photography, without the aid of an obvious distraction. Choose either a market or a busy street, applying all the techniques you have learned so far. In addition to the facial expressions, gestures and poses of individuals, also try to capture the relationships between people. Two people, talking, laughing, arguing, or negotiating, would be ideal. In some situations, such as a market where people are either buying or selling, you can learn to anticipate certain reactions and so preset the camera controls accordingly.

A long focus lens makes candid photography a relatively easy task for even an inexperienced photographer. The range of shots (**left**), taken in a London street market, conveys vividly the fascinating detail that can be captured in the course of a session's shooting. In addition to fulfilling the project brief, the aim here was to produce the basis for an eventual photographic essay on the market theme. One particular mood the photographer had in mind as part of this was the idea of looking and negotiating for a bargain.

79 · USING AN EVENT

The easiest start to candid photography is in a crowded situation, with many people, much activity and where no one minds being photographed. Public events, such as parades, fairs and general celebrations, fit the bill perfectly, so make one of these the subject of this project.

Just as with the nature essay (see p.152), aim for a variety of images that can be assembled later. A storyline for the photographs is unnecessary, as the event itself provides the theme. Photograph both participants and spectators, concentrating on the three themes of facial expressions, gestures and poses. All three should be animated, interesting, or unusual.

The stately pomp of London's Lord Mayor's Show contrasts with the carefree atmosphere of Philadelphia's Mummers Parade (**strip, bottom**). Here, both photographers have remembered that one of the aims of any reportage essay should be to capture the complete atmosphere of the event, contrasting formality with informality, if appropriate. In the London shots, for instance, a Honourable Artilleryman's hurried cigarette and dark glasses (**top left**) are interesting anachronisms, while the crown at the top of the mace (**top center**) makes an interesting detail that could easily have been missed. Similarly, the policeman with his back to the main procession (**strip, far left**) is an interesting touch. One of the problems both photographers faced was crowd barriers and crowd control; this made shooting with a 24mm–200mm zoom lens essential.

Portrait Photography

MANY ELEMENTS ARE involved in successful portrait photography, but none is more important than the relationship between the photographer and the subject. In nearly every case, it is this that determines the final result. Consequently, it is better at the start to simplify the other factors, such as lighting technique and the choice of background, so that you can concentrate on the more delicate problem of capturing at least some aspect of your subject's personality. Complete confidence comes only with practice, so you should take every opportunity to shoot in this field.

Lighting
Though professional photographers frequently take great pains over lighting, it can be a distraction until you have mastered the intricacies of the rapport between the sitter and yourself. The exercises for the lighting projects (see pp.58–63) give you an idea of the basic possibilities.

At this point, it is best to use a standard, uncomplicated set-up, like one of the two shown here. Note that in both cases, the aim is to achieve a broad and therefore soft light from a position between front, top and side. Reflectors, or a second light, fill in the shadows to reduce the contrast range. This is frequently a problem with portraits.

Composition
In most portraits, composition is determined largely by how much of the subject's body is included in the shot. The most usual forms of composition are head-and-shoulders and half-figure; full-length portraits are less common, because the face becomes relatively small.

Clearly, the tighter the image is cropped to the face, the fewer the compositional problems that are posed. Full-face shots, for instance, take care of themselves in this respect. Full-length shots need more care, particularly when the subject is shown in a specific setting, or involved in some activity.

Pose
Subjects differ greatly in their naturalness in front of the camera. The more relaxed a person is, the more easily he or she will take up a comfortable, unobtrusive pose. The majority of people, however, feel slightly reserved and so need help from you.

How much you influence the pose depends on the extent to which you want to control the photograph. One approach is to allow the subject to strike whatever pose seems natural; at the other end of the scale, you impose the pose, either by suggestion or demonstration. You will need to use different methods, depending on the personality of your sitter.

In preparing for a session, two techniques are very useful. The first is to observe your subject closely beforehand and make a mental note of the poses and attitudes in which he or she seems most relaxed and appears the most natural. The second is to build up a useful library of poses that you prefer for future use. As a guide, the illustrations here show some possibilities. Note that placement of the hands becomes extremely important in half-figure shots, while the attitude of the legs needs careful consideration in full-length poses.

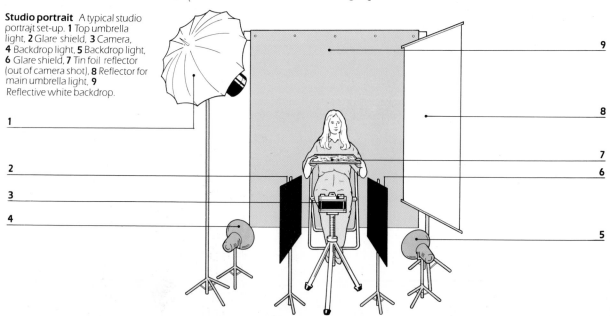

Studio portrait A typical studio portrait set-up. **1** Top umbrella light, **2** Glare shield, **3** Camera, **4** Backdrop light, **5** Backdrop light, **6** Glare shield, **7** Tin foil reflector (out of camera shot), **8** Reflector for main umbrella light, **9** Reflective white backdrop.

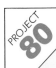

80 · A LIBRARY OF POSES

Although the pose is not necessarily the dominant factor in portrait photography, it usually causes the most problems. Cultivating the ability to suggest a pose, or to recognize a successful one when it occurs spontaneously, will give you confidence.

Using a basic lighting set-up, like the one illustrated on the left, ask two or more friends to model for you to create a catalog of all the poses you can think of that seem reasonably successful. Use the shots on this page as a guide at first, but also experiment with other variations. As soon as you achieve a pose you like, photograph it. Work to the four formats – full-face, head-and-shoulders, half-figure and full-length – and use a variety of simple props, such as a table, stool and different chairs. Photograph with black and white film and print the results as a contact sheet. File this for future reference whenever you undertake a portrait session.

This contact sheet of poses shows what can be achieved with thought and a co-operative model. However, the results are harder to achieve than it might appear. This photographer found the full face a problem, because it was difficult to get close enought to the model with his standard 50mm lens. The head and shoulders were also difficult; in order to allow room for the shoulders in the vertical format, he found he was leaving too much space above the model's head. Focus, too, presented problems at times.
*1/60 sec, f4.

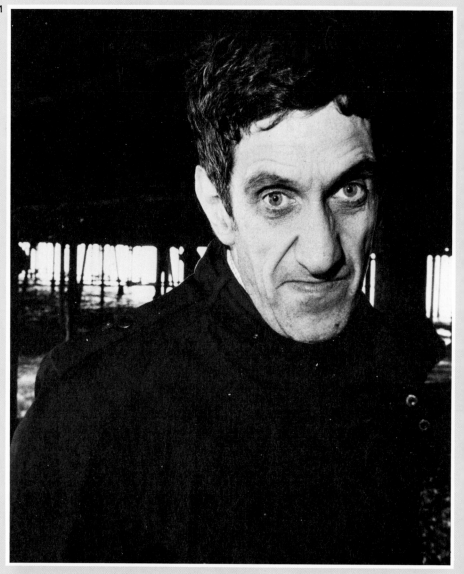

81 · A SIMPLE PORTRAIT

There is no reason whatsoever why portrait photography should be restricted to the studio. Outdoor shots can capture an informal, or fleeting, expression which the whole business of posing can often miss. You can also create interesting compositions, as in some of the examples here.

As a start, choose the simplest setting – a basic lighting arrangement and a head-and-shoulders pose. This involves the minimum amount of technique, so you will not be worried and distracted by it.

With head shots, there is usually little depth of field; if there is the risk of any part of the head appearing out of focus, you can lessen the effect by focusing on the eyes. Use a high-speed film to give you as much depth of field as possible. Shoot from no higher than eyelevel – possibly, even from slightly lower. Otherwise the forehead will appear large and the chin small, which is not usually attractive.

Be prepared to use at least a 36-exposure roll of film; the session is likely to be a little strained at first, but improve towards the end, as both you and the subject relax. Start shooting from the beginning, however. Nothing puts greater strain on a subject's face than the knowledge that you are waiting for a particular expression to appear before taking a shot. Using the camera rapidly helps to give the impression that everything is going well.

If your sitter needs encouragement, keep up a flow of conversation. Ask questions, so that he or she has something to think about other than the camera, but try not to shoot when the mouth is open. A closed mouth usually looks the best.

Make a contact sheet and choose the best shot, or shots, from it. Do not be surprised if many are not to your liking. This is normal

2

and is the reason for taking a large number of shots in the first place. Decide what it is about the selected frame or frames that makes them the most successful. Do the shots improve in sequence (in other words, did the session improve towards the end)?

The shots here show the wide range of opportunities outdoor portraiture can offer. The shot **1** is posed under a pier; the background of superstructure and sea makes an interesting frame for the model. The baby **2** has been caught reacting to the late afternoon sun, while the mother and baby **6** are depicted completely informally. The shot of the child **4** is totally opportunistic and spontaneous; it would be difficult, if not impossible, to pose. The patterns of light created by the slats of the Venetian blinds across the figure **5** add an extra dimension to the shot. The profile **3** is an interesting alternative to the conventional full face, or head-and-shoulders approach. In this last shot, the depth of field is deliberately reduced through the use of a wide aperture setting to concentrate attention on the figure.

5

6

82 · CHOOSING THE FOCAL LENGTH

In most portraiture, there is an element of flattery, though there may be times when you decide to capture some of the less pleasant aspects of your sitter's personality. Nevertheless, the chief aim is usually to produce an image that satisfies everyone concerned.

Most people are acutely aware of facial proportions. As focal length has an obvious effect on perspective, it pays to choose your lens carefully. For this project, photograph a friend full-face, using a normal, wide-angle and long-focus lens. Adjust the camera distance for each shot, so that the face fills the picture frame by the same amount. Compare the finished prints to see what a striking difference focal length can make. Of the three, the long-focus lens will give the most pleasing, best proportioned image. The wide-angle lens records the parts of the face that are nearer the camera – particularly the nose – much larger in proportion to everything else.

Even a standard lens is not suitable for full-face shots. With a 35mm camera, focal lengths of around 85mm, 105mm and 135mm are considered the most suitable for this type of shot.

These shots illustrate the importance of choosing the right lens for portrait photography. Of the three examples here, the shot (**center**), taken with a wide-angle lens, is the least satisfactory. The facial features are obviously out of proportion and the result is unflattering. The normal lens (**top**) has produced less clarity than the long-focus lens (**bottom**).

Still-life Photography: Lighting

BECAUSE SO MUCH control is possible in the studio, particularly with static subjects, still-life photography can be extremely exacting. The composition, camera angle, lighting direction, diffusion, color balance and all the other factors involved can be manipulated with extreme precision. As a result, professional standards are technically very high.

The projects here deal with the standard techniques used to light a single, uncomplicated subject. This is fundamental groundwork; it should not be taken as the only, or even the preferred, way of handling still-life photography. Such rules as exist are only there to help solve specific problems, such as controlling contrast with a particular object, or simplifying the appearance of a brightly reflective surface. Still-life photography can be one of the most powerful means of photographic self-expression precisely because so much of it is under the control of the individual photographer.

Basic lighting

Refer back to the lighting projects on pp.58–63. Of all the various systems, the one most generally useful is a moderately diffused area light. This is directional without producing hard shadows, covering the middle ground in terms of lighting diffusion. Naturally enough, the degree of diffusion produced depends on how close the light is to the subject, but at between 30cm (1ft) to 90cm (3ft) the effect is moderate with sets measuring up to about 120cm (4ft) square.

Building your set

Construct your set as shown in the diagram (top right). Your aim should be to produce an even, reusable surface; a white laminate is best. Clamped at the front of the table, nearest the camera, it will fall into a smooth curve simply by being bent against a wall.

Reflection and refraction

Two problems which often occur in still-life photography are caused by bright reflective surfaces, such as mirrors, polished metal, shiny plastic and glass, and materials that are transparent or semi-transparent, like glass, quartz and some plastics. With these, standard lighting techniques often do not work particularly well; odd-shaped reflections from lights, camera and surroundings tend to mar photographs of reflective objects, while refractive materials frequently lose depth and form when lit frontally.

For reflective surfaces, the answer is to use a large area light, plus large plain reflectors, so that simple, broad reflections are formed. In other words, the more diffuse the light, the simpler the image becomes. For refractive materials, the solution is less simple, as the surfaces are usually reflective as well. As a rule, however, backlighting helps to define edges and the inner structure in this situation.

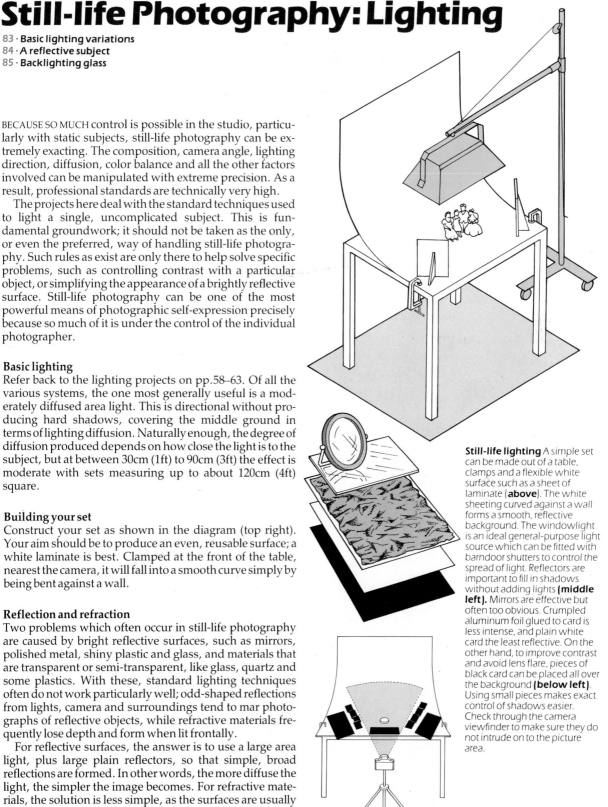

Still-life lighting A simple set can be made out of a table, clamps and a flexible white surface such as a sheet of laminate (**above**). The white sheeting curved against a wall forms a smooth, reflective background. The windowlight is an ideal general-purpose light source which can be fitted with barndoor shutters to control the spread of light. Reflectors are important to fill in shadows without adding lights (**middle left**). Mirrors are effective but often too obvious. Crumpled aluminum foil glued to card is less intense, and plain white card the least reflective. On the other hand, to improve contrast and avoid lens flare, pieces of black card can be placed all over the background (**below left**). Using small pieces makes exact control of shadows easier. Check through the camera viewfinder to make sure they do not intrude on to the picture area.

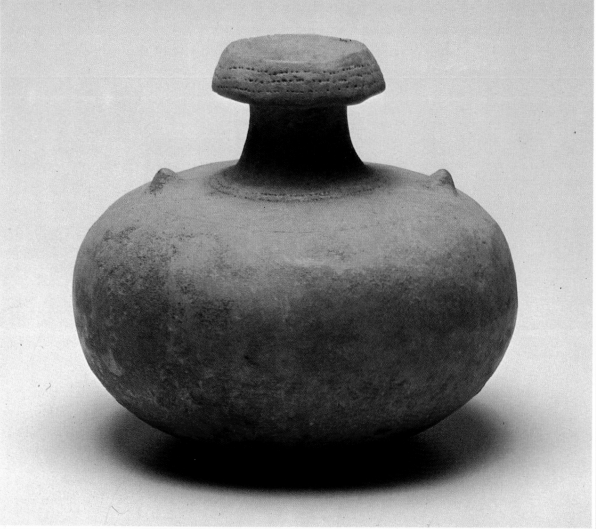

83 · BASIC LIGHTING VARIATIONS

With the lighting set described on p.171, set up a shot involving a bulky object – that is, an object not obviously tall, long or flat – with a matt surface. A ceramic bowl or wooden carving would be suitable. Arrange the subject, light and camera as shown in diagram 1, with the light directly over the subject pointing vertically downwards and the camera slightly elevated, pointing down at an angle of about 20° from the horizontal. The camera should be fitted with a standard lens.

The first precaution you should take is to mask off the light, so that none of it spills on to the lens. If this

happens, flare will result. You can use a flag and an adjustable lens shade, or a barndoor attached to the light. With both light and camera in position, establish where the shade should be by adjusting its position until its shadow falls across the front of the lens.

The next step is to mask around the subject, so that the surrounding white scoop does not cause flare. This is best done with pieces of black card, or paper, placing them in position by checking the edges of the picture area through the viewfinder.

For the first part of the project, leave the light in the same position, but position the camera as in diagrams 1–3 to take three

different shots. For the first shot (1), make the exposure with the camera in a slightly elevated position – as in the original set-up – the second with

the camera aimed horizontally (2) and the third with the camera strongly elevated and pointing down at about 45° to the horizontal (3). Each

time you move the camera, readjust the masking of the light and the white surface.

For the second part of the project, leave the camera in its original, slightly elevated position and vary the angle of the light, according to

3

4

5

diagrams **4—6.** First, move the light until it is almost over the camera to give you frontal lighting **(4).** Then, move it back behind the subject **(5).** Here, you will have to adjust the mask to prevent lens flare. Finally, with the light in the same position, take some small foil reflectors and adjust them in front of

6

the subject to fill in the shadows **(6).**
Compare the six finished prints.

All pictures 1/60 sec, f22. Nikon, Kodachrome.

84 · A REFLECTIVE SUBJECT

Use a pair of brightly polished, heavy duty scissors as the subject for this project. The scissors will provide a number of differently angled planes, one of which will be dominant. Use black velvet as a background and a high camera position, possibly even pointing the camera vertically downwards. If necessary, make minor adjustments to the position of the scissors by wedging small pieces of modeling clay underneath them, out of sight of the camera. Then, adjust the position of the window light until the largest area of the scissors reflects the light. Complete the lighting by adjusting pieces of plain white card around the scissors to lighten the tone of the other surfaces. Make the exposure. Then, removing both the reflectors and the diffusing head from the light, make another exposure for later comparison. Next, construct a light tent from tracing paper and, using the window light as before, make a third exposure.

For interest, take any other small, brightly reflective objects that may be lying around and photograph them with and without the light tent.

Light tent This conical light tent can easily be cut to size from tracing paper once the framing and focusing of the shot have been arranged. Other subjects and shots might need the addition of a further reflector to the set-up.

These shots of a pair of scissors illustrate the principles of reflective light. The shot (**top right**) is without reflectors. The one (**bottom left**) uses white reflectors, the results being excessively bright, harsh and lacking in some detail. The shot (**bottom right**) was taken in the light tent. Notice how much softer the shadows are, particularly on the lower part of the large 'O' of the scissor handle. Another possibility would be to pin extra pieces of black card on the tent, experimenting to create a black reflection along the cutting edge.

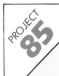

PROJECT **85**

85 · BACKLIGHTING GLASS

Glass, together with any other material that refracts light, usually needs a certain amount of backlighting to give it sparkle. Take an empty wine glass and, using the same basic set as in project 83, place the glass at the front of the scoop. Position the camera at the same level, pointing it horizontally towards the glass. For reference, make one exposure with the window light in its overhead position. Then, swivel the light until it faces the back of the scoop, as shown in the diagram here. This will backlight the glass with reflected light. Shoot the glass again and note the difference in the result.

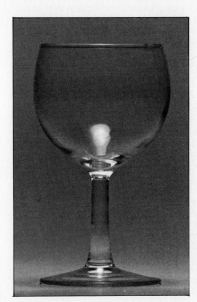

These two shots show immediately what a difference backlighting can make to refractive materials, such as glass. The shot (**above left**) was taken using a window light in an overhead position, producing a dull effect with a false highlight in the center of the glass. The shot (**above right**), backlit with reflected light, has shape, form and clarity.

Still-life Photography: Composition

86 · Composing a simple still-life
87 · Designing a still-life image

ALL STILL-LIFE photographs demand a certain degree of composition. With single subjects, this is usually straight-forward. In many still-life shots, however, the main subject is often shown in a relevant setting, or in juxtaposition with other objects; in either of these cases, careful and imaginative composition is very important.

Having already established what the basic rules of composition are through the image projects (see pp.90–123),

you are now applying them in the studio. The major difference between construction of a studio image and one on location is that there is a much greater freedom of choice in a controlled setting. This very freedom can lead to problems; the ability to select virtually all the elements of the image can be disconcerting, since there is often no guide as to where to begin.

To help channel the process, work through the following

PROJECT **86**

86 · COMPOSING A SIMPLE STILL-LIFE

This project enables you to understand the process of ordering a still-life composition. At each stage, when you make an adjustment or addition, you will find that your decision will influence what happens later; placing the principal subject in a certain attitude, for instance, restricts the choice of where other objects can be positioned and so on. The process, therefore, is one of narrowing decisions. At the later stages, all the elements of the image are so interlinked that any major change often means starting afresh.

Here, the principal subject is a kitchen- or table-knife. It is up to you to select an interesting, attractive shape. The setting is a simple and natural one, using a table-cloth, a wooden chopping board and an orange. Shoot in color, to a vertical 4:5 format. Make the composition as interesting as possible, trying to create dynamic tension.

Follow the following order and make exposures before each adjustment for the record.

1. Set up the camera on a tripod and arrange your basic lighting. For this subject, you will find that

procedure. First, define the purpose of the shot. This might be to present the subject in a visually attractive way, using a naturalistic setting to enhance its appearance. Establish what the format is and other technical requirements.

Find the main subject, if there is one. Define the setting in general terms. This might be abstract, unobtrusive or naturalistic, for instance. Assemble together any relevant props – objects that would normally be associated with the subject, plus others whose main purpose is to balance the image. For instance, you might decide to either complement or contrast with the appearance of the subject in its shape, color or texture.

Choose a background. This could be plain, textured, or a relevant prop. Decide on the scale – that is, how much of the frame the main subject is going to occupy. You are then ready to shoot.

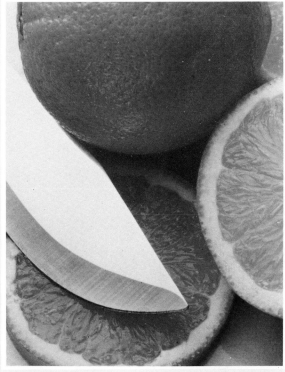 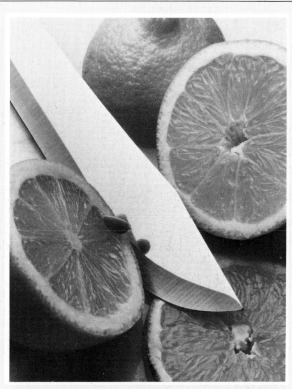

the window light, positioned more or less overhead, will probably work well.
2. Arrange the background – the tablecloth, board, or both.
3. Position the knife approximately. Since it is reflective, it will need careful arrangement later, but, for the time being, angle it so that it catches most of the light.
4. Adjust the lighting, adding reflectors as necessary.
5. Add other props.

6. Refine the composition. When everything is as you want it, make a final, detailed check for any inconsistencies and blemishes, such as specks of dust or marks on the knife. Make the exposure.
Finally, take a lemon and add it to the composition. How much disruption is caused by this?

The progression towards a good still-life composition is shown here. The final shot (**left**) has an interesting arrangement of varying shapes and colors, all of which support the main subject of the study – the knife. The shot (**center**) is identical, with the exception of the droplets of water on the knife. This seemingly minor addition is an effective extra touch that makes a considerable difference to the overall impact of the final shot. The shot (**right**) shows an earlier, experimental stage. The addition of the lemon is unsuccessful. It unbalances the composition, forcing the photographer to move further away from it. As a result, everything becomes smaller and there is much extraneous detail. 200mm macro, 1/60 sec, f22.

87 · DESIGNING A STILL-LIFE IMAGE

In this project, you have a free hand, the object being to create a still-life that is fresh and original. The subject is freshly-caught fish – a single fish or a group – for which you have to design a relevant setting. For instance, you could consider setting the shot where the fish is caught, the way it is sold in a store, its preparation in the kitchen, or the way it is served at the table. Aim for originality at all stages, from planning to composition. Do not limit yourself to the studio and artificial light if you have a better idea.

The variety of shots here illustrate only a few of the ways in which this project could be visualized, from the classic composition **2** to the interesting study wrapped in newspaper **1** . The latter shot is a thoughtful composition. The folds of the paper frame the subject, while the black and white newsprint is a complementary color. There are good dark shadows, while the photographer has carefully preserved the highlights on the fish. The use of additional props, such as the chopping board and onions **2** , conveys the atmosphere of cookery and the kitchen. In the shot **5** , a strong contrast has been established by the juxtaposition of an orange against the fish's scales; this is heightened by close cropping and the use of a dark background. In contrast, the detail **3** gains from a light background, plus the drops of water. The shot **4** shows a totally different solution, which gains from the close-up technique the photographer has employed.

4

5

179

Close-up Photography

CLOSE-UP PHOTOGRAPHY IS defined as occupying a scale of magnification from around 1/7x up to life size (1x). If the magnification is greater, the term used is photomacrography; this covers shots up to about 20x magnification, after which the special optics of a microscope are needed.

Close-up photography and photomacrography share the following distinctions. Special close-up equipment is needed and the depth of field is extremely limited. Extra exposure is needed to compensate for the loss of light when lens extensions are used. Most subjects escape normal attention because of their size, so they have the advantage of being unfamiliar. The real value of close-up photography lies in this last point. It offers a range of images that is outside most people's day-to-day experience and so offers good opportunities for exploring its possibilities with a camera.

Equipment

Careful practice is necessary before you become an accomplished close-up photographer. The reason for this is simple; many aspects of close-up work, such as exposure calculation, focus and depth of field, are more critical than in conventional photography. For most close-up and macro work, the standard method for magnifying the image is to move the lens further away from the film. To achieve this, various devices, such as extension rings, tubes and bellows, are used, each being designed to move the lens by accurate, measurable amounts.

The longer this extension, the greater the magnification, but also the less the amount of light reaching the film. To compensate for this, extra exposure is needed, either by using a slower shutter speed, or a wider aperture. The formula for calculating the increase in exposure is:

$$\text{Increase in exposure} = \left(\frac{\text{Lens focal length} + \text{extension}}{\text{Lens focal length}}\right)^2$$

The projects here and charts on pp. 184–5 show how to make use of this.

Magnification

The degree of magnification is expressed either in terms of how much larger the image is than the subject, or as a ratio. If the subject measures 10mm across and the photographic image of it is 20mm, for instance, the magnification is 2x. In other words, the magnification can be determined by dividing the size of the image by the size of the subject. Alternatively, the reproduction ratio can be used; the table here compares the two.

Magnification	1x	2x
Reproduction ratio	1:1	2:1

Close-up lenses This 60mm macro lens (**right**) has a 39° angle of view and a focusing range from 27cm to infinity. The maximum reproduction ratio is 1:2 (half life-size) and the maximum aperture is f2.8. By adding extension rings **1**, the reproduction ratio can be increased to 1:1. Extension rings increase magnification by extending the lens from the camera body. Different-sized auxiliary lenses **2** perform a similar function. They screw on to a normal camera lens to decrease the lens — subject distance. No extra exposure is needed, but on magnifications greater than 1:2, the quality of the image begins to deteriorate.

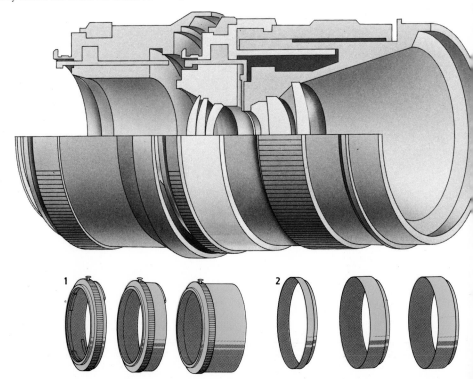

PROJECT 88

the picture covers exactly 36mm, as in the diagram. As the length of a 35mm lens itself measures 36mm, the image will be the same size as the subject and the magnification is therefore 1x. Extend the bellows

further and refocus until the 18mm mark on the ruler fills the frame. This will give a magnification of 2x (reproduction ratio 2:1). When 108mm of the ruler can be seen, the magnification will be ⅓x (1:3).

Return to the 1x setting. Measure the extension that the bellows has added –

that is, by how many millimeters the lens and body are separated. Now replace the standard lens with a wide-angle lens. Adjust the bellows until the magnification is again 1x and measure the extension. In both cases, this should be the same as the focal length of the lens (in this second case, less than before).

In other words, a 50mm lens needs to be extended by 50mm to give a same-size image and a 35mm lens by 35mm. To give a magnification of ¾x, extend a 200mm lens by 150mm.

88 · MEASURING MAGNIFICATION
There is no need to shoot any film for this project; simply make the necessary calculations from the image in the viewfinder. With a standard lens and bellows extension on a 35mm camera, focus on the scale of a metric ruler. Adjust the bellows until the length of

The answers to the three questions in this project are 2:1, 1:33 and 175mm.

Close-up equipment
Professional equipment is almost essential for serious photomacrography, but it is expensive. **1.** An extension bellows allows continuous focusing to produce high quality results. Some makes also offer tilts and shifts in the front lens panel, giving tight control over depth of field and perspective. **2.** A ring-light gives virtually shadowless lighting. It can be either a circular flash tube that fits over the lens, or an adjustable unit with supplementary lights to produce some modelling. Power packs are separate in both cases. **3.** A pan-and-tilt tripod head with separate movements, which can be adjusted individually with great accuracy. **4.** Tripod with a reversible center column for low camera positions. This can be combined with a horizontal arm fitting to give easy access to the camera controls.

89 · DISCOVERING CLOSE-UP IMAGES

This major project is more concerned with finding new, interesting subjects than the technical problems of close-up photography. Anywhere close to where you live – in the garden, for instance – mark out an area with string. Do not examine the area closely before you do this; select it in as random a way as possible. It might even be better to ask someone else to choose it for you.

Thinking only of close-up and macro subjects, find and photograph at least eight distinct subjects. You may well think it is impossible to come up with that number of interesting, worthwhile images, but, in all probability, you will be proved wrong. Remember that an important part of the exercise is to find the subjects.

The photographer here decided to shoot an area of his backyard, which was cluttered with building debris, to produce a collage of close-up images. The general area is shown above. He used a 200mm macro lens for all the shots, which were taken in bright mid-afternoon sun. This led to some interesting shadow effects. As he was hand-holding the camera, he did not shoot below 1/125sec to lessen the chance of camera shake affecting the results. He found the important thing was to get as close in as possible to the chosen subjects to produce the detail and viewpoint that raised them above the commonplace. By focusing on a specific area within the shots, he deliberately reduced the depth of field. This, too, helped add interest to the shots, obscuring unwanted detail and making them more abstract and interesting.

Exposure increase scale
Having corrected your focus for the shot you require, point your camera at the scale, so the arrow touches the frame's left-hand edge. The right-hand edge indicates in f-stops the necessary exposure increase.

F-stop increase

4	3	2	1²⁄₃	1¹⁄₃		1

Exposure increase

16.0	8.0	4.0	3.2	2.5		2.0

PROJECT **90**

90 · CALCULATING THE INCREASE IN EXPOSURE

Take a postage stamp and lay it flat. Position the camera pointing vertically downwards, as in the diagram. Use any convenient, stable light source, such as a desk lamp, but, once you have adjusted it, do not move it.

Measure the light level with an incident exposure meter, holding the meter in the same position as the stamp. Make a note of it. Adjust the extension and focus until the magnification of the image is ½x – that is, a reproduction ratio of 1:2. Measure the extension (if you are using a standard 50mm lens, this should be 25mm). The overall distance from the film plane, marked on the body of most cameras with the symbol ⊖, to the center of the lens will be 75mm. Calculate the increase in exposure required with the

¼× (1 : 4) ¹⁄₁₅ sec, f19 CU +3

A 50mm lens was used here. The individual calculations to obtain the appropriate exposure increase are shown under each shot.

formula below.

This means either increasing the exposure time by 2.25 times, or opening the aperture by about one f-stop.

Using black and white film, make one exposure at the original, uncorrected setting and one at the new, adjusted setting. If your camera has a TTL meter, the

reading will compensate automatically for the extension, but, of course, this only works with continuous light, not flash. Repeat the exercise at ¼x,

$$\text{Exposure increase} = \left(\frac{\text{Lens focal length} + \text{extension}}{\text{Lens focal length}}\right)^2 = \left(\frac{50 + 25}{50}\right)^2 = \left(\frac{75}{50}\right)^2 = 1.5^2 = \text{2.25 times, or an increase of approximately 1 f-stop}$$

Supplementary close-up lenses (diopters)
Reproduction ratio (magnification) 50mm lens, 35mm format

Diopter	+½	+1	+2	+3	+4
Lens focused on infinity	1:40 (0.025x)	1:20 (0.05x)	1:10 (0.1x)	1:6 (0.17x)	1:5 (0.2x)
Lens focused on 1 meter	1:20 (0.05x)	1:10 (0.1x)	1:6 (0.17x)	1:5 (0.2x)	1:4 (0.25x)

The strength of this type of lens is measured in diopters.

The higher the diopter, the greater the magnification and

the nearer the point of focus.

The Inverse Square Law
Close-up exposure is affected by the inverse square law. This states that the intensity of illumination is inversely proportional to the square of the distance to the light source. Put simply, this means that two meters away from a lamp, say, the same amount of light has

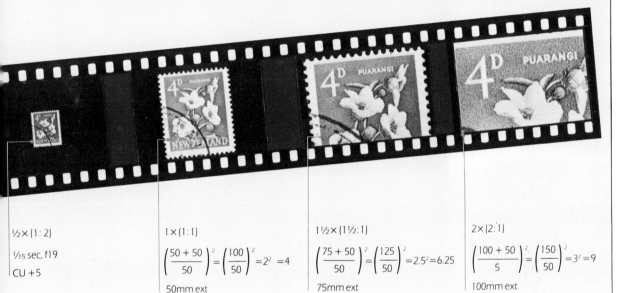

½× (1:2)

¹⁄₁₅ sec, f19

CU +5

1× (1:1)

$$\left(\frac{50+50}{50}\right)^2 = \left(\frac{100}{50}\right)^2 = 2^2 = 4$$

50mm ext

1½× (1½:1)

$$\left(\frac{75+50}{50}\right)^2 = \left(\frac{125}{50}\right)^2 = 2.5^2 = 6.25$$

75mm ext

2× (2:1)

$$\left(\frac{100+50}{5}\right)^2 = \left(\frac{150}{50}\right)^2 = 3^2 = 9$$

100mm ext

1x, 1½x and 2x magnifications. The results on the processed film will show how accurate your calculations have been.

Calculating flash intensity
Flash units are generally used at distances of only a few inches in close-up

photography, yet the scales supplied with such units do not normally extend this far. To calculate the exposure settings, first work out the intensity of the flash at a given distance and second the adjustment required for the extension.
Use the same set-up, but replace the desk lamp with

a portable, non-automatic flash unit, positioned 150mm (6in) from the postage stamp. The ASA guide number of the flash will be in feet; use this normally (see p.80), dividing it by 0.5ft (6in). The result is the nominal f-stop setting. In order to use this, it may be necessary

to move the flash further away from the subject. Then, calculate the necessary exposure increase and open the aperture by the required amount.

to cover four square meters; four meters away, it would spread over 16 square meters. In other words, twice the distance equals a quarter of the illumination; four times the distance equals a sixteenth of the illlumination. In close-up, the lens is the light source and the subject the film. The

aperture scale on a lens is calibrated for subjects at infinity, so, when the subject is closer than about ten times the lens' focal length, you must allow extra exposure (**see above**). Remember, however, that when the lens is focused on infinity, lens extension is one focal length, so, if you measure

the extra extension, the additional exposure is given by this formula

compensation = $\dfrac{\text{Extra extension} + \text{focal length}^2}{\text{Focal length}}$

In both cases, the increase in exposure is given as a factor, by which you must multiply the exposure time.

3 IMAGE INTERPRETATION

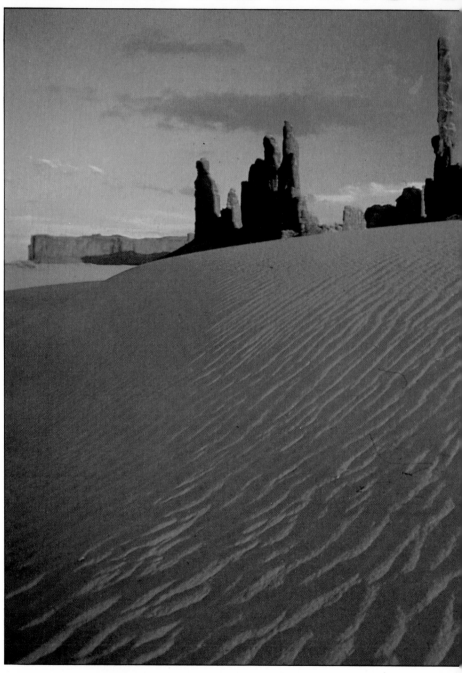

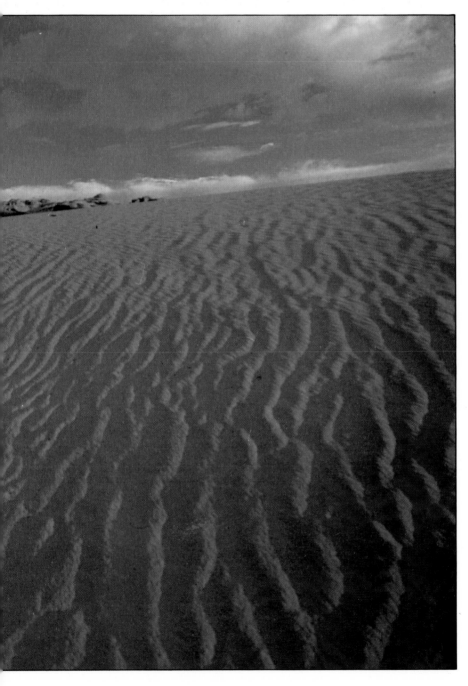

Having mastered the contents of the first two sections of Photoschool, This section is planned to start you along the road of advanced, intu itive picture-taking, encouraging you to experiment and break the rules to avoid the conventional and to produce images demonstrating your own individual approach and style.

Graphic Relationships

THE PROJECTS ON pp.90–123 were chiefly concerned with efficient composition, organizing the image according to the standard aesthetic principles. Some of these techniques, such as the contrast of shapes and the use of lines to direct vision, are quite powerful ways of controlling perception. As such, they can be used to alter the significance of different parts of the picture, or, in other words, their use enables you to impose an interpretation on your subject.

In a sense, every decision that you take in framing and composing is bound to involve some interpretation, even if you are unaware of this at the time. The process of selection begins as soon as you use the viewfinder. At this point, however, the aim is to learn actively how to alter meaning deliberately by means of composition.

Cropping

One of the most basic ways of changing the content of a photograph is through cropping. This sometimes produces the most spectacular results and is a well-established procedure in most forms of publishing, particularly in newspapers.

Cropping has many uses – it can change the proportions or balance of a shot, eliminate a distracting background, or alter a photograph's format. Using L-frames is the best way of deciding how to crop a picture. You simply move the frames around on the print or transparency until you find a composition you like, as above right. Often you will discover new possibilities in a shot that you never considered when you framed it originally. Cropping off the two higher figures from the picture (**right**) has transformed the whole mood and meaning of the image, turning a somewhat frenetic image into a more static, self-contained portrait study.

When your subject includes fast movement, there is not always time for precise framing. It can be better to leave a little space around the main center of interest and crop in when you print. Extraneous background details weaken the bullfight shot (**top**). Cropping in has focused attention entirely on the protagonists.

The equipment needed for cropping is minimal. A few sheets of paper will do, although it is easier to work with a pair of L-frames. For 20 x 25cm (8 x 10in) prints and smaller ones, cut the frames from thick black card, so that the inside edges measure 25cm (10in); they should be at least 10cm (4in) in width. Use them on a full-frame print, as illustrated here, to help you decide on the framing you prefer; you can then adjust the printing easel on your enlarger base-board to produce the recomposed image on a new print.

Cropping on an existing print is only one step removed from the decisions you have to take when framing a subject in the first place. It is a valuable procedure when someone other than the photographer is making use of the image – the picture editor of a magazine, for instance – and when there is a possibility that you may discover new ideas in a photograph by studying it at leisure after the exposure has been made. The advice given by some photographers to resist the temptation to crop, on the grounds of the purity of the original intuitive vision, is more often than not a pretension.

Distortion

The most common form of photographic distortion is that produced by a wide-angle lens. With subjects that have familiar proportions, this is more often than not unusual and unsettling. However, in common with eccentric composition, distortion can be an effective technique for emphasizing part of a subject strongly. Imagine, for example, the image of a man extending his hand towards the camera, taken with a very wide-angle lens. In terms of size, the hand close to the lens will dominate the photograph, out of all

Spectacular distortions can be achieved with a fish-eye lens. Vertical and horizontal lines seem to bow in toward the center of the frame, while perspective is highly exaggerated, creating a disturbing, nightmarish feeling from even the most ordinary subjects. In the picture (**above**), a fish-eye has greatly magnified the foreground and made the skyscraper appear to recede endlessly into the sky, as if sucked toward a vortex. The result is a menacing image that accentuates the height of the building and the cold, hard modern quality of the architecture.

true proportion to the man. Ordinarily, this simply might look strange, but, if the photograph were of a campaigning politician out amongst the voters, the treatment would have a special relevance.

Balance

The principle of balance explained on p.112 assumes that there is a need for some degree of equilibrium in any image. A slightly unbalanced image can be interesting, but an extremely eccentric one normally looks wrong, unless there is a reason for its unusual composition. In other words, someone looking at a strongly unbalanced image will first try to discover why the photograph is arranged in the way it is.

Some photographic ideas can actually benefit from imbalance, particularly human situations and relationships that are themselves discordant. Take, for instance, the example of a single figure leaning over the balcony of an unattractive high-rise block of apartments. Without thinking about it deeply, the natural tendency would be to fill the frame with the subject and keep it fairly central. However, if the photographer's intention was to imply that modern high-rise buildings detract from the quality of life and isolate the people who live in them, then it would be more effective to show the figure small. Such an interpretation could be strengthened still further by placing the figure at the bottom of the frame. This lends an impression of weight and oppressiveness to the building. Note that, despite these substantial changes in composition, the center of interest remains indisputably the figure.

Another use of balance is in size relationships – setting a small subject against a large one, or a single image against a group. Depending on the composition, it is not difficult to create an impression, say, of exclusion or insignificance.

Mimicry

Many objects, by virtue of their shape, bear a passing resemblance to others, even though there may be no other connection. In real life, this is rarely a source of confusion, because we see things in the context of their surroundings. In photography, however, these relationships can be exploited by juxtaposition and careful control of lighting.

Sequences and multiple frames

So far, only single photographs have been considered, together with the relationship between elements inside each frame. Juxtaposing separate photographs creates a new kind of relationship, where the complete effect depends on the interaction of independent images.

One of the commonest methods of achieving this is with a horizontal strip of pictures showing a sequence in time, but the possibilities are far wider. The series could show different aspects of the same subject, for instance, or the sequence might have an twist in one of the frames.

PROJECT 91

91 · PHOTOGRAPHING A SEQUENCE
Produce a series of photographs of a single subject, to be displayed in a strip. Use this technique to comment on the way the subject behaves, or functions. To do this, either photograph a true sequence, or make all the frames bar one identical, so

that the odd one out has an emphatic effect.

Here, the photographer has successfully used color and movement to convey the passage of time. The eye is immediately drawn to the warm red and yellow squares and follows their destruction with interest. The blank wall leaves the viewer with a feeling of suspense and allows him to invent his own ending to the story. All the photographs were taken using a 50mm lens, 1/125 sec, f11.

92 · CROPPING TO CHANGE CONTENT

Crop a photograph to produce two quite different images. Either use an existing photograph or take one especially in order to crop it. Make a sketch, if necessary, to demonstrate the changes you have made.

By positioning herself carefully, the photographer was able not only to produce an attractive

view of this plantation-style house in Charleston USA, but also, by imaginative cropping, the two shots below. The architectural unity of the original has disappeared. The shot (**below right**) looks as though it was part of a row of terraces, while the cropping has exaggerated the shadows which were part of the original composition. In the shot

(**below left**), the tropical trees have become the dominant part of the picture.

This realistic black and white shot of a canal quayside (**below right**) has been totally transformed by cropping (**below left**). The glaring sun has been removed and the quayside buildings have vanished, leaving only their reflections in the rippling water of the canal. The resulting composition is extremely abstract.

1

2

3

93 · DELIBERATE DISTORTION FOR EFFECT

Use the size distortion produced by a wide-angle lens – the wider the better – to emphasize one aspect of your chosen subject.

1. In this panoramic view of a Columbian city at dusk, a fish-eye lens has underlined the claustrophobic, closed-in feeling of a large town by curving the horizon inwards. The effect of uneasiness created by the mixture of artificial lights contributes to the overall mood of the photograph.

2. Combining a wide-angle lens with a low three-quarter close-up view has steepened the perspective of the red auto, exaggerating the size of the hood and front wheels. This gives the vehicle a slightly comical appearance, as if it has pretensions of being more powerful than it is in reality.
3. Here, the characteristic perspective distortions of a wide-angle lens have been maximized by framing the shot to include a large expanse of foreground. The abstract lines of the dune landscape appear to converge toward the horizon, further dramatizing the feeling of boundless space.

94 · CREATING ASSOCIATIONS THROUGH COMPOSITION

Use compositional techniques to produce a photograph that conveys the feeling of loneliness, isolation, exclusion, or conflict. Keep human figures small in the frame, so that facial expressions cannot be used to help the image.

1. Exclusion Strong thick bars are an obvious technique for showing exclusion. And, in this case, the outdoor summer setting gives it a poignant twist.

2. Isolation The small figure in the row boat is the only spark of life on the horizon, and the sense of isolation is heightened by the flat calm surface of the Dead Sea against the featureless dark sky.

3. Loneliness Photographing the figure at the end of the tunnel isolates his dark silhouette against the daylight ahead, increasing the sense of solitude. The converging lines of the walls of the tunnel lead one's attention in to the figure while the umbrella and the puddles of rain enhance the gloomy mood.

4. Isolation Here, it is the immense difference in size that conveys the theme of isolation – the house is tiny in the frame, while the hills dominate the picture. Positioning the horizon high in the frame draws the eye down to focus on the solitary building.

5. Conflict Gesture often conveys mood as effectively as facial expression. In this photograph, taken at Speaker's Corner, London, it is mainly the strong diagonal of the man's arm that creates a sense of conflict and tension. Its dynamic angle also contrasts with the static lines of the crowd and buildings behind.

95 · RECORDING MOVEMENT IN ONE FRAME

Take a photograph of a moving object, using a slow shutter speed. The principle here is similar to that of project 91, Photographing a sequence, but is more ambitious, as you only have one frame in which to capture the way the object behaves.

Be prepared to shoot a lot of film when trying to capture the perfect movement shot – experiment with different exposures to create varied degrees of blur. The photograph above evocatively captures the atmosphere of sailing by night. Taken when the boat was going through a spotlight during a race, a semi-abstract effect is achieved by the blurred red yacht against the dark water. The sharp dots of light from the static streetlamps beyond the reservoir heighten the impact of the blurred boat.

The shot on the right was taken just before nightfall when there was too much light to get a long exposure time.

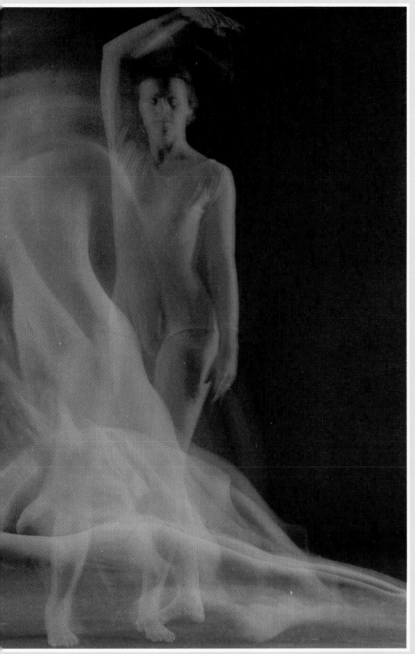

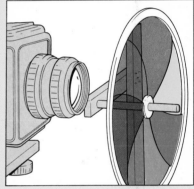

A relatively complex set-up was required to achieve the spectacular action shot (**left**). The dancer, dressed in a white leotard and tights to pick up the various colors from the wheel, stood against a black background. She was sidelit by two spotlights, screened off as in the top diagram to prevent stray light spilling on to the background and being recorded on film. An improvized color wheel containing six colored lighting gels arranged in a circle was lined up in front of a Hasselblad camera (**above**). The photographer then asked the dancer to perform a series of movements and took a long exposure while the color wheel was turned by hand. Several dry runs were necessary before a satisfactory result was arrived at and the motion of the wheel coordinated with the dancer's movements. Leaving the shutter open too long and rotating the wheel too fast overexposed the image and failed to record the colors (**below left**). And if the dancer moved too rapidly she recorded with too much blur. Success was finally achieved, as shown in the large photograph (**left**) – the different stages of the dancer's movement during the long exposure suggest her rhythm and grace, while the blurred sweeps of color add to the feeling of motion.

Symbolism and Cliché

SYMBOLISM PLAYS AN important part in interpretative photography. It is a means of conveying an idea through the use of a simple, recognizable image. In effect, it is a form of visual shorthand, using one object to represent a more complicated, or abstract theme and relying for its effect on the associations that we place on certain objects and shapes.

An egg is an obvious example of this. Apart from the fact that it is a container for a chicken embryo, it also has connotations of birth and beginning (from its function), simplicity and completeness (from its shape), wholesomeness (from its use as a food) and fragility. It therefore can be used in both photography and illustration as a symbol for any of these concepts.

In photography, symbolism generally has three uses. It can help you avoid stating the obvious and so add interest to the image. It can represent a concept that is abstract, or essentially non-visual. It can place an unusual interpretation on a theme, usually through the juxtaposition of more than one symbol.

The character of symbols in photography differs in some ways from that of symbols in illustration, however. In the latter, the image can be refined down to the bare essentials, so that the graphic elements alone become the symbols. This degree of simplification is rarely possible photographically, since real-life subjects normally resist such graphic refinement.

For this reason, the symbols used in photography are principally tangible objects. To qualify as a useful symbol, objects must be familiar, with a distinctive shape, and should have a fairly basic function.

One of the problems here is that, if symbols become too familiar, they lose their interest and lapse into cliché. The most successful symbols are those which are simple, yet used in a way that is not completely obvious. It is precisely because symbols generate familiar associations that it is important to be imaginative in their use.

Avoiding cliché

Though a familiar image may be dull, it is not necessarily a cliché. To be the latter, there has to have been an attempt, however inadequate, at a creative solution. Straightfor-

Symbols act on the subconscious mind and are taken in on a subliminal level. They are therefore extensively used in 'soft sell' advertising photography where the advertiser wants to convey a message succinctly without featuring the product itself. The poster (**above**) is designed mainly to illustrate gasoline's benefits to the consumer, but also to symbolize Esso's supremacy as the largest industrial corporation in the world. It uses two symbols – the tiger and the sea – for natural energy, and speed. The whole advertisement is geared to be scanned rapidly so that the eye follows the tiger to the Esso logo.

Ulster's Days of Rage

Newsweek
THE INTERNATIONAL NEWSMAGAZINE

May 11, 1981

GM Challenges The Japanese

Chevrolet's New 'J' Car

*Using a chichéd idea is sometimes irresistible because of its potency: the photographer knows well that a well-tried formula will reach the audience he is aiming at. This Newsweek cover shot (**left**) serves two purposes – it uses the visual concept of the cracked egg to symbolically announce the birth of General Motor's new baby, and backs up the headline 'GM Challenges The Japanese' by carrying the Stars and Stripes design on the egg shell.*

ward, literal photography only occasionally falls into this trap; an uncomplicated, craftsmanlike approach lacks pretension and so does not lay itself open to this danger. The problems generally begin when photographers strain too hard to be creative without being original.

More than in any other photographic field, the cliché is a feature of interpretative photography. It occurs most frequently when the photographer tries to convey abstract concepts through the use of simple images. Understanding its origins makes it easier to avoid and even, in special cases, to use it to advantage. It is easy to scorn an image for being hackneyed, but frequently clichés started life with higher status. Good ideas become clichés because they are so successful when first used that they are picked up by others and repeated. An idea may be so appealing that it is impossible to resist, even when the person using it knows that it is borrowed.

Another reason for the use and development of cliché is that, on occasion, there may be few adequate solutions to a problem. Imagine, for instance, photographing any concept connected with money, using symbols and possibly juxtaposition in a still-life setting. Virtually any symbol for money will be obvious and well used, not least because it is a popular topic. Coins, bank notes, wallets, safe deposit boxes – these and others are obvious enough, but inevitably overexposed.

Frequently, the simpler and neater a visual idea is, the more susceptible it is to overuse and the more quickly it ceases to be interesting. Though simplification is an important part of the creative process, it is all too easy to produce an image that is simplistic, instead of succinct. A large part of the problem can be laziness; it is easier to use an established idea than to be original.

To avoid cliché, you should familiarize yourself with the general currency of photographic ideas, particularly those used in advertising. Take every opportunity to see what other photographers are doing in all fields.

Additionally, before rejecting an image as clichéd, stop to consider whether it is the basic image that is hackneyed, or whether it is just the predictable way in which it has been treated. If the latter, you should be able to think of a more original approach and so preserve some freshness.

96 · USING SYMBOLS

Find and photograph symbols to illustrate each of the themes of power, patriotism, wealth and poverty. Clichés are bound to appear with common concepts such as these, but try to be as original as possible.

Power Two pictures of the space shuttle illustrate this concept well. In the photograph (**above right**), a fish-eye lens has strikingly exaggerated the power and size of the shuttle's engines and curved the sides of the hangar, making an effective frame for the engines in the middle. A head-on view (**right**) foreshortens the front of the shuttle, giving it a menacingly powerful appearance. The black border and central positioning allow it to dominate the composition.

Wealth Juxtaposing the nose of the Rolls-Royce with the green marble wall (**below**) and the gold letters effectively illustrate the concept of wealth without overstating it. Notice how the man's shadow shows up the vehicle's insignia.

Patriotism One of the most clichéd symbols of patriotism – a national flag – is treated in two dramatically different ways. By shooting from above (**center**), and allowing the flag, rather than the intent fervent faces to dominate the composition, the photographer has hinted at the idea of a country's subjects being subordinate in importance to the nation itself.

In the photograph of the young punk (**above**), the shallow depth of field of a telephoto lens has blurred the background, focusing attention on the Union Jack design on the boy's hair. Note how his face is profiled against the plain green sweater of the woman in front.

Poverty The church billboard behind the down-and-out (**top**) becomes a poignant and powerful message about poverty, and it is reinforced by the contrast between the sombre colors of the man's clothes and the sign's brightness.

Experimental Photography

ONE OF THE underlying themes of this book is that there are logical solutions to most creative problems and that the better your understanding of the sequence of decisions involved in taking each photograph, the more creative control you will possess. This 'logical' approach does not have to be ponderous; many photographs involve such

simple, rapid decisions that these are normally applied intuitively. Nevertheless, the steps do exist.

However, this method only works as long as you continue to analyze photographic problems with some degree of flair. The disadvantage of any system is that it can encourage pedestrian thinking, relying on tried and tested

PROJECT 97

97 · DISTORTING SURFACES

Buy a square sheet of silver foil and use it as the basis for this project. The very thin reflective coating on the foil gives it a quite good optical quality, while its flexibility makes it possible to manipulate any reflected image. Without the camera, experiment with the distorted images you can make by twisting and buckling the sheet. Depending on how much the sheet is pulled out of shape, you can create either recognizable distortions, or abstract patterns.

When it comes to actual photography, you must take precautions to hold the foil in position long enough for the exposure and to keep the image in focus. The distorted image needs great depth of field. The easiest solution is to tape the foil loosely to a board, or thick piece of card, and to use a fairly wide-angle lens. Use a small aperture.

Working in color – either on location, or in the studio – see what images are photographically possible. Finally, devise some likely uses for this technique.

1

2

1. The Albert Memorial Kensington Gardens, London. Having chosen a subject for the project, the photographer took a reference shot with a wide-angle lens.
2. Distorted image By setting up the camera on a tripod and pre-setting the shutter, the photographer was able to hold up a wide sheet of foil which reflected the image of the subject towards the camera. While the camera operated automatically the foil was moved to intensify the distortions. In the print above one of the columns of the memorial is distinctly visible, but the rest has become an interesting abstract image.
3. Choose an image The contact prints show the various degrees of distortion that were achieved. From these a choice can be made for the enlarged print.

techniques instead of seeking new ones. As an antidote, these projects are intended to encourage pure experiment – trying out ideas or techniques that are unusual, or unlikely, just for the sake of seeing what happens.

The projects that follow are experimental in the sense that the results are not predictable. The illustrations are just examples to keep your photographic eye fresh. Think of others in the same vein and make regular, if only occasional, experiments. There is no guarantee that you will find anything immediately useful, but the projects may stimulate other ideas and you may be able to draw on this bank of visual effects later to solve a photographic problem.

4. and 5. Crystal clear
Wrapping foil around a cut crystal glass created an image of multiple reflections. The glass was standing on the foil and the foil then brought up around it. Light was reflected off the foil onto the glass and vice versa. The fact that the glass was etched as well as cut creates an interesting textural effect. Although the glass can be seen distinctly in the center of the photograph its own distorted image, sparkling in refracted and reflected light, surrounds it.

98 · MOSAIC IMAGES

Using prints, arrange a block of, say, 15 frames in such a way that they combine to make one picture. You could do this either by cutting up a single print, or, more interestingly, by planning and shooting each frame separately.

Next, consider the possibility of photographing the subject under slightly different conditions across the block. For instance, take an outdoor scene and photograph it at different times of day, so that the combined image moves from daylight in the left-hand frames to night at the right. If you use more frames to make up the mosaic, the gradation will appear smoother.

Alternatively, take a city view and photograph it in every frame but one after business hours, when the streets are virtually lifeless. The rogue frame is then shot at the peak of the rush hour, so that the finished result shows the contrast in the daily cycle of city life.

These are just two ideas. Experiment with others of your own.

Interiors Using poloroid film, the photographer stood in the same position in the middle of her sitting room and took a series of shots moving the camera only, not her body. In this way, she has produced an exciting, almost two-dimensional idea of the shape, form and lighting of her subject, as well as contextualizing it on a wider scale. If viewed in isolation (eg, **bottom right**), the tiled floor would give you no idea of the way the room sweeps out through the glass doors on to the balcony beyond. There, the buildings opposite show that the room is in a city, while the lushness and relief provided by the palm and other potted plants, compensate for what would otherwise be a stark interior.

City of London A gray, drab area around the Bank of England (**left**) contains a surprising amount of intriguing and colorful detail. The photographer was able to compose a mosaic (**above**) of fascinating images – all in their own idiosyncratic way representative of the area – by varying the composition of the photographs and by using color imaginatively. The double-decker bus reflected in the office window and the close-up detail from the subway sign are a reminder of the importance of transport systems in large cities; while the crest on the sign, the polished brass door-bell and the discreet formality of a merchant bank's name plate symbolize this area's long-established role as one of the world's busiest financial centers – a fact which is outlined by the grandeur of the architecture. The top-hatted gilt broker, however, will be brought face-to-face with more contemporary objects when he buys a newspaper from the garish-colored box.

Juxtaposition

BY PLACING ONE image or subject against another, the photographer implies a relationship between the two. In most situations, this relationship will be natural, real and without hidden meanings; however, you also have the opportunity to create relationships from your own imagination by various means. Consider, for instance, a still-life composition using an egg. If you construct the image with an egg and spoon, then there is no possible confusion as to what is about to happen to the egg. If, on the other hand, you place a hammer next to the egg, the situation is very different. As the two appear next to each other, the relationship is clearly intentional, the only natural construction being that the hammer is for breaking the egg. What is unresolved is the reason for this.

This is juxtaposition on an extremely basic level, involving the positioning of one object next to another and relying on the functions or associations of each to spell out an idea. Not surprisingly, juxtaposition is particularly effective with symbols; there are several techniques for combining them, ranging from straightforward placement to the more complex methods of double exposure and montage, described below. Although effort is needed to solve the technical problems in such photographs, it is the idea that should be paramount. It is important to resist getting caught up in technical detail.

The relationship may be clear-cut, or it may be deliberately enigmatic. It may even be a purely graphic relationship – making comparisons between shapes, for example. Juxtapositions, too, can be complementary (one subject reinforcing another either graphically, or in its associations), or contrasting (where a relationship is forced on to two dissimilar subjects).

Six ways of combining subjects

1. Placement The least complicated method of juxtaposition is to place subjects together, or to choose a camera position and lens focal length that achieves the same effect. This generally works best in the studio, where you have more control over composition.

2. Double exposure and double printing Making two exposures on the same frame is a direct way of combining images. The technique makes it possible to use subjects that differ in location, size, lighting and so on. The prerequisite is that the subjects are lighter in tone than the background.

Double printing in the enlarger is similar in principle, except that the backgrounds should be virtually white, or else the negatives should be masked during printing.

3. Montage Using photographic prints, you can cut around one image with a scalpel or sharp knife and paste it on to another. This needs some skill and care to be completely effective.

Use a complete print as the base and make the other print on single weight paper. Shave the edges of the smaller print on the base side, so that it will lie almost flush with the surface of the larger print. The edges will still be visible to a small extent, so, to complete the montage, it is best to rephotograph the prints. Matt surface paper is

This interesting fish shot was produced by sandwiching two transparencies of similar fish types together. The shot of the large fish was created artificially; a picture of a small fish was enlarged to become an imitation monster of the deep.

therefore better, as it produces fewer reflections.

4. Combining subjects with artwork Another possibility is to lay objects on an illustration, painting, or any other form of artwork. There is no need to create an illusion of the subject being a part of the illustration, though well-diffused lighting will avoid prominent shadows.

5. Sandwiched transparencies This method simply involves taping two transparencies together. When you have decided on a combined image, tape the two transparencies together and mount the sandwich. Because this increases the density of the image, it is usually better to use slightly overexposed transparencies. In contrast to the double exposure method, the subjects should be darker than the backgrounds.

6. Projection With two slide projectors and a screen, images can be juxtaposed in a way that is similar in effect to double exposure. The quality of the end result will not be quite as high, but the technique is simple and you can see exactly what you are doing. Set up the projectors, screen and camera — the last on a tripod — in a completely darkened room, with a transparency in each projector. Aim both at the screen, adjusting the enlargement and light levels until you are satisfied with the combination. Make sure that the camera film is color balanced to the projector lamps.

99 · IMPOSING A RELATIONSHIP

Using any of the six methods described on the facing page, photograph any two subjects in juxtaposition. In doing this, you should aim to make a clear commentary on the relationship you choose to create.

Three technical devices were used here to impose a relationship on the subjects of these shots. The three-part study of the girl (**bottom right**) was produced by triple exposure on the same negative. With such a shot, getting the poses to work is essential, so it is important to plan carefully and even to make a trial run, if necessary. The poultry were superimposed on to the egg by projection (**bottom left**), the resulting image being projected again on to the background of a petrified tree to produce the final shot. The city skyline (**top**) was transformed by sandwiching a shot of a sunset on to it; careful examination reveals that this has not worked perfectly, since the clouds float across the tallest of the buildings to detract very slightly from the realism of the shot.

100 · CONVEYING A CONCEPT

Conceive, design and photograph a suitable image for a book jacket, the layout for which is shown below. Selecting the theme requires imagination, but it should revolve around careful consideration of the title.

Rock Business

THE ILLUSTRATED GUIDE TO THE MUSIC INDUSTRY

THE COMPLETE GUIDE TO
INTERIOR DESIGN AND DECORATION FOR THE HOME
PRINCIPLES, TECHNIQUES AND MATERIAL

THE COMPLETE GUIDE TO
INTERIOR DESIGN AND DECORATION FOR THE HOME
PRINCIPLES, TECHNIQUES AND MATERIALS

These book jackets show what can be achieved by thoughtful design and good photograhy. The paint can and brush of the first jacket, though deceptively simple concepts, were more difficult to photograph. The can and brush, with their carefully arranged amounts of over-spill, were placed on a long background strip and lit by an overhead diffuser through a sheet of plastic. Electronic flash was used. 1/1000 sec, f32.

The jacket for the rock music book was fairly easy to compose. Having selected the background of an electric guitar, a pocket calculator was secured under the strings with double-sided tape to visually complement the financial implications of the title. The jacket was lit from an angle and shot, the photographer taking care to avoid the problem of flare by careful metering of the light level.
1/1000 sec, f64.

Rock Business

THE ILLUSTRATED GUIDE TO THE MUSIC INDUSTRY

Breaking the Rules

THE STATEMENT THAT rules are made to be broken is a well-worn truism – and not always a sound one. In photography and illustration, rules have a tendency to grow spontaneously and can just as often be restricting as helpful. Any didactic approach to an art or craft runs the risk of creating a restricting formal structure, and a teaching course, such as this, can run the risk of being taken as instruction, rather than advice. Principles which simply explain the way that the different elements in photography work can harden into constraints, which put brakes on originality.

It is not difficult to break rules, but to do so for a definite purpose means being able to recognize them in the first place. Much of photography is based on standards that are so well accepted that they are rarely questioned. As an example, the frame of a photograph is almost always rectangular, or square. This is so for good reasons – these include the need for the frame to be unobtrusive so that the image will dominate – but, basically, the reasons are conventional. Changing the shape of the frame would be noticeable immediately and so this could be used to draw attention to a particular feature of the image. This is the subject of project 101; it offers the possibility of some interesting solutions.

The important factor is to have a definite reason for breaking any particular rule. Here are some more rules, few of which are questioned seriously by most photographers.

1. The center of interest at least should be sharply focused.
2. The subject should be exposed so that it appears more or less as it is experienced in real life.
3. A photograph that purports to be documentary should not be tampered with through processes such as retouching. It should remain 'honest'.
4. Composition should not stray very far from accepted norms.
5. Scenes should appear the right way up; in other words, their horizontal lines, even if notional, should not be tilted.
6. Current aesthetic standards are preferable to previous ones and there is an inevitable improvement in such techniques as lighting.

It is easy to see how such ideas become the perimeters within which virtually all photography is confined. They are sensible principles that encourage a clear and uncomplicated view of the role of photography. Even the last one is a justifiable arrogance, as it supports the notion of improvement and change.

Some of these 'rules' have already been tackled in earlier projects. Breaking away from them may seem to be at first glance an experimental exercise, but experiment, as treated on the previous pages, contains an element of uncertainty about the final result. At this final stage of Photo School, you should have a fairly clear idea of the outcome of various techniques and approaches, so that, in breaking any accepted canon, you can achieve a deliberate effect.

PROJECT 101

101 · CHANGING THE FRAME

Find and photograph a subject that will be enhanced by a non-rectangular frame shape. Alternatively, use a standard rectangular, or square, format, but construct an image within it that gives you a reason for altering part of the frame edge – cutting, bending, or tearing it, for instance. The important thing is to make the break or twist in the frame an integral part of the image.

1

Changing or breaking the frame can have dramatic effects when used to good purpose.

1. Changing and breaking The frame has been changed at the top to accentuate the arch over the door. Breaking the frame around the children's feet brings them further out of their background and forward towards the observer.

2. Burst of speed The cut-out round the motorcyclist's head gives the impression that the speed with which he is traveling brings him bursting upwards and outwards from the page on which the photograph is printed. Breaking the photographic frame round motorcyclists and racing cars is a favorite graphic device used to great effect by designers wishing to emphasize speed and fast action.

3. Direction Bringing the finger out beyond the frame provokes a strong sense of direction even to the point of being a visual command.

4. Pigeon's eye view Looking down on the stacked-up fruit on the market stall is a very much more interesting shot than a view from eye level – the full trays of succulent fruit are more appealing than the wooden sides of the crates. Cutting out the image around the bottom of the piles of crates and the fruit seller's feet accentuates the height of the camera position and brings the observer's eye straight down onto the fruit.

102 · DEFOCUSING THE SUBJECT

Produce a photograph with a clear center of interest, but with the composition arranged in such a way that the areas of sharp focus lie elsewhere in the background or foreground. Despite the deliberately soft focus on the main subject, the image should be logical and coherent.

This bar scene fulfills all the requirements of the project. The main subject lies in the softly-focused background and the construction of the shot – from the sharp detail of the foreground – seems to lead inevitably to it.

103 · ALTERING THE SURFACE OF THE PRINT

Produce a print or transparency in which the surface of the emulsion is deliberately mutilated. The object of this is to present the photograph as a two-dimensional object, rather than as an illusion of reality. As with the other projects here, the mutilation should be justifiably related to the image.

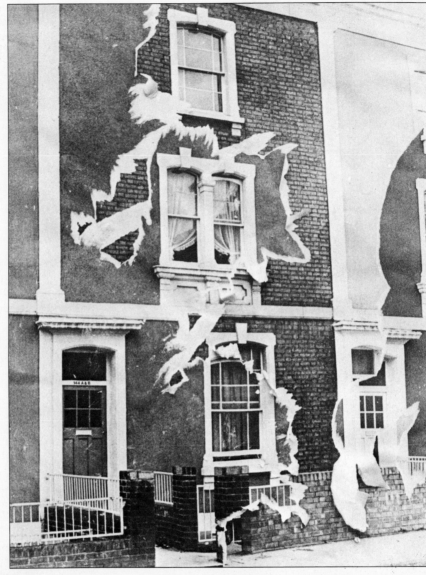

The mutilated transparency (**left**) was simply and deliberately ripped by hand and then re-shot to dramatize the theme of a threatening fist literally bursting out of the frame. The photographer has intensified this feeling by cropping in closely on the image, making it even more dramatic. The shot of this slum building (**above**) was produced by superimposition, a technique frequently used in photomontage. A ripped print was placed carefully on top of the original shot of the building and the result re-photographed.

Photographic Assignments

104 · A photo assignment

FULL-SCALE PHOTOGRAPHIC assignments are commonplace in the life of the professional photographer. By setting yourself such assignments, you will not only have the opportunity to use the practical, compositional and interpretative techniques you have learned; you will also be taking the final steps towards becoming a creative, rather than merely competent photographer.

It is important to remember that patience is one of the photographer's cardinal virtues. Too many amateurs make the mistake of rushing shots, when with a little extra thought and preparation, the unexciting results they obtain could have been transformed. Different assignments require different qualities and techniques, however. A sporting event, for example, will demand quick decisions and lightning reactions from the photographer, who will need to be in constant readiness. Whatever the topic, always try to inject a little originality into your pictures and do not be afraid to experiment.

It is vital to analyze your chosen assignment topic carefully before you start taking pictures. Select a varied range of subjects (buildings, views, people etc.) which cover every aspect of the topic, and which will give as balanced an impression as you are aiming for. Take as many shots as you need of each one, but make sure you deal with all of the subjects in the time you have at your disposal. It is easy to become engrossed with one particular subject, and to spend too long on it. Although you may succeed with one excellent shot in the end, the assignment as a whole will suffer.

Finally, do not expect too much of yourself and your camera at first. You may take up several rolls of film and not come up with a single picture that satisfies you. Be prepared to take plenty of film with you, and if you are unsuccessful, arrange to return another day. As already demonstrated in the previous pages, a change of lighting and weather conditions can transform a subject. Encourage yourself with the thought of the infinite number of excellent pictures just waiting for you to take them!

Copyright line — (C) Michael Freeman 1978 — Date

Note of location, subject, technical detail catalog

INTERIOR OF MUSEO DE BELLAS ARTES, MEXICO CITY

Mexico 12

2695

Code for reference to master catalog

All your transparencies should be properly mounted, labelled and identified. Essential information includes a note of the location and subject, technical detail, catalog code and a copyright line, if you are working professionally.

PROJECT 104

104 · A PHOTO ASSIGNMENT

Set yourself a photographic assignment to cover a particular place of interest. It could be a market, a tourist attraction, a playground or a larger area such as a small town. Use the techniques learned in the previous projects to produce as striking a set of images as possible. You will probably use several rolls of film, but narrow your final choice of prints down to between five and ten, and make sure they present a balanced view of the subject. It may help to imagine that your photographs are being published by a prominent magazine, and to construct a series of captions or a basic storyline to accompany them.

Smithfield Market in London provides a great variety of images.
1. Meat barrows Before business began, very early in the morning, the photographer was able to set up a tripod and carefully judge the light values of each component in this

2

3

image. The range of tones produce a good photograph.
28mm, ¼ sec, f11

2. Horse and cart Traditional transport contrasts sharply with the refrigerated van behind. The dome of the market towering over the scene lends an air of urban respectability.
28mm, ⅟30 sec, f3.5

3. E.G. Pettifer Ltd. Again the photographer used his tripod in order to extend exposure time and improve the contrast in the image.
28mm, ¼ sec, f11

4. Production line Contradictory demands of low lighting levels but fast action by the subject were overcome by allowing some blurring of the hand and arm of the subject, which in turn indicates the hard work taking place.
28mm, ⅟30 sec, f3.5

5. Head shot The gruesome sight of the head-filled bin is given added pathos by the full head staring out of the center of the picture.
28mm, ⅟30 sec, f3.5

6. Butchered The power of this image is emphasized by the two halves of the pig disappearing out of the photograph on each side.
28mm, ⅟30 sec, f3.5

3

4

7

2

1

5

6

When taking photographs with a hand-held camera, as here, there is little point in taking long-focus pictures because of problems of camera-shake. All these shots were taken using a 28mm wide-angle lens.

1. Island of Alcatraz Despite the bobbing of the boat, the photographer achieved a sharp image by shooting at very fast speed. 1/1000sec, f22

2. Prisoner's eye view The photographer bracketed the shot in order to be sure of getting the right exposure both for the door and the view beyond. 1/15sec, f5.6

3. and 4. Decay and order Both photographs were taken at 1/250sec but the reflection off the water behind the look-out makes the land beyond the island seem very distant. The contrasting tones of the trees and weather-boarded house create a warmer atmosphere. 1/250sec, f16/f22

5. Frames within frames The exposure was set for outside the window. The casement therefore frames the image – a device borrowed from the world of fine art. In addition, the dirty windows allowed less light into the interior creating an impression of an over-exposed image. 1/250sec, f8

6. Behind bars Clever contrast creates a patterned image. The sun bursts tantalizingly through. 1/1000sec, f22

7. Guard dog The intruding photographer is reminded that his presence is unwelcome. 1/500sec, f22

Glossary

A

Aberration Lens fault in which light rays are scattered, thereby degrading the image. There are seven different forms of aberration common in a simple lens, including spherical and chromatic aberration, coma, and field curvature.

Additive process A color process which combines lights of different colors. The three primary colors — red, blue and green — produce a range of colors.

Aerial perspective The effect of depth in a scene which is conveyed by haze.

Angle of view The widest angle of those light rays accepted by a lens which forms an acceptably sharp image on the film. This angle is widest when the lens is focused at infinity.

Aperture A circular hole centered on the lens axis, which is adjustable on all but the cheapest cameras. It is the part of the lens system that admits light.

ASA The American Standards Association rating of the sensitivity of a film to light, which is based on arithmetical progression. ASA 100 film, for instance, is half the speed of ASA 200.

Automatic exposure control Camera system in which the photo-electric cell that measures the light reaching the film is linked to the exposure or lens aperture to adjust the exposure automatically.

B

Back lighting Lighting from behind the subject which is directed towards the camera position.

Barndoor An adjustable shaped door used to control the direction of light and the width of the beam on floodlights and spotlights.

Barrel distortion A camera aberration in which the shape of the image is distorted. A square object appears barrel-shaped, with the straight edges bowed outwards, because the magnification decreases radially outwards.

Bracketing A method of insuring against incorrect exposures, by making a series of shots of a single subject, each varying by a progressive amount from the estimated correct aperture/speed setting.

C

Cable release A triggering device used to fire a camera shutter when there is risk of blurring through camera shake.

Camera shake Unintentional movement of the camera during exposure, causing blurring in the image.

Center of curvature The center of an imaginary sphere, part of which is the curved surface of a lens.

Characteristic curve A curve plotted on a graph showing the relationship between exposure and density, which is used to describe the characteristics and performance of the sensitive emulsions of film or paper.

Circle of confusion A circle below a certain size formed by the lens, which looks like a point to the human eye. The size sets the limit for a sharply focused image.

Color compensating filters Filters, available in primary and complementary colors at different strengths, used to alter the color of light.

Color contrast Subjective view of the difference in intensity between two close or adjacent colors.

Color conversion filter Colored filter used to alter the color temperature of light.

Color temperature The temperature to which an inert substance has to be heated in order for it to glow at a particular color. For photography, the scale of significant color temperature ranges from the reddish colors of approximately 2000°K through standard 'white' at 5400°K, to the bluish colors above 6000°K.

Complementary colors A pair of colors which, when combined in equal proportions, produces white light (by means of the additive process).

Contact sheet A print of all the frames of a roll of film arranged in strips, same-size, from which negatives are selected for enlargement.

Contrast Difference in brightness between adjacent tonal areas. In photographic emulsions, it is also the rate density increases, measured against exposure.

Covering power The diameter of acceptable image produced at the focal plane by a lens, when focused at a given distance.

D

Density The ability of a developed silver deposit to block transmitted light in photographic emulsions.

Depth of field The zone in front and beyond the plane of sharpest focus in which the image is acceptably sharp. Normally, there is greater depth of field behind this plane than in front of it. The more the aperture is stopped down, the greater the depth of field.

Depth of focus The distance through which the film or lens can be moved before the image becomes unsharp.

Diaphragm An adjustable opening on a lens, that controls the amount of light passing through.

Diffraction The scattering of light waves that occurs when they strike the edge of an opaque surface.

Diffuser Material that scatters transmitted light.

DIN Deutsche Industrie Norm, or the logarithmically progressive rating of a film to light.

E

Electromagnetic spectrum The complete range of energy waves traveling in space, from radio waves to gamma rays, and including visible waves (light).

Electronic flash Artificial light source produced by passing a charge across two electrodes in a gas.

Emulsion Light-sensitive substance composed of silver halides suspended in gelatin, used for photographic film and paper.

Exposure The amount of light reaching a film emulsion, being the product of intensity and time.

F

f-stop Numbers on the barrel of the lens indicating the ratio of the focal length to the diameter of the aperture. A lens' light-gathering power is normally described by the wider f-stop it is capable of. Usually lens aperture rings are calibrated in a standard series: f1, f1.4, f2, f2.8, f4, f5.6, f8, f11, f16, f22, f32 and so on. Each of these stops differs from its adjacent stops by a factor of 2.

Film speed rating A film's sensitivity to light, measured on a standard scale, usually either ASA or DIN.

Filter Transparent material, usually colored, fitted to a lens in order to alter the characteristics of light passing through it.

Fish-eye lens A very wide-angled lens, characterized by extreme barrel distortion, which gives a special and strong graphic character to the image.

Flare Non-image forming light which degrades the quality of an image, because of scattering and reflection. Coating is used to reduce it.

Flash See Electronic flash.

Flash guide number Notation used to indicate the aperture setting when using an electronic flash, proportionate to the output of the flash unit.

Focal length The distance between the center of a lens (the principal point) and its focal point.

Focal plane The plane at which a lens forms a sharp image.

Focal plane shutter Shutter located close to the focal plane in the camera, consisting of two blinds that form an adjustable gap which moves across the film area. The size of the gap, which is controlled by the shutter speed dial, determines the exposure.

Focal point The point on either side of a lens where light rays entering parallel to the axis converge.

Focus The point at which the image of the subject is made as sharp as possible by the lens.

G

Gelatin In photographic film and paper, the substance used to hold silver halide particles in suspension, in order to construct an emulsion. This is coated on to a backing.

Grade Classification of photographic printing paper by contrast. The most common are grades 0-5, ie, from soft to very hard, although similar grade papers from different manufacturers often vary.

Graininess A pronounced speckled texture made by clumps of silver halide grains in the film emulsion.

H

Hardener Chemical agent, usually chrome or potassium alum, which combines with the gelatin of a film to make it more resistant to scratching.

I

Incident light reading Exposure measurement of the light falling on the subject only; it therefore takes no account of the reflective qualities of the subject.

Inverse Square Law The geometrical rate at which the illumination from any light source falls off with distance. It is, in fact, inversely proportional to the square of the distance.

K

Kelvin The standard unit used to express the relative color quality of light sources.

L

Latent image The invisible image formed by exposing an emulsion to

light which can be made visible by development.

Lens A transparent optical disk which redirects light from the subject on to the film in the camera.

Lens flare Non-image forming light reflected from the lens surface, which degrades the quality of the image.

Lens shade An attachment to the lens which shades the lens front from non-image forming light which can cause flare.

Line film Film capable of very high contrast, which can be developed so that the image contains only full density black, with no intermediate tones.

Long-focus lens Lens with a focal length much longer than the diagonal of the film format with which it is used.

M

Magnification The ratio of the size of the image to the size of the subject used to produce it.

Mean Noon Sunlight The color temperature to which most daylight color films are balanced. It is an arbitrary choice — 5400°K — being the average color temperature of direct sunlight at midday in Washington DC.

Mired shift value A method of measuring color temperature, which is used in calculating the differences between light sources. To obtain the mired value of a light source, one million is divided by its color temperature in Kelvins.

Mirror lens Compound lens which uses two mirrors to form an image by reflection. Its length is much shorter than that of traditional lenses of the same focal length, because it compresses the distance that the light rays must cover into a short tube.

N

Nanometer 10^{-9} meter.

Negative Photographic image produced on an emulsion by exposure and development, in which tones are reversed (as are colors if color film). It is used to make a positive image, normally a print, by projection.

Normal lens See Standard lens.

O

Optical axis Imaginary line which passes horizontally through the center of a lens system. A light ray following this line would not bend.

Orthochromatic film Film which is sensitive to green and blue light, but reacts weakly to red light.

Overdevelopment Term indicating that the amount of development recommended by the manufacturer has been exceeded, usually either by prolonged development time or by an increase in development temperature, and usually results in an increase in contrast and density.

Overexposure Term used to indicate the excessive exposure of light-sensitive material, either because light is too bright, or the material has been exposed for too long. Usually, overexposure increases density and decreases contrast.

P

Panchromatic film Film which is sensitive to all the colors of the visible spectrum.

Panning Rotating the camera smoothly in order to keep a subject continuously in frame.

Parallax error Displacement error caused by the camera's viewfinder being in a different position from the lens, and therefore seeing a slightly different picture at close distances. Most viewfinder cameras indicate the amount of displacement. Only through-the-lens viewing systems avoid parallax error.

Photo-electric cell Light sensitive cell used to measure exposure. Some cells produce electricity when exposed to light; others react to light by offering an electrical resistance.

Photoflood Over-rated tungsten lamp used in photography, with a color temperature of 3400°K.

Photomacrography
Close-up photography with magnifications in the range of X 1 to X 10.

Photomicrography Photography at great magnifications using the imaging systems of a microscope, to which a camera is fitted.

Polarization Restricting to one plane only, the direction of the vibration of light — which normally vibrates at right angles to its direction of travel in every plane — through the use of a plane-polarizing filter.

Primary colors Three colors —blue, green and red — each occupying one-third of the visible spectrum, which, when used in carefully chosen proportions, can reproduce almost any color; combined equally they make white light. In photography, each of the three layers of emulsion on color film is sensitive to one of the three primary colors.

Prism Transparent substance shaped so that it refracts light in a controlled manner.

Programmed shutter Electronically operated shutter with variable speeds, which is linked to the camera's TTL meter. When a particular aperture setting is selected, the shutter speed is automatically adjusted to give a standard exposure.

S

Safelight Darkroom light which has a color and intensity that does not affect light-sensitive materials.

Scoop Smoothly curved studio background, used principally to eliminate the horizon line.

Selenium cell Photo-electric cell that generates its own power from the light which it is measuring.

Sensitivity The ability of an emulsion to respond to light.

Separation negative Black and white negative exposed through a strong colored filter in order to analyze an image in terms of its blue, green and red content. Used in dye transfer printing, and also in non-photographic printing.

Shutter Camera mechanism used to control the time that image-focusing light is allowed to act on the sensitive emulsion of a film.

Single lens reflex (SLR) Camera system which allows the image focused on the film plane to be previewed, and thus eliminates parallax error. A hinged mirror that diverts the light path is the basis of the system.

Spot meter An extremely accurate hand-held exposure meter, which measures reflected light over a small, precise angle of view.

Standard lens Lens with a focal length equal to the diagonal of the film format. It produces an image which appears to have normal perspective and angle of view.

Subtractive process One of the two fundamental methods — which used colored filters, dyes or pigment — by which color is produced photographically. Cyan, magenta, and yellow are the subtractive primaries and when viewed against a white light source, will each absorb quantities of a primary color. Combining all three primary colors in this way produces black (light being absent).

T

Telephoto lens Lens with a long focal length, which enlarges distant subjects within its narrow angle of view, by means of diverging and converging elements.

Through-the-lens (TTL) meter Exposure meter built in to the camera, which is normally located close to the instant-return mirror of a single lens reflex or to the

pentaprism.

Tone Uniform density in an image.

Tone separation The isolation of tonal areas in an image, usually by combining varying densities of line positives and negatives.

Toner A chemical used to add an overall color to a processed black and white image, by means of bleaching and dyeing.

Transparency Positive image on a transparent film base, designed to be viewed by transmitted light.

Tri-chromatic System of reproducing or reusing specific colors by the variable combination of only three equally distributed wavelengths, for instance, blue, green and red; or yellow, magenta and cyan.

Tri-pack Color film constructed of at least three layers of emulsion, each sensitive to a different color.

V

Viewfinder Simple optical system used for viewing the subject.

W

Wavelength The distance between peaks in a wave of light. Among other things, this distance determines the color of the light.

Wide-angle lens Lens with an angle of view which is wider than that considered normal by the human eye (ie, more than about 50°). Wide angles of view are characteristic of lenses with short focal lengths.

Windowlight A studio light which is enclosed in order not to spill unwanted light.

Z

Zone System A method of evaluating exposure developed by Ansel Adams and others. Light measurement is divided into numbered zones in order to achieve a specific tonal range.

Zoom lens Lens with a continuously variable focal length over a certain range at any given focus and aperture.

Index

Acknowledgements

Special thanks to the students of the Department
of Graphic Design, Lanchester Polytechnic, Coventry,
and the photographic students of the Art Department,
Eastbourne College of Further Education, Eastbourne,
and to the International
Center of Photography, New York City.